D1154277

Theorizing Ambivalence
in Ang Lee's
Transnational Cinema

FRAMING FILM
The History & Art of Cinema

Frank Beaver, *General Editor*

Vol. 17

PETER LANG
New York • Washington, D.C./Baltimore • Bern
Frankfurt • Berlin • Brussels • Vienna • Oxford

Chih-Yun Chiang

Theorizing Ambivalence in Ang Lee's Transnational Cinema

PETER LANG
New York • Washington, D.C./Baltimore • Bern
Frankfurt • Berlin • Brussels • Vienna • Oxford

Library of Congress Cataloging-in-Publication Data
Chiang, Chih-Yun.
Theorizing ambivalence in Ang Lee's transnational cinema / Chih-Yun Chiang.
p. cm. — (Framing film: the history and art of cinema; v. 17)
Includes bibliographical references.
1. Lee, Ang, 1954– —Criticism and interpretation.
2. Motion pictures and transnationalism.
3. Motion pictures and globalization. I. Title.
PN1998.3.L438C43 791.43'6552—dc23 2012007139
ISBN 978-1-4331-1932-3 (hardcover)
ISBN 978-1-4539-0828-0 (e-book)
ISSN 1524-7821

Bibliographic information published by **Die Deutsche Nationalbibliothek.**
Die Deutsche Nationalbibliothek lists this publication in the "Deutsche
Nationalbibliografie"; detailed bibliographic data is available
on the Internet at http://dnb.d-nb.de/.

The paper in this book meets the guidelines for permanence and durability
of the Committee on Production Guidelines for Book Longevity
of the Council of Library Resources.

© 2012 Peter Lang Publishing, Inc., New York
29 Broadway, 18th floor, New York, NY 10006
www.peterlang.com

Printed in Germany

CONTENTS

ACKNOWLEDGMENTS

I would like to thank my mentor and Ph.D. research advisor, Dr. Darrin Hicks from the Department of Communication Studies of the University of Denver, who gave generously his ideas, time, and unwavering advice during the process of completing my studies. Dr. Hicks has always been a source of inspiration, a great mentor, and a long-term example of creative and critical scholarship for me.

Special thanks to the Chiang Ching-kuo Foundation for International Scholarly Exchange. Without the awarded fellowship, I would not be able to complete this study. I am also grateful to Drs. Bernadette M. Calafell and Kate G. Willink who provided positive feedback for this research. I am especially grateful to my mentor Dr. Lily Mendoza from Oakland University, who was the inspiration for this study. I am thankful for her long-term mentoring, friendship, and support, which opened up my interest and a new world of understanding in cultural studies and intercultural scholarship. I would also like to thank the series editor, Dr. Frank Beaver from University of Michigan, for his support and interest of my work. Thanks to the editors at Peter Lang Publishing for their careful reviews of the manuscript during the conclusion of the publication process.

In addition to my academic support, I am most grateful to my parents and family who provided nothing but support. I thank my parents Jim Chiang and Wei-Chen Shih for their support while I completed the research

journey. I am grateful to my aunt, Dr. Yuan-Yuan Chiu, and my uncle, Dr. Honda Chiu, who helped me numerous times, offered unconditional love and believed in me throughout these years while I completed my research. Thanks to John, my life-partner, who provided persistent feedback for the writing of this manuscript.

Finally, I want to especially thank my American friends and family— Donna Goben and Vern Irwin. I thank Donna for her many years of unending support, help, and personal friendship. I thank Vern and the cat Russia for their kind companionship at the stage of initial writing of the manuscript of the book. Finally, my gratitude goes to many friends from Taiwan, the Communication Studies Department at DU, and Stella's coffee shop, who have ever given me their hands and words of encouragements.

INTRODUCTION

This book began with the desire to develop the notion of *ambivalence* and the politics of Chinese identity in transnational cinema, theoretically challenging ideological constructions of racial and ethnic identity that are historically produced and defined within a homogeneous nation-state mechanism in a postcolonial and transnational context. In the past two decades, the explosion of transnational Chinese cinema in the global film market has raised many critical issues. As current transnational feature films such as *Curse of the Golden Flower*, *The Flower of War*, *Kung Fu Hustle*, and *Red Cliff* (coproduced with major Hollywood studios and Pan-Asian actors and distributed internationally) capture worldwide acclaim, they begin to display the burgeoning demands for a transnational Chinese film market. Issues surrounding the global visibility of a minority subject in transnational films have become much-debated topics in many academic fields, obliging us to interrogate the essentialist understanding of culture, nation, and identity.

In particular, the successful transformation of Chinese identity into a cross-cultural commodity in the global film market warrants further discussion of the cultural politics that facilitate the global circulation. Such cultural politics demand that one take an alternative approach to reexamining the indeterminate, ambivalent, and dynamic nature of the "local" and the "global," the "Euro-American center" and the "Third World local." As Mackintosh, Berry, and Liscutin (2009)

sharply posited, globalization is far from being a hegemonic force. Instead it is a site of continuing cultural negation, resistance, and subversion.

Ang Lee (Li An) is considered one of the most prominent directors to negotiate Hollywood film production successfully. He is the first Oscar-winning, Asian film director; his internationally acclaimed movies were described as "Confucianizing Hollywood" (Yeh & Davis, 2005, p. 177). With the success of *Sense and Sensibility*, Ang Lee has almost achieved the status of *national hero* from the perspective of audiences in Taiwan (Chen, 2000b). Nowadays, what really matters "is not so much the ideological content of the film, but whether it will disseminate the name of Taiwan" (Chen, 2000b, p. 176). The study of Lee's films has become a "need-to" topic in the academy. When studying cultural migrancy in Ang Lee's *Crouching Tiger, Hidden Dragon* (*Crouching Tiger* hereafter), for example, Chan (2003) asked an important question: "What happens when a cultural text travels from one place to another?" (p. 56).

Self-identified as a "Chinese" director in the diaspora, Ang Lee has always taken on his *burden* to be a film director who contributes to the representation of Chinese culture on the big screen. In an interview with the *New York Times* when *Crouching Tiger* came out, Ang Lee noted that the reason for the movie's success was its expression of Mandarin culture. He stated,

> We had escaped from the mainland in the civil war, and we missed that culture. For those of us too young to remember the mainland, we did not really know the old culture. So when we would see it in this movie, we would think, "Oh, that is China." When I went back to China to make "Crouching Tiger, Hidden Dragon," I knew nothing about the real China. I had this image in my mind, from movies like this. So I projected these images as my China, the China in my head. (Lyman, 2001)

Ang Lee has repetitively addressed the fact that *Crouching Tiger* was based on his cultural imagination of the "great Chinese theme." After *Crouching Tiger*, his American film, *Brokeback Mountain*, and the Chinese film, *Lust, Caution* continued to generate for him enormous attention in the academy and the public. The divergent perceptions of Ang Lee's movies underscore the point that interpretations and reactions to the cultural texts cannot be defined or understood in a one-dimensional vacuum. The change in sense-makings is indeed based on *who* the interpreter is and the specific group to which one is perceived as belonging.

Not only do Ang Lee's works serve as a site of contestation of the meaning of culture and identity, but they also function as a *symbolic bridge* to other Chinese diasporic communities with different nationalities. These groups include people like myself, an international scholar away from my native country, emotionally attached to Ang Lee's nostalgic, domestic family dramas and English-language films. I was profoundly moved by Ang Lee's speech when receiving the 2007 Best

Director Academy Award for *Brokeback Mountain*. On the stage, with tears in his eyes and his voice quavering, Ang Lee humbly said that the award *belongs* to the people from Mainland China, Taiwan, and Hong Kong. He also wished them "Happy Chinese New Year," in both English and Mandarin, in front of American and non-American audiences made up of millions of people. The acceptance speech indeed reinforced the film's significant social impact and its function as a powerful and effective communication medium for mobilizing nationalism and constructing and co-constructing one's identity. To put it another way, the speech provided a means to hail one's transnational ethnic imagination, in this case, my sense of *Chineseness*. My overwhelming sentiment resurfaces to echo my own positionality, namely,that of a self-perceived Chinese scholar from Taiwan who lives in the U.S.

This point was made even clearer on a winter evening in 2007, as I was waiting in line to purchase a ticket for Ang Lee's latest film, *Lust, Caution*. I was fascinated to see that a number of audience members with yellow skin and black hair were scattered throughout the small, independent theatre located on Broadway in Denver, a city with a predominantly White population and a very small Chinese population. I have gone to see a film several times each month over the past five years, and that was the first time I saw so many Asians in the audience. Most of them spoke Mandarin Chinese, which is the national language of both Mainland China (People's Republic of China) and Taiwan. I easily recognized the different accents and could identify whether they were from the mainland or from Taiwan.

I saw that movie several times in the same theatre. Each time, there were Asians in the audiences. On one occasion, I was even greeted by strangers with big smiles and, in Mandarin Chinese, "Eh! Ni ie lai kan *Se Jie?*" (Hey! You also came to see *Lust, Caution?*). To my surprise, I was immediately marked as a member of the group of "Chinese" viewers, even though we did not know each other and had never met before. I was engaged in a putative *reunion* of the imagined community (Anderson, 1991) at that specific moment. At that moment I had a strange feeling of being marked as a Chinese/Taiwanese, and/or a Chinese/Taiwanese in the diaspora.

On the one hand, I felt welcome and included; I was identified as a member of the Chinese group by others. It validated a sense of belonging and strengthened my bonding to such a cultural group. It also appeared to me that it was a situation in which an ethnic minority, in this case "Chinese" in the diaspora, is (re)*unified* to share a *collective* cultural pride in a successful *Chinese* film in the West. On the other hand, I found myself uneasy, since I was "mistakenly" identified as being from Mainland China rather than from Taiwan. It appeared to me that the possibilities of being "other Asian members" were automatically excluded in that "context of contingency" (Bhabha, 1994a). Through the exchange of smiles and engaging in enthusiastic discussions among fellow Chinese members of the audi-

ences inside and outside the theatre, we automatically identified and connected with each other as being from the *same* national group.

My feelings of uneasiness stemmed from my hesitation to respond to the passionate call for co-ethnic diasporic solidarity (Ang, 2001a). I had never identified (and will not identify) myself as a person from Mainland China in my everyday life in the U.S., yet simultaneously I was ambivalently pleased to be "mistaken" for a member of a Chinese group, sharing a moment of collective cultural pride. In Taiwan today, the unresolved, severe political tensions with the mainland have influenced some people to deny their Chinese cultural roots and to refuse to identify themselves as "communist Chinese." They foster a strong hostility toward the nation in order to solidify their indigenous Taiwanese consciousness. Therefore, a scene of *reunion* such as the one that took place at the theatre in Denver might never happen in Taiwan.

My experience in that movie theatre was one of a profound sense of ambivalence concerning my own subjectivity and identity. I also realized that imagining myself to be a member of the Chinese diaspora was a way of aligning myself with "a powerful deterritorialized community nationally bound together by an abstract sense of racial sameness and an equally abstract sense of civilizational pride" (Ang, 2001b, p. 57). Yet, I was not relieved from the uneasiness involved in the specific condition of being part of a Taiwanese/Chinese diaspora in that context. I have always subliminally engaged in the equivocal ambivalence of defining my own national identity.

Combined with the tremendous amount of public discourse surrounding Ang Lee and his works, I am driven to ask: "What do Ang Lee's transnational films mean to the audiences? Namely, how might his films be interpreted differently by various cultural groups of audiences within different national and historical conditions?" Indeed, many attempts have been made to address the influences of his cultural background that shape his works. In this study, instead of asking, "Are Ang Lee and his films Taiwanese? Chinese? American? Taiwanese American? Chinese American?" (Lu, 1997a, p. 18), I wonder, "How does 'Chinese' become an equivocal notion that no longer guarantees an ethnic solidarity under different social conditionings?" To expand on this question, I ask, "In what ways are the subjectivities of *Chinese* and *Taiwanese* problematic and ambivalent not only in his films but also in one's everyday experiences? How does one, as an audience member, negotiate one's identity and subjectivity through the discourses of his films?"

Rather than constructing his films under the framework of dualism, namely, either as "cultural sellouts," or as the products of cosmopolitanism, I am proposing a more adequate and nonmonolithic way of theorizing the politics of national identity in transnational cinema. I want to provide a more provocative framework by employing the notion of ambivalence to expand the discussions on the politics

of national identity represented in transnational cultural productions in an era of globalization.

The questions I aim to answer in this book are: How does the notion of ambivalence serve as a more adequate framework to theorize the politics of national identity in transnational film productions in a global context? How does film function as a discursive site for negotiating and reproducing one's *national identity* and *subjectivity*? How is the meaning of national identity constructed in different contexts? Who gets to actively seek out and bring the certain knowledge into being, and for what purpose? More specifically, can the films of Ang Lee be *simultaneously* liberatory and limiting? If so, in what ways and under what conditions does the cinematic discourse of Ang Lee serve an emancipatory function, and in what ways is it limiting? The polarized reactions from different groups of audiences present an interesting puzzle to me. By studying these questions, I will be able to engage in a systematic analysis of the essential conflict in interpreting Ang Lee's films among different cultural groups in relation to the construction of Chinese identity. Further, I will be able to discuss how this contributes to the audience member's sense of being a *world citizen* in an age of transnationalism.

Film producers are known to share with their audiences not only the classical cinematic paradigm but also more general paradigms of narrative and representation (Saxton, 1986). The discourse of film not only has a narrative function but also a social function. We should understand films as cultural collaborations because they involve not only "crew, cast, and studio, but also all of us who consume the film" (Saxton, 1986, p. 20). A cultural text cannot have a complete or closed meaning by itself but rather is always open to interpretation. Given this, aside from film texts I will incorporate into my analysis the public discourse about the films from three audience communities. Among these are first, the Chinese community that includes China, Taiwan, and Hong Kong, and second, the community of Chinese diasporas. In doing so, I am able to unpack the politics of national identity (such as the notion of Chineseness) interrogated in the cinematic discourse and examine the effects of such representational practices in the context of globalization.

I focus on two of Ang Lee's films—*Crouching Tiger, Hidden Dragon* and *Lust, Caution*. The justification for the focus of my research lies in the fact that both films represent distinct, yet controversial subjects on the issues of Chinese identity and culture. Since the Internet has become an increasingly larger factor in new communication technologies that help build national identity and facilitate nationalism (Ang, 2001a, 2001b, 2001c; Appadurai, 1996; Duara, 1995; Georgiou, 2006; Shome & Hegde, 2002a, 2002b, among others), my research materials will include multiple sources from Internet websites. They include Internet bulletin boards, interviews, and media coverage. I will examine the Chinese-language websites that are particularly popular among Taiwanese, Chinese, and members

of Chinese diasporas. Using ambivalence as my theoretical framework, my examination focuses on the discursive formation of Chineseness in the two films. This brings the concept of ambivalence to the forefront to theorize the ways in which the discourse of Ang Lee's films succeeds in uniting Chinese hailing from different countries of origin into a common, transnational, imagined community.

In the first chapter I map out a critical review of the debate of the margins struggling to come into representation within a context of globalization. I discuss the construction of culture and identity historically and politically, explore how the processes of globalization and transnationalism impact their theorization, and further examine complexities of the relationship between globalization and the visibility of minority subjects in cultural production in a postcolonial and transnational context. I employ postcolonial criticism to inform my discussion of the ambivalent discourse of transnational Chineseness. I then focus on the theoretical debate of transnational cultural productions, specifically transnational Chinese films and New Chinese cinema in relation to various forms of global capitalism that shape the politics of representing nationhood and national identity. In doing so, I extend the postcolonial framework that historically and predominantly emphasizes the European. The discussion maps out the theoretical context and understanding of the study.

Chapter two discusses the sociopolitical and historical context of Taiwan, China, and the United States to unpack the specific conditions in which cultural identity has operated. To establish my subsequent analysis, I offer a critical justification of my choices of the two films by analyzing their popularity in both Eastern and Western film markets. In the third chapter, my analysis focuses on the conceptual framework of ambivalence by identifying, examining, and then applying four aspects of ambivalence as a concept from a postcolonial perspective. In chapter four, I engage a textual analysis of *Crouching Tiger*, incorporate Ang Lee's autobiography and published interviews, and examine the discourse of audiences.

Chapter five offers a critique of *Lust, Caution* and its receptions, following the same format as chapter four. Ang Lee's films function as a mediated engagement for the audiences to reaffirm, research, and reengage their cultural roots. However, the films simultaneously reassign and problematize a static meaning of national identity and cosmopolitan identity. The final chapter begins by connecting research questions to the theory of ambivalence to untangle the political and historical moments in shaping a specific version of Chinese identity that has been performed in the discourse of *Crouching Tiger* and *Lust, Caution*. I then discuss the implications of applications of the theory of ambivalence in studying culture and communication as a whole.

In examining the cinematic construction of Chineseness in diasporic film director Ang Lee's internationally acclaimed films, *Crouching Tiger* (2000) and *Lust, Caution* (2007), I take a unique approach to the study of transnational cinema by

exploring the representation of Chinese identity in these transnational films and the public discourse from audience communities within various Chinese settings. This book takes these two films as case studies. Engaging a systematic analysis of the audience discourses from Taiwan, Mainland China, Hong Kong, and diaspora populations, the book expands the theoretical discussions on the politics of national identity and cultural syncretism represented in transnational cinema and further provides a good example of the familiar cycle of ambivalent emotion towards the West in the aftermath of postcolonialism.

China's and Taiwan's long history of engaging in a subordinate relationship with the West enhances the resurgence of ambivalence. The representations become a significant and predominant way to mediate one's bodily experiences, to connect and collaborate with one another, and to form and inform one's cultural identity. The analyses of these films and the audience discourses are essential to understanding the ways in which new media technologies impact and alter the human interactions between peoples in various cultural, social, and political contexts. I focus on audience receptions and public discourses surrounding the two films in hopes of contributing an alternative way of understanding national identity in relation to the politics of cultural representation and enabling a rethinking of its impact in the age of transnationalism and uncertainty.

ONE

The Disruption of
the Global and the Local

Representation and Cultural Identity
in the Age of Uncertainty

The increased complexity between the local and the global as well as its ef-
fect on the idea of nationhood and the national identity is one of the most
distinctive features in contemporary postcolonial and transnational contexts.
Through identity one sees the complex interplay between cultural and historical
contexts and one's subjectivity. Cultural identities are never static; rather, they
are constructed through a changing process without the limitations of special
boundaries. Under these circumstances, one needs to understand the complexities
of globalization that intersect with the constructions of national identity of the lo-
cal. The local communities simultaneously undergo their own transformations in
order to respond to and engage in transnationalism—negotiating, constructing,
and reinventing their own subjectivities. The ideas of *pluralism* and *cosmopolitan-
ism*, as liberal as they may sound, indeed create the ethnic differences—the ethnic
absolutism—that could further lead to neo-racism and oppression.

Moving away from the conventional identity paradigm that is objectively de-
fined within a static nation-state mechanism, critical interrogation such as postco-
lonial theory opens up discussions on how the local engages with the global under
the complexity of globalization and transnationalism. The impact of transnational
forces, such as the rapid circulation of images, goods, information, and move-
ments of diasporic populations, demonstrates the limitations of the nation-state
framework.

Grounded in the discourse of modernity, the idea of Euro-American-centric modernism operates within the issue of globalization. The circulation of power maneuvers within the global mass culture through cultural interchanges between the local and the global (Ashcroft, 2001). In the context of globalization as a continuation of Western neocolonial economic domination, postcolonialism only makes sense within specific historical contexts; that is, there are no essential "post-colonial cultures," there are only postcolonial "moments," where various discourses, representations, and tactics cohere to create a systematic argument (Ashcroft, 2001; Clifford, 2005; Hall, 1996a, 1996b; and Young, 2001, among others).

New cultural politics have arisen following the phenomenon of globalization. Under Western humanism, racial or national identity is the production of a historical legacy that interplays with reductive cultural or national sameness and differences. Clifford (2000) asserted, "Where 'culture and place' are reasserted politically in the new system, it is increasingly in nostalgic, commodified forms" (p. 101). It seems inevitable for voices that had been marginalized to adopt hegemonic traditions as a way to somehow free themselves from hegemony's power; to become individuals, and not just remain indistinguishable beneath the collective rubric of "Others" assigned to them in the discourse. Clifford (2000) argued:

> Human beings become reflexive agents capable of effective action only when they are sustained 'in place' through social and historical connections and dis-connections . . . this is the work of culture . . . taking up discourses of the present and the past. (p. 96)

For cultural producers, the "cultural traditions" and "native identity" often-times could be a reproduction of sets of particularisms which acquire the status of national mythology. Colonial domination resulted in European imperial imaginary unity, with the aim to distinguish the colonial power from the colonized "Other" (Ashcroft, Griffiths, & Tiffin, 1999; Fanon, 1963a, 1963b; Gilroy, 2000a, 2000b).

Subjected to European colonialism, nationalists invented and employed the model, *cultural belonging*, which could be artificial and problematic, reflecting imperial constructions such as language, customs, and tradition. While discussing the national culture, Fanon (1967) argued that when confronting colonial culture and facing their own internal void, native subjects who have adopted the colonizer's culture and become part of the body of European culture, could only look toward *exoticism* as a means to resist and recreate their own culture and subjectivity in the process of being liberated. In other words, through the medium of *culture*, "going native" in order to establish their subjectivity and language meant to become the "dirty nigger" previously essentialized by White men, thereby becoming unrecognizable. It was colonialism that placed native subjects on the battlegrounds.

The native or local intellectuals, in the process of searching their culture, highly valued the *traditions, customs,* and *looks* of their own people. "Culture" was made to be the native intellectuals' passive resistance to colonial rules. Culture never merely equates to simplification; on the contrary, it is opposed to the natives if it is considered as translucidity of custom (Fanon, 1963a, p. 224). Take native artists, for example; the danger of nationalism lies in that even though they tend to deny the influence of foreign culture on renaming their cultural traditions, they are not aware that emerging national thoughts within the colonial culture have radically changed the native people. The process of searching culture and national consciousness is questionable and insufficient, because the revival of history and tradition does not take into account the present national reality.

Due to the constant tensions between the colonial rulers and the colonized native subjects, the passive resistance is reflected on their cultural productions. That is, when natives become cultural producers, their works become differentiated and marked as particularism, confined to a *national imagination* while struggling for liberation. On the whole, the cultural expressions reassured the colonial power, since they are locked in a rigid code or form of representation that is at the heart of colonial culture (Fanon, 1963a, 1963b). Thus, Fanon (1963a) asserted, one must free oneself not by reproducing European paradigms or denials, but by joining the native people "in that fluctuating movement which they are just giving a shape to, and which, as soon as it has started, will be the signal for everything to be called in question" (p. 242). Essentially, one has to recognize the zone of occult instability and indeterminacy. The defense of communal interests often mobilizes the fantasy of a static culture as well as a frozen identity. Nationalism can therefore be both liberating and oppressive. Cultural nationalism of *roots,* accordingly, operates within the false consciousness of racial ideology. Simply put, as Appiah pointed out, the very categories of race and cultural nationalism are actually the products of European colonialism that subject the racialized natives to an imaginary identity category, contrasting sharply with the White, civilized "Other."

Westernization Versus Nativism: The Politics of Recognition Between the "Global" and the "Local"

In the Cold War, the U.S.-led modernization project provided an international framework for development and the building of a capitalist nation-state system through various international institutions such as the International Monetary Fund (IMF) and the International Bank (the World Bank). Globalization, according to Berger (2004), bore the commitment under U.S. leadership to support internationally the market economy and national development. The U.S.-sponsored liberal-capitalist version of national development has recruited various

allies with the desire for anticommunist reconstruction, beginning in Western Europe and Japan (Berger, 2004). Promoting a specific version of modernity that simultaneously excluded other forms of modernity, globalization is a highly selective and unequal process.

Following the Cold War, globalization changed the global order and had profound impacts in Asia-Pacific and the rest of the world. East Asian countries such as China, Taiwan, Hong Kong, South Korea, and Singapore especially have been through important changes economically, socially, and culturally. What globalization has brought to the rest of the world is an effective spread of capitalist transformation and the nation-state system. "Asian Renaissance" is a term coined by Berger (2004) as he provocatively examined the extremely complex political reformation of East Asia. "The battle for Asia," described by Berger, is aimed at readjusting the economic and political structure of Asian nations under the post-Cold War U.S.-led globalization project. Berger posited that the major change for Asia from decolonization to globalization is the adoption of the processes of capitalist transformation (socialist challenges to capitalism) after 1945.

Ibrahim's book, *The Asian Renaissance* (1996), contended that the development of "Pan-Asian consciousness" was a form of Asian regionalism which sought to provide an instrumental tool during the Asian crisis in 1998.[1] The neo-Confucian philosophy was employed not only to distinguish the quintessential differences between the "East" and the "West" but also to serve as a tool for the move from the decolonialization of Asia to globalization—not to Westernize Asia but to modernize Asia in the "Asian Way" (Naisbitt, 1995). The emergence of the synthesized East and West has played a crucial role in identity consciousness. One of the profound impacts of globalization has been the affirmation and reaffirmation of a sense of Pan-Asian identity (and/or pan-Chinese identity) which has led to the construction of a "Greater Chinese identity." Before engaging in further discussion of the ways in which modernity and globalization inextricably and invariably influence media representation of minority ethnic identity (referred to in this book as *Chineseness*), it is important to understand the cultural study of globalization that emphasizes the relationship of mass consumption, modern communication technologies, and globalization.

The global configuration of mass culture as a characteristic of globalization is through electronic communication and information technology, such as advertisements, the Internet, films, and television. Central to today's global interactions, especially "the cultural traffic," as Appadurai (1996) called it, is the tension of cultural homogenization and cultural heterogenization. On the one hand, a

1 The Asian financial crisis was from 1997 to 1998, revealing the weakness of the Westernized, namely Americanized, international financial system due to some incompatibilities of Eastern and Western social, cultural and political values. The new Confucian ethic and the spirit of Asian capitalism arose during that time (Berger, 2004).

homogenizing form of cultural representation has emerged, i.e., the attempt to recognize and absorb differences within the larger, overarching framework of what is fundamentally an American perception of the world. Global mass culture "is dominated by television and by film, and by the image, imaginary, and styles of mass advertising" (Hall, 1997a, p. 27), the most ubiquitous form of which is characteristically Western, specifically American.

On the other hand, a heterogenizing form of cultural representation has also asserted itself. Appadurai (1996), *Modernity at Large*, reminded us of the ambivalent nature of the process of globalization, arguing that it is not only based on a deeply historically uneven development but also on a *localizing* process. The process of globalization should not only be considered as an implication of the hegemonic Americanized process. Instead, the relationship between the local and the global is far more complex and encompasses contradictions. It is necessary to have a deeper understanding of languages and histories based on geopolitical boundaries—that is, to have a firm grasp on the ways in which different societies and religions (such as Confucianism and Islam, among others) appropriate different forms of materials of modernities and various cultural practices of modernities. The modernization process can be varied, depending on local political trajectories.

The paradox of globalization involves the politics of nostalgia (Appadurai, 1996). In the constantly changing postmodern world, searching for the past in the present became the central theme of late capitalism. The politics of memory, namely, selectively remembering what has been lost is the commodifying desire under the peculiar postmodern commodity sensibility. Through modern media and various modes of image production and reception, a peculiar version of transnational, cultural construction of imagination and the imaginary has transformed into a new global order and permeated the world system. Westerners, i.e., Americans, as Appadurai (1996) noted, are not always living in the present, since through media technology they can easily stumble into various nostalgic cultural productions such as fashion, arts, cinema, and foods.

In "progressive," cultural, capitalist societies, the "Third World Others," as a reflection of the Westerners' "backward past," are regulated as temporary spaces where modernity becomes a normalized modality of their present (Appadurai, 1996). Imagination, therefore, is a crucial factor in the postelectronic and postindustrial world. Through various sources of media technologies and mass mediated events, audiences transform their imaginations into their everyday discourses of imagined selves, the Others, and the globe. In other words, the global and modernity become the flip side of the same coin; media become spaces for transforming the politics of imagination into postindustrial cultural productions that usually lend a sense of nostalgia for the people to act upon. This leads to the next section, wherein I discuss diaspora as a significant challenge to our understanding of identity and culture as objectively defined within a nation-state mechanism.

Diaspora and Its Challenge to the Nation-State Boundary

In the era of globalization, the growing interconnectedness and interdependence among cultures and nations highlight issues of diaspora, dispersion, and displacement as they complicate how we study the concepts of *culture* and *identity*. The mobility of bodies and changes challenges the boundaries of identities. The theoretical, political, and intellectual debates on the issues of transnationalism, global disjunctures (Behdad, 2005), and diasporic differences in relation to new world (dis-)order have arisen in many fields of study. Clifford's (1997) theory of traveling cultures took a further step by studying postcolonial travelers while accounting for the complex traveling systems.

As noted previously, postcolonial theory has been concerned primarily with the development of national and cultural identity through various cultural productions such as literature, films, aesthetics, and cultural artifacts (Ashcroft, Griffiths, & Tiffin, 2002). Theorists such as Bhabha, Hall, Gilroy, Ashcroft, Griffiths, and Tiffin have sharply critiqued the traditional, essentialized identity paradigm and destabilized the binary construction of colonized and colonizer. The marginalized peoples who lived "in-betweeness" not only passively received the imposed European colonial culture but syncretized it as their unique culture.

Diaspora studies deconstruct the boundaries of the nation-state, reconstructing a non-Western model of identity formation. The diasporic in-betweeness moves beyond the binary construction of colonized and colonizer, center and periphery, serving as a model for resisting the hegemony of Western modernization. Diasporas, as a product of transnationalism, are in fact grounded in systems of inequalities. They evoke the specific trauma of forced displacement, usually resulting from specific and violent histories of economic, political, and cultural interactions, such as the history of African slavery (Clifford, 1997; Gilroy, 1993). Thus, diasporic studies are generally concerned with the idea of cultural dislocation, examining the effect of the practices of displacement in relation to a new constitution of cultural meanings (Ashcroft et al., 1999, 2002). In other words, diaspora is one of the effects of imperial dominance, the displacements of people through slavery, indenture, and settlement. It not only involves geographical dispersal but also the question of "identity, memory, and home which such displacement produces" (Ashcroft et al., 2002, p. 218).

To illustrate, central to the theoretical debates on transnational cultural productions is the "politics of recognition" (Taylor, 1992); minority subjects need to assimilate into the dominant forms of representation. The *particularities* with which people choose to identify and connect collectively function as political solidarity. The sovereign-state and the distinctive model of national belonging are formed and accentuated. Marginalized, in order to survive, they mimic and appropriate the colonizer's discourse, while developing a distinctive discursive

practice—what Ashcroft (2001) called "the post-colonial transformation"—to resist the imperial power. In other words, through the brutal alienating process, marginalized place has transformed into a space of creative energy. Marginalized, colonized subjects have their own behaviors that vary from predominant Western modernism, and this requires serious attention. It is only through reconstructing the Third World's own description without depending on the Western hegemonic structure that they can truly liberate themselves from that always already subjected identity. The decentering of Eurocentrism needs to "resist the opposition of the Third World as logically and culturally posterior (or should that be anterior?) to the possibilities and positivities of the First World because that opposition consigns the Third World to an irretrievable anachronism" (Dayal, 1996, p. 119).

Such cultural politics in transnational cultural productions represent a new *tactic* of intervention of the global power drawn from the West. By appropriating the cultural capital and means from the Western, dominant cultural discourse, the locals are able to speak and further redeploy their local situations and markets. In light of this, the line between the global culture and the local culture is blurred because of the relations of "interpenetration" through the transcultural process (Ashcroft, 2001). Through the consumption of Western commodities, goods, advertising, and cultural productions such as films, music, and other forms of mass culture, local identities are constantly constructed and reconstructed through the process of interaction and appropriation. On the one hand, this constant, shifting identity construction, as Ashcroft would call it, is a local response to global effects. On the other hand, various differences from the locals also contribute to the global culture. Ashcroft (2001) noted that "by appropriating strategies of representation, as well as strategies of organization, communication and social change, through access to global systems, local communities and marginal interest groups can both empower themselves and influence those global systems" (p. 221). Rather than seeing that the "locals" only passively receive the global dominance, the fluid and dynamic interactions of popular and mass culture themselves represent agency from the locals.

Essentially, new cultural politics have arisen following the phenomenon of globalization. It is argued that within the context of globalization as an extension of the neocolonial condition, cultural productions demonstrate the resistance to the imperial power since the subjects themselves exhibit agency by appropriating and mimicking the dominant cultural forms. Furthermore, due to the latest wave of globalization characterized by the logic of finance capitals and the international division of labor by critical scholars, transnationalism should be considered as part and parcel of the process (Shih, 2005). The moment of transnationalism is a more scattered space where cultures and meanings across multiple spatialities and temporalities move beyond the binary opposition of the local and the global.

Within transnational space, cultural hybridities occur at the national, local, and global levels.

Communication Research on Postcolonialism, Globalization, and Diaspora

Within the area of culture and communication, the binary oppositions that both produce and inform these divisions, such as First World/Third World, White North/Black South, colonizer/colonized, and center/periphery, have been challenged by postcolonial theory and by contemporary international and critical intercultural communication scholars such as Chitty (2005); Chuang (2000); Chang (2000); Mendoza (2002); Mendoza, Halualani, and Drzewiecka (2002); Halualani, Mendoza, and Drzewiecka (2009); Shome & Hegde (2002a, 2002b); Shome (1999, 2003, 2006), just to name a few. They point out that globalization is a fully international system of cultural exchange through which imperial power is strategically maintained and expanded. It operates within the network of power relations that is deeply embedded in the political, cultural, and economic legacy of Western imperialism. Through the emergence of global economic forces, categorical identities and differences, such as ethnicity and nationality, proliferate, are (re)produced, and are assembled by various communicative, technological means, invoking national myth. Identity is constantly negotiated to serve political ends.

Critical intercultural communication scholar, Shome (1999, 2003), has been stressing the importance of the politics of location and space that closely intersect with power inequality in the age of transnationalism. Various communicative practices and cultural phenomena are intertwined in each other, and scholars will benefit from recognizing other forms of modernity that impact our everyday life and cultural practices. The critical vein of postcolonial theory opens up diverse theorizations on nations and national identities that were once subjected to European colonialism. In the article, "Interdisciplinary Research and Globalization," Shome (2006) sharply posited the urgent need for transnational interdisciplinary practices to reconsider the long-term (U.S.-centered) research orientations in communication studies, especially within the context of an asymmetrical globalization. It is significant, she contended, for scholars who work on critical global and postcolonial studies to employ "transnational literacy," a term coined by Spivak, in order to truly acquire "cultural maps, relations, and politics of cultures outside of western modernities/geographies"(p. 29). In other words, by dismantling the dominant "postcolonial" vocabulary grounded in the American academy, one can begin to see the unseen collisions and collusions, diverse yet intertwined histories, cultures, and relations in conditions of globalization.

In a similar vein, Mendoza (2002) for a long time has problematized the "theoretical hegemony" (p. 233) on cultural identity and politics and their im-

plications for cross-cultural communication. She asserted that it is no longer sufficient to examine communication practices within a general, abstract theorizing. Rather, she advocated a perspective that "demands the grounding of all theoretical analyses within the specificities of a given historical moment" (Mendoza, 2005, p. 23). She pointed out that one needs to "learn to develop the ability to read and analyze dynamically across contexts (the context of power, in particular) in ways that pay attention to what might be very different meanings, functions, and significations served by very similar identity invocations" (2005, p. 23). It is in light of this thought that I seek to gain a full understanding of the ambivalent discourse on identity, in particular, Chineseness, in Ang Lee's transnational *Crouching Tiger* and *Lust, Caution*. I seek to comprehend the implications of this ambivalent discourse for the audiences by taking into serious consideration the historical, political, and cultural contexts that help shape these communities.

To reiterate, the dialectic of the local and the global has influenced the idea of nationhood, cultural practices, and the construction of cultural identity within local communities. The intersecting discourses of the global and the local reflect that the boundaries of cultural identity and nationhood are temporal and spatial, constantly subject to endless changes. In order to be "recognized" and visible, the locals constantly transform and reinvent themselves to engage in transnationality. The articulation of the global imaginary, therefore, is transformed into representations and cultural narratives, such as transnational film productions, as I will define below. In this sense, local engagements in transnationality can be liberating and empowering since they can provide tools to create different cultural formations and identities. Under transnationalism one needs to reexamine the "routes" of displaced populations, such as diaspora. It reforms the relations between the local and the global that undergo a reciprocal process, reshaping one another. Through systems of representation, fragmentations of history and different temporalities are sutured together.

In the above section, I show the dialectic of globalization and localization that complicates the issue of identity construction. It is essential to consider the global in a local context. The resistance and acceptance of "global ideology" lead to a more unified world culture, yet simultaneously it produces a fragmented cultural hybridity of a local culture. This international flow of products and capital has resulted in the proliferation of national or regional identities. Identity, in the global context, consolidates national identity that is oftentimes conceived as a means for locals to resist or to research their roots. The traditional identity paradigm constructed by the Western notion of the modern state has become problematic. In this study, under a conditioning of diaspora, the constructions of Taiwanese and Chinese identity no longer become fixed categories and constantly need to be contested and negotiated. Along with the end of the binary opposition of East and West asymmetries, intercultural relationships, diaspora, the third cul-

tural building, and the growing interconnectedness and interdependence among cultures and nations become important subjects to study in the field of culture and communication.

Global Visuality in Transnational Cultural Production: On Chineseness as a Representational Problem

In previous sections, a review of the literature has shown that the dialectic relationship between globalization and localization moves beyond a binary construction, in many ways transforming a new logic of cultural productions. Postcolonial theory indeed provides a sharp thesis on representing minority subjects in different cultural productions. Instead of the colonized subjects being absorbed into the colonizers' language, they demonstrate resistance to the imperial power, since the subjects themselves exhibit agency by appropriating and mimicking the dominant cultural forms. In the following sections, the primary concern is with the political and cultural dimensions of Chineseness under a transnational flow of capital. I attempt to examine the positionality of Chinese modernity within a global context, as well as explore "Asian" values within a specific historical context.

Scholars such as Rey Chow ("Introduction," 2000; *Writing Diaspora,* 1993), Ing Ang (*On Not Speaking Chinese,* 2001b), Allen Chun ("Fuck Chineseness," 1996), Shu-Mei Shih ("Toward an Ethics of Transnational Encounters," 2005), Aihwa Ong (*Flexible Citizenship,* 1999), and others raised the question of Chinese ethnic identity by problematizing and deconstructing the notion of Chinese identity and its representation, as it is usually constructed as cultural essentialism— "sinocentrism." Chineseness is no longer a notion that can only be considered under a nation-state mechanism; instead the discourse must be situated within specific cultural and political contexts.

As discussed previously, postcolonial theory primarily emphasizes the process of decolonization of the countries and the peoples from previous European colonies. However, the theories that have been appropriated by some critics actually fall into a static binary construction of the hegemonic West versus an oppressed East or the rhetoric of Orientalism versus Occidentalism (Lim, 2006; Lu, 2001; Shih, 2005, 2007). Such reactions present themselves as a critique of postcolonial theory, established in the Western context, transformed into a form of Chinese nationalism. Such criticism against Western postcolonialism results in the creation of another academic discourse—Chinese national studies—that advocates establishing an inward reexamination of Chinese traditions and values that have been commodified within the academy (Lu, 2001).

In responding to the globalization and domination of Western modernity, a Pan-Asian value—specifically Confucianism—was revived. Academic work ranges from historian Prasenjit Duara's (1995) discussion on questioning the narrative

history of modern China, and historian Arief Dirlik's (2006, 2007) studies on China's alternative modernity, to anthropologist Aihwa Ong's (1999) studies on Chinese diasporas. Studies on Asian modernity in the age of globalization extend to "overseas Chinese communities, the Chinese diaspora, and Asian countries with a history of Chinese influence" (Lu, 2001, p. 41). The extensive research and vibrant discussions bring the contested construction of "Asian identity" and the "Chinese-speaking world" (Mainland China, Taiwan, and Hong Kong) into the forefront of theoretical debates on global awareness.

Scholars provocatively contest the inadequacy of postcoloniality that is primarily based on the modern world history of European colonialism. However, such a theoretical standpoint cannot be applied universally to various individuals and societies in diverse contexts. Ong (1999a, 1999b), for example, in a sharp critique, pointed out that the danger of postcolonial theory is in assuming that all racial, ethnic, and cultural oppressions are the result of Western colonialisms. Such totalized "speaking" of postcolonial situations has become academic discourse amongst scholars based in the West without any consideration for the scholarship of non-Western countries. Hall also warned us that such a theoretical approach universalizes oppressions of race, ethnicity, and gender. Thus we need to move beyond an analysis that is based on colonial legacies and colonial nostalgia (Ong, 1999a, 1999b), and to understand how these countries are transformed by their global, political, and economic interactions with the West.

Technically speaking, China does not fit into the postcolonial condition as it has never been territorially occupied and colonized by European countries. However, most Asian countries, such as Mainland China and other East Asian Tiger countries—Taiwan, Hong Kong, Singapore, and South Korea—influenced by the values of traditional Confucianism, are undoubtedly subjected to Western forces economically and politically, given the pervasiveness of the global capitalist structure. The close economic interdependence between Asia and the West within such a capitalist world system generates a "modern" Asia which is deeply embedded in a "multicultural" and "hybrid" space where a cosmopolitan character is translated into cultural production, consumption, and people's everyday social praxis. Such changes in material, economic, and cultural conditions, as many Chinese scholars contend, need to be taken into account when discussing Asian countries undergoing a construction of *alternative modernity*. Ong wrote an analysis of Asian modernity: when addressing Asian Tiger countries, she argued, "they would not consider their own current engagements with global capitalism or metropolitan powers as postcolonial but seek rather to emphasize and claim emergent power, equality, and mutual respect on the global stage" (as quoted in Lu, 2001, p. 63).

Thus, it is essential to reconsider the subjectivity of China, or the Chinese-speaking world by extension. One needs to ask, "How and to what extent is China postmodern and postcolonial?" In order to have a more holistic under-

standing of the politics of cultural production in the age of global capitalism, we need to examine the aesthetic features of Chinese cultural productions in relation to the mode of production within a socioeconomic context. Questions pertaining to modality and agency in Chinese modernity have been raised by critics, including: "How does Chinese modernity and its condition fit into the theoretical framework of postcoloniality?" (Lu, 2001); "Will Asia perpetually remain the passive object of representation in the West's global lens?" (Lu, 2001); and, as Berry (2000) asked, "If China can say no, can China make movies?" Postcolonial theory could appear as another totalizing framework that generalizes the "Third Worlds" situation and theory. Thus, postcolonial criticism needs to account for geographical and historical specificity.

Besides Chinese living in Mainland China, Hong Kong, Taiwan, or Southeast Asian countries such as Singapore and Indonesia, the overseas Chinese community plays a significant role in constructing the political and social discourses of Chineseness and a distinctive Chinese modernity. Chinese diasporic intellectuals have provocatively challenged "ethnic oneness," sinicization of Chinese identity from a diasporic perspective. Central to the theoretical claim is the problematization of the realm of cultural authenticity utilized as a potentially oppressive political mechanism. Minority cultural workers, and specifically Chinese diasporas, in this case, participate differently in postnational and/or the so-called nomadic contexts. In her research on Chinese transnationality, Ong (1999a, 1999b) proposed an alternative theorization of the Chinese diaspora as "flexible citizenship." She saw that the changing ways of providing financial services, new markets, and labor under the globalization regimes have a few implications. For example, one is the development of a new kind of social organization that requires deterritorialized and highly mobilized intercultural communication. Due to the segmented international division of labor, the new transnational professionals "evolved new, distinctive lifestyles grounded in high mobility (both spatial and in terms of careers), new patterns of urban residence, and new kinds of social interaction defined by a consumerist ethic" (Ong & Donald, 1997, p. 11). "Third cultures" have emerged out of the new social rearrangements.

The notion of transnationality informed by Ong mainly draws a distinction between European postcolonialism and Chinese transnationalism. Thus, rather than concentrating on a relationship of colonizer and colonized, Chinese transnationality connotes a more flexible relationship between the Asian Pacific region and Western capitalism. It is specifically concerned with cultural logics of states and global capitalism. Chinese transnationality, as Ong (1999b) remarked, more specifically involves "the practices and imagination of elite Chinese subjects, and the varied responses of Southeast Asian states to capital and mobility" (p. 4). For example, by the 1980s, 87% of Chinese immigrants who lived in Southern California were from China, Taiwan, Hong Kong, and Southeast Asia. They were pre-

dominantly well-educated professionals living upper-middle-class lives, receiving an elite Western education, working in high-tech companies, etc. Such transnational practices embody more scattered, flexible, less-structured, border-crossing activities and transnational practices shaped by business networks, economic migration, and state-capital relations within a global economic context. The relatively special independent lifestyles transcend political boundaries of nation-states; new identities emerged out of the dispersion among Chinese diasporas.

In discussing the "diasporic consciousness" raised by Chinese diasporic intellectuals, Chow (1993) argued that displacement constitutes an ever-shifting identity. She posited that "whenever the oppressed, the native, the subaltern, and so forth are used to represent the point of 'authenticity' for our critical discourse, they become at the same time the place of myth-making and an escape from the impure nature of political realities" (p. 44). Sharply critiquing Chinese nationalist intellectuals' assertions that the authenticity of Chineseness actually becomes "the assured means to authority and power," Chow pointed out that the native intellectuals are "robbing the terms of oppression of their critical and oppositional import, and thus depriving the oppressed of even the vocabulary of protest and rightful demand" (1993, p. 13). In this perspective, she clearly pointed out the limited effect that the natives want to achieve. Chow instead suggested that diasporas are "tactics of intervention" (1993, p. 15) because they embody in-betweeness by speaking already "inauthentic" language which has already proven the interruption of hegemonic discourse. Through migration and traveling, for Chinese diasporas, transnationalization destabilizes the reductive inscription of Chineseness.

Likewise, while challenging the limits of the Chinese diasporic paradigm, Ing Ang (2001a, 2001b) observed that it is liberating to develop an imagined Chinese diaspora subject in the environment where one feels symbolically excluded. The transnationalization of the imagination creates a sense of belonging. Chinese diasporas function as discursive communities in which people establish commonality of those who belong or are excluded. Diasporic solidarity, in this sense, is developed through common ground. That is, it is historical mistreatments, such as anti-Chinese racism, that drive Chinese diasporas to bond together.

Authenticity becomes a political mechanism that regulates Chineseness into an essentialized entity. Preconceived notions or images of a true/false, right/wrong "native" identity operate under such a mechanism. This reduces the multiplicity and complexity of both Chineseness as a given object and of the reality of being ethnicized within a cultural logic of multiculturalism. At the same time, however, the construction of a distinctive racial paradigm such as "being authentic Chinese" reinforces ethnic absolutism and can be problematic. The resulting diasporic hybridity challenges the assumption of purity.

Since the 1990s, an influx of Western popular culture into Chinese societies has greatly influenced Chinese media culture. The Internet and Western (mainly American) music; art; cinema; fashion; television, visual, audio, and new telecommunication technologies not only created the realm of the "global village" as McLuhan envisioned, weakening the grip of the modern concept of the nation-state but also opened up a whole new space of third culture, hybridity, divergence, and fragmentation in a transnational and postnational milieu. Diaspora, traveling, and migration complicate and problematize "China" itself through interrelated Chinese communities such as Taiwan, Hong Kong, and large overseas diasporic communities. Given that the new market for the world economy is comprised of a significant number of Chinese-speaking people and societies, it is important to study popular culture and mass media and the ways in which they become a source of ethnic and national identification. Through media analysis, communication, and cultural studies, we are able to understand the societies that are partly mediated by commodities, images, and new telecommunication technologies. In this project, I argue that by situating the Chinese subject in a larger historical and global context, one sees the ways in which complexities and dimensions of political, socioeconomic, and cultural relationships are at play in constructing the Chinese subject and humanism through cultural productions, cultural discourse, and mass media. Thus, instead of taking cultural productions as isolated subjects to interpret and analyze, I attempt to examine the *interaction* and dialectic relationship between globalization and Chineseness and between the texts and the consumptions.

Transnational Cinema and the Representation of National Identity

The notion of *transnational cinema* has been used to encompass filmmakers and filmmaking across genres, treating these as elements of a global system that includes the global circulation of financial capital and commodities and the international distribution and consumption of cinematic productions. According to Ezra and Rowden (2006), transnational cinema comprises "both globalization—in cinematic terms, Hollywood's domination of world film markets—and the counterhegemonic responses of filmmakers from former colonial and Third World countries" (p. 1). Transnational cinema problematizes the dichotomy of Western (mainly U.S. Hollywood) films, and non-Western, *Third World cinema*. The majority of film industries in the world are influenced by U.S. cinema, especially commercial films, such as the most prominent productions of India's Bollywood and Nigeria's Nollywood. The lines between Western and non-Western, national and global, although still implemented in the popular imagination, begin to dissolve. Given the increasingly transnational practices of collaboration, distri-

bution, and choice of site of international cinematic exhibition, the traditional definitions of *world cinema* and *Third World cinema*[2] have been destabilized.[3]

The proliferation of national and international film festivals enhances the significance of international recognition and visibility of films across national and regional communities. The establishment of film festivals based on the European model functions as a space for the cross-cultural exchange and understanding of non-Western films (Ezra & Rowden, 2006). Thus the emphasis on cultural specificity and ethnic and national distinctiveness has been central to the site of international presentation. In other words, film festivals have become a site of cosmopolitanism, providing an outlet for the international exhibition of cinematic productions of national and ethnic particularity. In the milieus of transnationalism and cosmopolitanism, forms of cultural nationalism are inextricably linked with the politics of self-representation. Indeed, it is true that transnational cinema arises "in the interstices between the local and the global" (Ezra & Rowden, 2006, p. 4).

Transnational visuality, a phrase used by Lu (1997a, 1997b, 2001), has been a significant area of study, examining diverse manifestations of image production, distribution, reception, and consumption across national and regional borders. Historically, transnational films in Chinese film studies cover films from Mainland China, Taiwan, Hong Kong, and Chinese diasporic communities, examining the nature of Chinese national cinema within an era of global capitalism (Zhang, 2004; Lu, 1997a, 1997b; Berry, 2000, among others). Since the 1980s, the increasing popularity of Chinese films has brought a "Chinese film fever" to international film festivals, drawing significant attention to the nature of Chinese national films. Lu (1997a, 1997b) referred to Chinese national films produced with foreign capital and employing cross-national distribution as transnational Chinese cinemas.[4]

The world of film production has embraced a bonanza of new talent from Mainland China, Taiwan, and Hong Kong. International audiences are not only

2 Third World cinema as a theoretical concept was used to describe films shaped by the impact of European imperialism and colonialism. Such films served as discursive sites of resistance to hegemonic power. Scholars such as Roy Armes (1987), Hamid Naficy (2001), Rey Chow (1993, 1995, 2000, 2002), and Wimal Dissanayake, among others, contributed significantly to the discussion of the politics of representation and political function, such as resistance to imperial oppression in Third World cinema.

3 Dennison & Lim (2006) in their introduction to *Remapping World Cinema* pointed out that *world cinema* historically refers to non-Western cultural films created in the Western world. The label, "world," however enables various aspects of politics (such as the politics of self-exotization), ideologies, and a web of power to situate the term within an age of globalization. The questions about authorship/auteurship, readership, as well as "site of exhibition" complicate the meaning of *world cinema*.

4 Lu (1997a) observed that there are four levels of transnational Chinese cinemas: "first is the split of China into separate yet connected terrains, namely the Mainland, Taiwan, and Hong Kong after 1949; second is the globalization of production, distribution, and consumption within the context of transnational capitalism in the 1990s; third is a cross-examination of the politics of self-representation of Chinese identity in the Mainland, Taiwan, Hong Kong, and Chinese diasporas; and finally is a review of the history of Chinese national cinemas" (p. 3).

beguiled by Mainland dramas by artists like Chen Kaige (director of *Yellow Earth* and *Farewell My Concubine*) and Zhang Yimou (director of *Raise the Red Lantern, To Live,* and *Hero*), but they are also impressed by the Taiwanese domestic comedies of Ang Lee (director of *The Wedding Banquet,* and *Crouching Tiger, Hidden Dragon*). Taiwanese New Cinema directors, including Edward Yang (*Yi Yi* and *Mahjong*), Hou Hsiao-hsien (*A City of Sadness* and *Three Times*), Tsai Ming-Liang (*I Don't Want to Sleep Alone* and *What Time Is It over There?*), to name only a few, resonate with a cinematic indigenous movement in Taiwan (Chen, 2000b). Moreover, international audiences are thrilled by Hong Kong action films with Jackie Chan and Chow Yun Fat, two of the most famous action stars in the world, as well as Wong Kar-Wai's nostalgic melodrama, *Chungking Express,* and *In the Mood for Love.* Undoubtedly, Chinese films have shown wide appeal across audiences of every class.

The international film market has seen this trend for about two decades now, ever since the sensational debuts of Chen Kaige's *Yellow Earth,* and Zhang Yimou's *Raise the Red Lantern* in International Film Festivals in the 1990s (Corliss, Harbison, Ressner & Turner, 1995; Lim, 2006). Compared to the genre films of Hong Kong (the third largest film market after the U.S. and India), Taiwanese and Chinese directors need to submit their works to international film festivals to increase visibility due to the shrinking domestic markets experienced in the late 1980s (Lim, 2006). Only through such avenues could Chinese and Taiwanese films increase the possibility of collaboration, gain screening rights, and secure future financial investment. Different kinds of politics and power were thus involved in the cross-cultural public screenings in film festivals. On the one hand, participating in Western film festivals provides the financial and cultural capital considered necessary to obtaining and rendering "legitimate" the "values" of the native works. On the other hand, the Chinese and Taiwanese governments also garner financial support for local film directors who have won awards at international film festivals (Lim, 2006; Wang, 1995).

Indeed, it seemed to foreshadow the emergence of what is deemed by some film critics as a pristine and passionate intelligence in cinema from Mainland China, Taiwan, and Hong Kong. At the heart of the controversy around the aesthetics of cinematic production in contemporary Chinese cinema are the question of nationhood and the contested notion of ethnicity. Most criticism of transnational Chinese films, especially the Fifth Generation films, seems to be constructed under the framework of First/Third World dualism. The presupposition is that Chinese cinema is undoubtedly categorized as Third World cinema by some Chinese native critics. For example, Lu (1997b) provided a systematic examination of the discursive formation of Chinese nationhood and ethnicity in Zhang Yimou's films (including *Raise the Red Lantern, Ju Dou, To Live,* and *The Story of Qiu Ju*) in the context of postcolonialism. Zhang Yimou's cinematic art has been the focus of

much critical discussion with the advent of the growing field of cultural studies in China in the 1990s. Lu noted the following in particular:

> The international popularity of Zhang's films conveniently thematizes a set of interrelated main concerns of current cultural debates in China: the fate of Chinese national cinema in the condition of transnational capital, "cultural critique" and "cultural exhibitionism" in Fifth Generation cinema, Third World cinema and Third World criticism, Orientalism, and postcolonialism in Chinese style. (1997b, p. 105)

Zhang Yijing (1997, 2004), to cite another example, critiqued the "cultural exhibitionism" of Chinese national cinema, stating that its greatest success accrues to foreign capital and that it satisfies Western audiences' curiosity about the already exotic, mystified Chinese national culture. For some Chinese native cultural critics, Chinese cinema is presumed to dominate the production and distribution of the global film market and has always been associated with the distortion and misrepresentation of a Third World cultural nation. In discussing "globalization" and "transnational cinema," the kind of criticism that mirrors Edward Said's notion of Orientalism is not uncommon.

After achieving fame and success from the international film market and international film festivals, these films are charged with being cultural sellouts of the Chinese nation in the international film market (Lu, 1997a, 1997b; Zhang, 1997). New Chinese Cinema, as Chow (1995) argued is "a cinema created around the very contradictions of culture and commodity, of (self-)expression value and (self-)exhibition value, in a modern capitalist economy that depends on export to sustain internal growth" (p. 171). Specifically, to be visible in the global film market is the main characteristic of global mass culture. It is a strategy for these Chinese filmmakers to operate based on the logic of the global commodity in order to exist and find renewal in the international film market. This is due to the challenge of a smaller domestic film market, the Chinese film censorship system, and the changes in China's film industry. How to make the national or local culture "able to be seen" in the transcultural market is the crucial and inevitable onus on any would-be successful Chinese filmmaker. This is no easy task. Indeed, the films directed by Fifth Generation Chinese filmmakers such as Zhang Yimou and Chinese diasporic director, Ang Lee, have been criticized by many nativist critics as "distortions of the real China" (Xu, 1997). The sting of such critiques is that in order to serve the Hollywood film industry and make their films successful as global commodities, such noted filmmakers are prone to sacrificing a more "authentic" representation of Chinese culture and tend to interpret Chinese tradition in Western terms, thereby internalizing Western values and Western practices of symbolic manipulation (Lee, 2003; Lu, 1997a, 1997b).

It is in this light that Lu (1997b) concluded that "New Chinese Cinema, especially Zhang's film art, is paradigmatic of the fate and predicament of Third World culture in our present time" (p. 105). The reinvention of Chinese national cinema in Zhang's aesthetics raised the important question for both Chinese critics and all cultural workers about the way "Third World" filmmakers strategically locate themselves in the new transnational market. The popularity of such transnational national cinema appears to lie in the fact that international audiences regard them as authentic depictions of the Chinese nation and its history. Chow (1995) likewise argued that Zhang Yimou is indulging in a self-exhibition that is complicit with the voyeuristic tendency of orientalism, noting that "in its self-subalternizing, self-exoticizing visual gestures, the Oriental's orientalism is first and foremost a demonstration—the display of a tactic" (p. 170). The "authentic Chinese history" itself has already been subjected to an essentializing notion of nation and of correct meaning of tradition as defined by the critics. It may be said that in general, most of the cultural critics invoke Western postcolonial theory to examine the relations of culture and power between First and Third World cinemas.

Critics of the Chinese cinemas tend to interpret the Fifth Generation of filmmakers' work as expressions of a certain version of Chinese culture. In effect, they see the directors' collective mission as the initiation of a complete attack on Chinese society and politics—a romanticized mission perceived to do a disservice to the representing of the "real" China with its repression of Chinese people. According to Chow (1995), the ethnicity—or element of Chineseness—of Chen Kaige's films seems to signify cross-cultural commodity fetishism, in other words, cultural commodities hybridized and globalized primarily for Western consumption. In such critiques, there appears to be the assumption of an authentic cultural text, the possibility of an undistorted representation of real Chinese culture to which these Chinese producers should pay heed.

It is in this vein that, to cite another example, Ang Lee's *Crouching Tiger* was criticized by Taiwanese and Chinese intellectuals as having its success turn on its ability to satisfy Western audiences' craving for the exotic. The improbable martial arts skills, the romances between the two pairs of lovers, the actors' and actresses' accents, all serve as exotic signifiers which attract international audiences (Lu, 2005). Critics claimed that the Mandarin spoken with an accent by most actors and actresses further exoticizes the film in order to make it more appealing than English (Fong, 2001; Guo, 2001). They similarly pointed out that Ang Lee marks cultural differences and combines Eastern philosophy with a Westernized plot masquerading as Chinese "original culture" in order to make the film succeed in the box office with its "original culture" in the international film market. Critics argued that this film became a classic Oriental fantasy by producing a martial arts drama set in the Qing dynasty through Orientalist aesthetics. Shih (2007) argued

that the trilogy is an example of how a Third World artist employs his flexible subject positions—national and minority subject—to successfully create Sinophone articulations in his filmic representation.

On the other hand, there are those who offered different insights about this film. K-F. Lee, for example, explored how the concept of "home and country"—*jiang hu*—in this film relates in a complex way to Ang Lee's Chinese diaspora identity. She argued that, far from being a simple question of literal accuracy of representation, what Ang Lee added are new layers of meaning of *wuxia* to Chinese culture that effectively provide an alternative meaning to Chineseness (Lee, 2003). Based on the *wuxia* film genre, the cultural imagining of China serves as a site for cultivating Chinese audiences' nostalgia. It also constitutes and projects Chinese audiences' cultural identity on the global stage. Contemporary transnational Chinese filmmakers (such as Ang Lee) are criticized by many Chinese viewers for the way their works are said to distort the "authentically Chinese" (Zhang, 1997, p. 96). Predominantly, critics pick on Ang Lee's imaginary China in *Crouching Tiger, Hidden Dragon*, saying that it fails to ground its representation in the "concrete China." Both film critics and filmmakers viewed their role as social critics, presenting these films as political critiques of Chinese society and government (Lu, 1997b).

Ang Lee and his films have been mainly categorized under Chinese National Cinema, Transnational Chinese cinema, and sometimes, world cinema. His early Mandarin language films (some of these have been termed the "Father Knows Best Trilogy": *Pushing Hands*; *the Wedding Banquet*; and *Eat, Drink, Man, Woman*) were, however, considered part of New Taiwan Cinema. The politics of naming itself presents political tensions between Taiwan and Mainland China. I argue that the politics (and difficulties) of "categorizing" Ang Lee, his position and subjectivity, and his works destabilize and problematize a normalized genre of "transitional Chinese cinemas" and further demonstrate instability and indeterminacy of national and ethnic identity within the context of transnationalism. I attempt not to "assign" a totalizing definition to Ang Lee's cinema without a serious interrogation of the processes by which the films have been conceptualized and discussed. In the academy, Mainland China has for a long time presented a "cultural matrix" (Nornes & Yeh, 1995) of all Chinese people; Chinese-language films from Taiwan and Hong Kong are relatively overlooked under a fallacious definition of 'Chinese' equivalent to the People's Republic of China. Thus, in this study I intend to account for the politics of "naming" and the attendant embedded contradictions and tensions, and to understand "the situatedness of each discourse in its specific context, including that of our own" (Lim, 2006, p. 1). The politics of naming brings into play the power structures inherent within the discourse of "transnational Chinese cinema," "Chinese national cinema," as well as "Taiwanese new cinema."

In this chapter, I reviewed the debate on globalization, transnationalism, and the concept of diaspora to situate this study on examining the politics of national identity in Ang Lee's filmic discourse and the receptions of his films in a macro context. In order to discuss the global process and further understand the ways in which the locals engage in, and interrupt, the hegemonic Western construction of the worldview, in chapter two, I contextualize the research by historicizing the construction of Chinese and Taiwanese identity. I will trace the political and historical contexts of Taiwan and China that are closely connected to the U.S., to gain further insight into the ways in which one's national identity operates and is constructed and contested.

The struggle between Chinese and Taiwanese identity and consciousness, according to scholars, has been the fundamental cause of the conflict within Taiwan and the Taiwan Strait conflict (Yu & Kwan, 2008). National identity is defined by a collective national consciousness. However, collective national consciousness, and, further, national identity and reality, is "manifested in the processes of Sinicization and Taiwanization" (Yu & Kwan, 2008, p. 33). The political tension between China and Taiwan is derived from the Chinese Civil War in 1927. The leader of the Chinese Nationalist Party, Chiang Kai-Shek retreated to Taiwan after being defeated by Mao Zedong, the leader of the Chinese Communist Party. Two fundamentally different political structures and rulerships have divided Chinese people from Mainland China and Taiwan since then. By examining the ways in which Taiwanese and Chinese identity and consciousness is being constructed within particular historic and sociopolitical moments, I hope to provide an alternative view for rethinking the politics of representing national identity in the transnational films of Ang Lee.

TWO

Speaking Beyond Postcoloniality

The Historical Construction of Chinese and Taiwanese Identity

In the first decade of the twenty-first century, *Crouching Tiger* broke the box office record and was rated the most popular foreign-language film in the North American film market. It earned over US$200 million at the box office, and also established the record for a foreign-language film in the Western European film market. It also occupied a leading position in East and Southeast Asia (Wu & Chan, 2007). Likewise, *Lust, Caution* was a big winner of numerous awards in both Asian and Western film festivals, including the best film at the Golden Lion Awards (Venice), the best film at the Golden Horse Awards (Taiwan), and the Best Asian Film at the Hong Kong Film Awards. It also received various nominations from the British Academy Awards and the Golden Globe Awards. It earned over US$5 million in Mainland China within the first four days of showing in theaters[1] and attracted over a million audience members in the South Korean market within the first week of its debut.[2] The film also remained in the entertainment news headlines for a few weeks after its debut. However, unlike *Crouching Tiger's* global popularity, the representation of Chinese culture and history in *Lust, Caution* resulted in a more polarized and extreme reaction toward the film from Chinese and Western audiences. Throughout various Chinese-language film websites and online discussion boards Ang Lee's movies, particularly his three most impor-

1 Ang Lee's *Lust, Caution* breaks the box office record in Mainland China, *The China Times*, November 7, 2007.

2 Uncut *Lust, Caution* draws one million in South Korea, *Broadcasting Corporation of China*, November 30, 2007.

tant, internationally acclaimed movies, *Crouching Tiger*, *Brokeback Mountain*, and *Lust, Caution*, have become the topics most frequently discussed.

While there is enormous glorification of Ang Lee as a legend in the history of Chinese cinema, controversy also exists among Chinese audiences and academics. Coupled with international recognition, political pressure in China put Ang Lee and his films in an ambivalent position. International viewers acknowledge Ang Lee as an image producer spreading the icon of Chinese culture to the international screen. Specifically targeting *Crouching Tiger, Hidden Dragon* and *Lust, Caution*, Chinese audiences, by contrast, regard some of Lee's work as a national betrayal, accusing it of "distorting" Chinese history. A group of Mainland Chinese diasporic scholars made the serious charge that Ang Lee distorted the history of WWII in *Lust, Caution*. They refer to Ang Lee as an "immoral literatus" due to the explicit sex scenes and the glorification of a historical race traitor during the Chinese-Japanese War portrayed in this film. The polarized receptions reveal that these two films evoke intensely mixed emotions of excitement, anger, glory, and shame among Chinese audiences, though Western audiences interpret them as Chinese culture depicted on the big screen. By far the most politically controversial debate in Chineses film studies centered around Ang Lee's latest epic film *Lust, Caution*. After *Crouching Tiger* won for Best Foreign Language Film at The Academy Awards in 2001, *Lust, Caution* was submitted as Taiwan's official entry, competing for the 2008 Best Foreign Language Film award. However, it was not eligible because "Taiwan did not prove that creative talent of that country exercised artistic control of the film" (Galloway, 2007). The Academy argued that there were not enough Taiwanese in the production team. *Lust, Caution* also won the Golden Lion Award at the Venice Film Festival in 2007, yet its production country was changed from China-USA, to USA-China-Taiwan, to China on the Venice Film Festival official schedule after complaints from Ang Lee's office. Such controversies regarding the representation of Ang Lee and his transnational films are not uncommon. His films have been advertised and categorized discursively as Chinese films, Taiwanese diasporic films, New Taiwan films, Chinese transnational films, and so forth. Yet, a lack of clear answers to such questions about the "naming" and "identifying labels" not only complicates the nature of national and ethnic identity but also destabilizes a monolithic understanding of Chineseness and further raises a whole discussion of the negotiation of identification and the politics of transnational cultural production in an age of globalization.

Before embarking on further discussion of the historical account of the construction of Chinese and Taiwanese identity, I want to explicate the politics of Taiwanese national cinema, namely Taiwan New Cinema, as it will provide an understanding for the "categorization" of Ang Lee's films. Ang Lee's early Mandarin film productions were considered part of New Taiwan Cinema, part of a new wave or movement of native cinema in Taiwan in the post-1980s (Kellner, 1998).

Since the late 1980s, a new wave of Taiwanese directors has emerged, representing Taiwanese history, culture, society, and identity in a series of films by Ang Lee, Hou Hsiao-hsien, Yang De-chang (Edward Yang), and Tsai Ming-liang. Employing a social realism approach, their new wave films developed distinctive themes and concerns about Taiwanese local problems and social issues and were later described by critics as "Taiwanese national films." The cinematic techniques used by these directors also focus on presenting realistic social problems in contemporary Taiwanese society, probing a sense of social realism, and representing political and cultural interventions in the local society of Taiwan. Taiwan New Cinema has emerged and is well recognized as an important development of world cinema. Yet, while most directors emphasize the representation of "native" identity and culture, the films of Ang Lee deeply embody a sense of cosmopolitanism. Lee produces films for a global market, presenting Chinese and Taiwanese culture and identity from a destabilized, uncertain, ambiguous, and ambivalent approach.

Naming and/or defining a cultural identity, such as "Taiwanese identity," requires consideration and discussion of historical disjuncture and discontinuity and the cultural syncretism resulting from colonialism and the imposition of foreign cultures. A collective cultural identity for people in Taiwan is difficult to grasp and identify due to the fragmentation of identity inextricably formed by many cultural Others—principally Chinese, American, and Japanese. A display of "cultural syncretism," a term used by Paul Gilroy, emerges in the everyday life, cultural imagination, and practices for Taiwanese people. Gilroy (1994) proposed that "uncontaminated" cultural purities do not exist when it comes to the social functions of cultural identity in people's everyday encounters. In a postcolonial and transnational society like Taiwan, what does it mean to "represent" Taiwan as a person, such as Ang Lee, who holds a passport from that nation? How does a person like Ang Lee negotiate the constructed Chinese and Taiwanese national and trans-national subjectivities as an increasingly cosmopolitan sense of self arises in a global, postmodern milieu? How does the negotiation of identity and subjectivity function as infinite intercultural processes for individuals who seek a sense of their positions both as individuals and as members of a "culture" (or multiple cultures) in which they live? In what ways do cultural memory, agency, nostalgia, self-reflexivity, and the employment of a diasporic imagination interplay in constructing a collective subject position for Chinese living in the United States? How are the "past" and "memory" deconstructed and reconstructed and translated into cultural productions, and how do they continue to shape the "present" and "future" lives these people live?

The notion of Taiwan New Cinema, however, raises a new question of the politics of representation of "native culture" and the construction of "national" films in a global context. Critical communication scholar, Chen Kuan-hsing, for example, problematized the notion of Taiwan New Cinema by suggesting that it

reveals a politics of global nativism[3] that was integrated into the logic of consumption, much like transnational corporations. Constructing Taiwan's national cinema is the result of a burgeoning film industry where filmmakers had more freedom than under the periods of Japanese colonial occupation, the authoritarian policies of Chiang Kai-shek's nationalist government (Kuomintang or KMT), or the political and cultural process of Americanization at the end of the Cold War. Struggling to define a "self-identity" and present a narrative history of Taiwan, the native filmmakers convey in their works a struggle over a collective and/or popular memory and imagination of the island. Ang Lee's early Mandarin-language productions are usually categorized as Taiwan New Cinema because they participate in the new wave of producing films that aim to create a Taiwanese public sphere for political intervention and social transformation. Since Taiwan has a distinct sociopolitical path from that of the People's Republic of China (PRC), the practices of articulation and identification of people in Taiwan, closely intersecting with the nation's unique historical context, require a detailed unfolding. Here, it is important to note that historical narratives on Taiwanese and Chinese identity function as a way to naturalize, justify, immortalize, and, at times, manipulate notions of the past and memory, bringing these into alignment with present-day political constructions of nationality and ethnicity. Thus, the historical "facts" I refer to in this chapter should be considered as a process of unfolding narratives (Bhabha, 1990a, 1990b; Brown, 2004).

Identity Crisis and the Struggle over Memory

Taiwan is located in Southeast Asia, comprising one major island and the three other smaller islets of Penghu, Matsu, and Kinmen. There were only a few Han immigrants living in Taiwan during the Ming Dynasty in the sixteenth century. Taiwan was formally claimed as a Chinese territory in the Ming Dynasty. During that time period, the main population was comprised of aboriginal ethnic groups (Chen, 2006). It was later colonized by the Dutch for 30 years in the seventeenth century and then by Japan from 1895 to the end of World War II in 1945, due to cession resulting from the Sino-Japanese War. A great deal of Han Chinese immigrants came from Fujian, the southern part of China, in response to the economic and political disintegration of the Ming dynasty and the Dutch colonists' demand for a larger labor force (Chen, 2010). The emphasis on the predominant Han identity later became a contentious political issue and requires room for negotiating "Taiwanese identity" for the people of Taiwan.

Through the classification of ethnicity, such as China's historical narrative on Han identity, the majority ethnic group in China is referred to as the Han eth-

3 Global nativism refers to an idea of the natives generated from the commodification of the complicit dialectical relationship between nationalism and transnationalism (Chen, 2006).

nicity. Han, as a dominant ethnic group, considered themselves as a single group embodying Confucian civilization (Brown, 2004). There was no unified ethnic group in Taiwan before Japanese colonial rule in 1895 (Chang, 2000). During Japanese colonial rule, a unified sense of a "Pan-Taiwanese identity" which was limited to Han was formed as a resistance to European colonialism and Japanese occupation and as a form of political solidarity, yet this idea finally resulted in a failed formation of a nation-state.

During the period of Japanese colonialism, the Japanese government separated Taiwan from Chinese political and cultural policy. Under Japanese colonial practices, a different education system and policy was developed that forced the Taiwanese people to assimilate into Japanese culture (Chen, 2010; Ching, 2001). The Japanese government also utilized identity classification of peoples in Taiwan, mainly distinguishing Aborigines who lived in the high central mountains as "barbarians" from those who adopted Han culture and lived in the western plain as "civilized Aborigines" (Brown, 2004). However, the most important distinction is the categorizing of peoples in Taiwan into differences, Japanese and non-Japanese, with the aim of transforming them into loyal subjects of the Japanese empire.

Not until 1945 did Taiwan officially return to her "motherland"—China— after half a century of Japanese colonial control, following a 1943 agreement among Franklin Roosevelt, Joseph Stalin, Winston Churchill, and Chiang Kai-shek. The Chinese Civil War divided the government into two parties: Chiang Kai-shek's Nationalist Party (formally, Kuomintang or KMT) and Mao Zedong's Chinese Communist Party (CCP). The Nationalist Party was defeated and then fled to Taiwan to continue the government of the Republic of China (ROC) with its capital in Taipei, while the Chinese Communist Party founded the People's Republic of China in Beijing. Taiwan was returned to Chinese rule with KMT. However, tensions arose between "Mainlander" Chinese and "Taiwanese" (mainly earlier Han immigrants in Taiwan and Aborigines, as I will discuss below). KMT declared martial law, suspending the democratization of Taiwan by enforcing rigorous censorship of language and all forms of cultural productions under the Temporary Provisions Effective During the Period of Communist Rebellion. During this period, cultural productions such as cinema and literature were expected only to serve the purpose of propaganda, to form a unified national Han identity; that is, KMT was to be portrayed as part of greater China, the real Chinese culture, with the mission of "retaking the mainland" and defeating Mao's communist regime. For example, the popular music during the time was considered transformative as part of KMT's nation-building project in Taiwan (Shin & Ho, 2009). Chiang Kai-shek once claimed that "the Japanese Empire will collapse as they keep singing popular songs while Chinese will be singing anti-Japanese songs" (Hwang, 1981, as quoted in Shin & Ho, 2009). Such political representa-

tion of popular music embodies an ambitious idea of the renaissance of "a greater cultural China."

A unified Han identity as well as a politics of "authentic cultural China" was formed under KMT. The policy of KMT aimed to form an identity politics of "authentic Chinese" in order to fight against the Chinese Communist Party. During the period of martial law, the people of Taiwan could speak only Mandarin Chinese as the national language of the Republic of China (ROC); also, the educational system employed only a nationalist idea for promoting anti-Chinese communism and anti-Japanese imperialism. At the same time, Chiang Kai-shek aimed to develop ROC into an industrialized and democratic country. The martial law period had a great impact on Taiwan's economic development. The Nationalist government developed Taiwan into an export-oriented economy. This was known as the "Taiwan miracle."

Furthermore, after World War II, during the Cold War period, the U.S.-led globalization and democracy project increased pressure and built alliances to fight against communism. Even though Taiwan was not subjected to U.S. military occupation, like some other East Asian countries such as South Korea, the U.S. and ROC signed the Mutual Security Agreement. Taiwan was later subsumed into America's political agenda of forming a neocolonial structure—a global capitalist system. By receiving U.S. financial and military support, Taiwan became part of the capitalist system and developed a rather wealthy and stable economy through exploitation of its laborers.[4] Now a neocolonial economic structure, Taiwan underwent a period of rapid development and industrialization starting in the 1960s and continuing through the early 1980s. This growth was mirrored in Singapore, Hong Kong, and South Korea, marking an economic transformation in East Asia.

As discussed above, identity politics involves the process of decolonization after the Japanese occupation and was based on the project of nation-building with its desire to naturalize and promote a Chinese national identity. However, Chiang's authoritarian ruling policy increased tensions between "the mainlanders" and "Taiwanese" (Han immigrants before 1949). The tensions occurred between the 228 (February 28) Incident in 1947 and a subsequent period of time known as "White Terror"[5] until the mid-1950s. Political dissidents were suppressed, often harshly. "Differences" among the early Han immigrants were not eliminated because of the Pan-Chinese idea; instead a form of suppression was enacted. A binary construction of identity as either "native Taiwanese" or "Mainlander Chinese" gradually formed. The official record shows that Han people were divided into Taiwanese regional identity, *ben-sheng-ren* (literally translated as people from

4 The manifestations of Taiwan as a "subempire" are through its capital expansion and employment of cheap laborers in Mainland China and Southeast Asia in the 1980s. Taiwan also imported foreign labor (from Thailand, Indonesia, or Vietnam, for example) (Chen, 2000a).

5 "White Terror" was deeply rooted in an anticommunist ideology; political discussions were highly scrutinized, censored, and restricted.

within Taiwan province), in contrast with *wai-sheng-ren* (literally translated as people from outside the province, namely from Mainland China). In other words, kinship was one of the main criteria for such categorization. "Mainlanders" maintained a closer connection to Chinese culture, language, and ancestry and were the dominant political power, yet were excluded from small and medium-sized businesses which were mainly operated by Taiwanese (Brown, 2004; Chang, 2000; Chen, 2000a).

Legacies of the Cold War: Americanization as Desire and Internationalization of Taiwan

Not until 1987 did President Chiang Ching-kuo, Chiang Kai-shek's son, lift martial law. Further political liberation followed in the wake of this watershed event. During the martial law period, resistance and protest against the Nationalist government was suppressed, yet there was an underground advocacy of "independence" for Taiwan. Political opposition to the Nationalist Party, in the form of the Democratic Progressive Party, still reproduced an ideological structure of Taiwan-centric "Taiwanese consciousness" and *Han-min-nan*—chauvinism that aimed to make a distinction from Chiang's Chinese nationalism (Chen, 2000a).

Following this period of political linearization there was openness and freedom of the public sphere, including cinemas, journalism, popular culture, academic publications, museum exhibits, and so forth. Through cultural productions, a new era was born that probed social criticism of the political and economic tensions of Taiwan, including the issues of national and ethnic identity. Taiwanese popular music such as folk music had much more freedom to express social and political criticism, reflecting people's everyday life and social situations in Taiwan. Taiwan New Cinema also presented itself as part of the nativist movement that emerged in the atmosphere of an aesthetic philosophy of "social realism." This philosophy sought to capture the uniqueness of the mundane life of people in Taiwan, the impact of the urbanization and industrialization of the island, and rural stories and ambiances usually based on native literature (Kellner, 1998).

Both Japanese colonialism and the Cold War had significant effects on the construction of a national and ethnic identity in Taiwan. During the Cold War period, the U.S. military was stationed in Taiwan to "protect" Taiwan and help fight against the communism of Mao's PRC. Chiang Kai-shek's political strategy of democratization of Taiwan therefore facilitated a basic national policy and a normalized common sense among the masses, that is, a common goal of "Fighting against Communists" (Chen, 2000a). On the one hand, an anticommunist sentiment began to be entrenched as part of a Chinese nationalism; "Red Chinese" became a common enemy. On the other hand, Americanism became part of a structural feeling that has infiltrated people's everyday cultural practices, becoming

part of a popular national consciousness. Chen (2000a) posited that Americanization became deeply infiltrated into the national-popular imaginary and consciousness due to the process of democratization. This was facilitated through the massive importation of American popular culture such as jazz and pop music, Hollywood films, satellite TV, popular sitcoms, MTV, food, restaurants, fashion, arts, American English education, and so on. American cultural productions were dominant imports, penetrating the public discussions of locals and functioning symbolically as internationalization and globalization. This open market to American mass culture productions brought such "Americanism" into consumption, generating a capitalist lifestyle. "Americanism" functioned discursively as a symbol of desire, democracy, freedom, wealth, and as a model for the people of Taiwan. Moreover, Americanization and dependency on the American democracy model and systems have been deeply rooted and pervasive. This was due to the fact that a majority of social elites and intellectuals in Taiwan had attained advanced degrees or work experience in the U.S. The record of Taiwan's Education Ministry shows that 80–90% of students pursued advanced degrees in the U.S. before 1980, which created a dominant population of foreign students during that time (Chen & Chien, 2009). This phenomenon illustrates the ideology of anticommunism and pro-Americanism that was incorporated into people's imaginations politically and culturally through various institutions and practices. The goal of constructing Taiwan as a bourgeoisie state since the post-Cold War era has given rise to Americanism as a desire and as a facet of the cultural imagination that is deeply rooted in Taiwan's national consciousness and cultural subjectivity (Chen, 2000a).

It was precisely as a result of such global strategies of building East Asian countries as "political alliances" against communism that the processes of decolonization manifested differently from other former European colonies. With the ambition of creating a global economic structure in the East and Southeast Asia, America has always been the closest "ally" and "consultant" of Taiwan. Decolonization happened in a very different way, compared to other postcolonial countries that are mostly former English colonies. As Chen (2001) put it, the long-term impact of colonialism and imperialism depends on a complex process of "negotiation and articulation between its political and economic power and local histories" (p. 83). Even after the U.S. ended diplomatic relations with ROC in 1978—the most severe crisis of the U.S.-Taiwan relationship at that historical moment—"Americanism" was still inscribed in the cultural memory and public imaginary; namely, "America" was never outside of the island (Chen, 2001). Another obvious example would be Club 51, established in 1994. Club 51's motto was "Rooted in Taiwan with America in the Heart," seeking protection from the U.S. after a series of Taiwan Strait crises[6] resulting in severe political tension between PRC and ROC (Shih, 2007).

6 In 1996, 51 intellectuals and businessmen with American experience from Club 51 wrote "An Open Letter to the Social Elite of Taiwan" to demand American intervention in the Taiwan Strait crisis resulting from a

Taiwanese Nationalism and the Struggle for a National Identity

A paradox appeared in the process of state-building, giving rise to the desire for a cultural and national particularity for Taiwan. Ironically, while the reinvention of nation-building in Taiwan was imbued with the politics of Pan-Chineseness and pro-Americanism, as mentioned previously, local desire for constructing a unique Taiwanese identity has simultaneously arisen. I would argue that rebuilding national and cultural identity was a *project* and was never static, and that the identity construction being articulated by the people of Taiwan has been a disordered process. This process and struggle over identity signify the long-lasting political effects of imperialism, colonialism, and the neocolonial structure of global capitalism that has impacted and continues to impact this island.

The "traditional culture" of Taiwan was rooted in mainland China before Mao's communist occupation. Thus, the "mainlanders" (*wai-sheng-ren*) and their generations embodied a nostalgic sentiment of the "lost home," the "home" mainly referring to mainland China. "Being Chinese" became a complex symbolic system, involving an infiltrated sense of anticommunism and Confucianism, yet simultaneously including a process of Americanization. Each piece of the fragmentation of national identity for the people of Taiwan presents a fragmented local historical trajectory.

It is important to note that the attempt to create a renaissance of "Asian values" in the East Asian region involved a politics of Pan-Asianism, namely, Confucianism, which also symbolizes nationalists' struggle over decolonization after World War II. "The Great Asianism" started with Sun Yat-sen's desire to unite East Asian countries invaded by Japanese imperialism and Western cultural imperialism. This idea transformed itself into a means of national self-determination and empowerment, a social movement to interrupt hegemonic European colonialism and imperialism. An idea of "cultural China" was raised especially during the 1997 Asian regional financial crisis (Chua, 2004). The (re)search for a *lost* cultural value and identity to help position Taiwan in the world economically, politically, and culturally was a significant issue. That issue functions as common cultural ground for the dispersed communities of Chinese descent that will unite and facilitate the expansion of the global capitalist market. That is to say, with the expansion of Chinese communities and Chinese capital dispersed overseas, the desire for the politics of a "cultural China" supposedly "unites and provides cultural continuities exemplified by other allegedly 'ethnic-cultural' characters" (Chua, 2004, p. 201). Though in a rather flimsy way in contemporary times, the emotional desire for a Confucian East Asia constitutes the foundation of everyday life of East Asians.

series of missile attack threats from PRC from 1995 to 1996. The letter advocated that Taiwan become the 51st state of the U.S.A.

In Taiwan, for the last two decades of the twentieth century, the questions of identities and the negotiations between Sinophone Chinese and native Taiwanese are far more complex than simplified binary constructions such as mainlander/colonizer or native/colonized would allow. Social constructions of "Chinese" and "Taiwanese" should not be read as mutually exclusive identity labels. In fact, the constitutive ethnic and national differences, namely, the alleged ethnic and cultural characteristics, were utilized as a way of mobilizing the public national consciousness and as a root of political solidarity. As I argued previously, such identity politics embodies historical, social, cultural, and political significance that changes over time and with varying social conditions. The processes of articulation of and identification with a cultural or national identity formation and subjectivity involve politics of imagination, memory, and affective desire.

(Re)constructing a Cinematic Discourse of Chineseness

The emotional structure of the feeling of national identity embodies an ambivalent nature which I will discuss in chapter three. I concentrate on Ang Lee's transnational cinemas, seeking to bring out critical issues involving his discursive construction of Chinese identity. In doing so, I attempt to further an understanding of the ways in which living personal and national historical experiences closely intersect with each other and have continued to shape the macro level of national space as well as the desire and bodily experiences of identities and subjectivities on a personal level. Lee's diasporic subjectivity further complicates the process of such articulation and cultural representation.

The cultural subjectivities and articulation, as Shih (2007) posited, lie in the negotiation of multiple languages, ethnicities, and cultures in Taiwan. It became impossible to create a collective "imagined community," especially after martial law was lifted. Taiwan's foreign relations and international status underwent a dramatic change after the U.S. switched its diplomatic relations from ROC to PRC in 1978. Moreover, ROC withdrew from its seat as one of the founding members of the United Nations in 1971. Such significant changes in ROC foreign relations resulted in an ambivalent response to the U.S. and its own identification. With the rise and later governance of the opposition political party—the Democratic Progressive Party (DPP), which advocates a distinct, Taiwanese identity—not only was a different political atmosphere fostered to resist KMT's authoritarian regime and the threat of communist China, but also an active attempt was made to construct a distinct, "Taiwanese identity" in order to maintain or "clarify" a cultural particularity which should be considered as a constituted discourse. Such a discourse has been distributed, articulated, and circulated within the public discourse through public spheres such as mass media, institutions, and textbooks in educational institutions.

It is important to note that construction of a Taiwanese national consciousness and the independent movement should be considered as a defensive response to the PRC's threat to Taiwan (Chen, 2001). After PRC's missile threat to Taiwan in 1995, President Lee Teng-hui advocated a "New Taiwanese" discourse. When he came to power in 1988, he declared that KMT governance was a "regime coming from the outside as a colonial state" (Chen, 2001, p. 82). This political discourse functioned as a trigger for the Taiwan Independent Movement. Lee's policy of the "Theory of Two Countries"—and, later, President Chen Sui-Bian's policy of "Each Side a Separate Country"—had a profound impact on the public imagery of "Taiwanese identity."

The unfolding of the historical narrative, described in previous sections, provides a context where pop culture productions, such as those from Taiwan New Cinema, have situated themselves, so as to have a firm grasp on identity politics and the cultural discourse being articulated, constructed, and co-constructed by cultural producers and the public. During that historical moment, Taiwan New Cinema represented liberation and access to an opening film market, as well as postcolonial ambivalence in seeking self-definition and political determination. This ambivalence was made visible within the global film markets, through international film festivals, where Taiwan New Cinema productions were exhibited and garnered attention as part of the more general category of transnational cinema. Paradoxically, it was precisely because of such international recognition of the local films that they received more public attention in the domestic film market.

Postcolonial ambivalence toward the *naming* process could be the result of the fact that Taiwan New Cinema both embodied "Third World nativism" (seeking out cultural particularity) *and* coalesced into a global film market (becoming a significant part of World Cinema). The desire of local filmmakers to draw a distinct, nation-state political boundary can only be recognized within an "always already" borderless, global arena. Filmmakers from Taiwan ran into hurdles and could participate in the international festivals only if they submitted their works under a "subnational" epithet such as "China/Taiwan" or "China/Taipei" (Wu, 2007). This highlights the relationship between the local and the global, namely, the fundamental dialectic and ambivalent nature of the ways in which native politics and culture engage globalization. The process of globalization is fraught with ambivalence and contains an inherent paradox. As Dirlik (2006) observed, the relationship of nationalism to globalization is a contradiction "to be understood in the dialectical sense of a unity of opposites, with the one set against the other but at the same time incomprehensible without reference to the other" (p. 491).

In chapter three, I will discuss further the unfolding of this inherent contradiction and ambivalence and examine how these bring the complexities of nationalism, identity politics, and diasporas and their cultural productions to the forefront. Thus, in examining the cultural nationalism resulting from Ang Lee's

(trans)national films, I argue that it is important to account for the politics of *naming* Ang Lee's transnational films. My aim is to make a case for a more complicated understanding of identity politics, cultural production, and global visibility.

The notion of national identity and cultural articulation in Taiwan is no longer, or more precisely speaking, has never been a single dimension of a political entity. Instead it has become a project and cultural discourse that is constantly being constructed, deconstructed, formed, reformed, and transformed. Identity formation for the people of Taiwan is not only a distinct political framing; it has become a structural feeling, emotional attachment, affective desire, and nostalgic sentiment deeply rooted in people's everyday lives. Through cultural production such as cinematic discourse, we can see the structural effects of identity formation on the people, and how it works on the body and desire, becoming deep-seated for those living within such an episteme. The recurrent sentiments and the tensions of such emotional encounters are represented throughout Ang Lee's cinematic discourse and the audience receptions of his transnational films. In Taiwan, the complex entanglements of colonialism and the Cold War have been translated into Ang Lee's cinematic representation and the responses of viewers. The process of searching for and/or desiring the "certainty" of a *lost* cultural root is a way for people to ground themselves from the uncertainties of a postmodern, transcolonial, and postcolonial milieu. While constantly searching for a cultural belonging and certainty, the emotional engagement and the embodiment of the identity formation simultaneously involve a process of exclusion. It is therefore important to examine the persistence of an ambivalent mode in the films and audience responses.

As presented in chapter one, scholars have argued the politics of the strategic flexibility and universal appeal of Ang Lee and his works. As helpful as these critiques may be, however, there is actually a persistent, nostalgic sentiment and longing for a cultural root constituted in Ang Lee's representation of Chinese identity and Chinese culture in the transnational cinematic discourse. Yet, the recurrent themes of Chineseness simultaneously embed themselves deeply in an ambivalent mode. I will extend and propose a different analytical framework to examine his films and explore how he, as a public figure, has been constructed as a national representative for audiences from different Chinese-speaking countries such as PRC and Taiwan as well as dispersed, overseas Chinese communities. How do audiences negotiate, affirm, and/or reaffirm their national and ethnic identity and the imaginary of a particular culture through these films? How does Ang Lee's transnational cinematic discourse become a discursive site of negotiation of national and ethnic identity and culture for audiences? What kind of cultural meanings are being circulated through his films and audience communities, and what are the implications? Chapter three will theorize the various aspects that will further guide the analysis of the notion of ambivalence.

THREE

Theorizing Ambivalence

Ambivalent Formations in Ang Lee's Transnational Films and Their Audiences

This chapter is a theorization of various aspects of the notion of ambivalence. Important theoretical and critical debates on identity politics and cultural representation were reviewed in relation to the forces of transnationalism and globalization. The cultural dimension of the notion of Chineseness is far more nebulous than its political function as defined within a static nation-state mechanism.

From the outset, it should be important to note that the attempt is not to analyze all forms of ambivalence. Rather, the aim is to work through it conceptually, in order to provide an alternative framework for rethinking how ambivalence has been constructed in cultural productions such as cinematic discourse and audience perception relating to a specific culture at certain moments in time, particularly the twenty-first century. By focusing on constructive aspects of ambivalence as a space of possibility in Ang Lee's cinematic discourse and the perceptions of this discourse, I challenge the predominant characterization of ambivalence as a negative connotation. The theorization of ambivalence in contemporary, transnational cinematic discourse relating to representation of national identity and communicative effects has been largely neglected or simply marginalized, accorded only a perfunctory overview.

Through a systematic conceptualizing of the notion of ambivalence, it will be possible to open up the discussion of the representation of Chinese identity deeply embedded in Ang Lee's transnational cinematic discourse. Such theorization will hopefully contribute to a deeper understanding of the communication

effects of media, and specifically, the ways in which cinematic discourse evokes widespread national and ethnic solidarity or engenders disputes over these forms of cultural unity. This analysis will allow us to rethink further the indeterminate nature of national and ethnic identity in relation to mediated texts, and audiences' perceptions and experiences with them on a broader level. Situating globalization within a context of a continuation of neocolonialism is the beginning of the conceptual framework of ambivalence from a postcolonial theoretical perspective.

Ambivalence as Coexistence of Contradictory Tendencies

It would be helpful to begin with the conventional understanding of ambivalence. According to the *Oxford English Dictionary*, ambivalence is "the coexistence in one person of contradictory emotions or attitudes (as love and hatred) towards a person or thing." In the *Merriam-Webster Dictionary*, it is defined as "simultaneous and contradictory attitudes or feelings toward a person, an object, or action," resulting in "continued fluctuation (as between one thing and its opposite), and uncertainty as to a certain approach." That is, ambivalence is characterized as a common human phenomenon involving apparent emotional, sentimental, affective desire, and contradictory feelings and attitudes with respect to a person or an object.

In psychoanalysis, ambivalence refers to a condition in which two contradictory feelings and tones exist simultaneously. That is to say, it is a *coexistence* of opposites, representing oscillation, and/or fluctuation. In his remarkable study, *The Rat Man*, Freud wrote about the interdependence of love and hate for an object or a person and simultaneous, contradictory tendencies. Freud's theory of ambivalence mainly stems from the Oedipus complex of children. He argued that they could love and hate their parents simultaneously. Drawing on the thesis of children sharing bisexual desire for their parents, Freud considered that the Oedipus complex plays an initial role of structuring a subject's identification. In order to have the mother's love, the child would develop a love-hate relationship toward his or her father and want to replace him in order to possess the mother. Thus, as Freud put it,

> Identification, in fact, is ambivalent from the very first, it can turn into an expression of tenderness as easily as into a wish for someone's removal. It behaves like a derivative of the first, oral phase of the organization of the libido, in which the object that we long for and prize is assimilated by eating and is in that way annihilated as such. (Freud, as quoted in Sarup, 1996, p. 32)

Ambivalence, in other words, is an original, emotional tie to an object through identification, especially in the context of sexual behavior. Yet the sexual desire—

or libido, to use Freud's own word—was repressed and further transformed into a private, taboo, and somehow unconscious desire.

The development of "self"—the unconscious and primitive id—is therefore based on an ambivalent relationship with the "Other"—the superego that represents the social conditions that relate external forces involved in a child's understanding of the world and the self. The ambivalence pertaining to social prohibition, such as a child's desire for masturbation, is understood as "primitive" and neurotic, i.e., against the civilized social order. Thus, according to Freud, such repression and regulation of sexual behaviors transform into a private desire, in direct opposition to public social expectations (Khanna, 2003). The conflict between the ego and the id, that is, the primitive, yet unacceptable desire versus the social expectations, leads to the formation of ambivalence. Thus, in Freudian psychoanalysis, ambivalent emotions, including conflicting or contradictory impulses, are represented as repressed, unconscious needs and desires (Woodward, 1997). Such fragmented and divided states of conflict and fluctuation are further developed as a modern problem. From readings of *Totem and Taboo, Civilization and Its Discontent*, and *Mourning and Melancholia*, it becomes evident that Freud's theory on ambivalence suggests that ambivalent feelings are repressed, resulting in melancholia and causing disturbances, destabilization, and mourning in the modern context.

Developed from Freud's theory of ambivalence as the coexistence of opposing instincts, French psychoanalyst, Jacques Lacan, observed that ambivalence is located in the relationship with "the Symbolic Other," being accompanied by the feeling of aggressivity directed at moments of identification (Khanna, 2003; Sarup, 1996; Woodward, 1997). Lacan developed the theory of the mirror stage to describe a child developing a psychic wholeness of self by viewing its own image in the mirror, prior to the entry into language as a system of signification and the symbolic order. A mirror stage, according to Lacan, "is far from being a mere phenomenon which occurs in the development of the child. It illustrates the conflictual nature of the dual relationship" (Lacan, 1994 as quoted in Khanna, 2003, p. 109). The dual relationships indicate that the child never feels as complete as do others around it. Identification takes place, and the construction of self is sutured within that image.

Lacan's emphasis on language is significant. Entering into language and communication systems plays a crucial role in a child's development of a sense of being a *complete* subject. He posited that it is mainly through the language and symbolic order that a child becomes conscious of the distinction between his own body and the Others. It is through the hailing, the discourse from the others outside of the self, that the self can be recognized. The "linguistic mode of reflexivity" (Sarup, 1996) developed by Lacan presents a significant stage where one begins to constitute oneself. In other words, identification is always relational by symbolic mark-

ing with the Others; one establishes a sense of "I" based on the reflected "I" that is outside the self. The construction of the self and of subjectivity is mainly through communicative interaction with the Others. The gap between the self-image of a child recognizing a reflected self and the Symbolic—the outside world—leads to a fundamental "misrecognition"; an illusive identification, to use Lacan's own word. The misrecognition results in the split of subject or many fragments of ruptured subjectivities, later to be concealed by ideology.

The aspect of coexistence of ambivalence reflects the contradictory effects of globalization and nationalism that were identified in chapters one and two. Hall (1992), in his remarkable essay, "The Question of Cultural Identity," has pointed out that globalization breaks down the boundaries of national identity yet simultaneously deepens cultural nationalism and local identity as a form of resistance to it from native communities. Further, a culturally syncretic identity has emerged while the form of national identity is in decline.

Third World nationalism is a product of globalization and neocolonialism. It is a defense mechanism that represents social struggles for local communities, reconstructing and reinventing their "self-identity" and self-representation. The process of reclaiming oneself is not only political but also very ambivalent because it demands both the dominant historical paradigm and the deconstruction of it. More specifically, the process of ambivalence involves the coexistence of a sense of cosmopolitanism and nationalism. Cosmopolitanism is indeed built on the cultural particularity and imaginary inscribed on the local communities.

The emergence of "new ethnicity" in a borderless world today, as Hall (1997) argued, signifies the changing of the identity paradigm. However, these changes cannot be separated from their histories. If, as some postmodern scholars suggest, one makes a complete break with the past, then modernism actually overlooks the people who have not achieved the definition of modern or made the requisite "changes." When the margins struggle to represent their own voices in modern times, "ethnicity is the necessary place or space from which people speak" (Hall, 1997a, p. 34). The marginalized space can be a place of power, a place of resistance, because the margins take on the essential categories not only to re(search) for their hidden histories, and to re(claim) the representations of themselves but also to open up a new possibility to critique the restraints of identity politics. The new space allows them to speak their own languages, recover their own histories, as well as construct their new "roots." For example, Hall (1997a) told us, "you could not describe the movements of colonial nationalism without that moment when the unspoken discovered that they had a history which they could speak; they had languages other than the languages of the master, of the tribe" (p. 35). The reconstruction of history generates the "new ethnicity," dismantling the identities from the imperialists' lens, as it were, in the postmodern diversity.

As was discussed in chapter two, a new Pan-Asianism has emerged in the East Asian region, resulting in "a greater cultural China" imagination which has permeated various forms of cultural productions in the entertainment industry in Chinese-language regions. On the one hand, there is the sentiment of creating a regional identity that is based on cultural particularity and national language. On the other hand, a collective transnational subjectivity has been formed that aims to catch up with the global-postmodern trend. The coexistence of an increasingly cosmopolitan sense of self, arising in a global postmodern milieu, precisely draws upon a national, cultural imaginary—that is to say, Asianism and Confucianism recurred along with the idea of competing with the West following the Cold War.

The coexistence of paradoxical emotions is the first aspect of ambivalent formations that will be drawn upon in this study. The ambivalent feelings are produced within discourse, language, and representation; in psychoanalytic terms, ambivalence is rendered by individuals who recognize the unattainable, misrecognized self that is defined through the discourse of the Others. Ambivalence represents itself as a struggle for structuring a whole sense of self; it is a coexistence of contradictory feelings and emotions toward an object, a memory, a person, or one's analyst self. After the internalization of the gaze from the Others, being oneself no longer has a clear distinction from the Others. This perspective is expanded to further the discussion of ambivalence in relation to globalization, the sentiment of cultural nationalism, and the identification with the nation-state.

Ambivalence as Equivocation and Contradictions in Mimicry

The second aspect of the notion of ambivalence is the *equivocal power relation* between the colonizer and the colonized, the self and the Other. Namely, I suggest examining both liberating and problematic functions of cultural nationalism relating to the representation of national identity in Ang Lee's transnational films. Building on psychoanalysis, postcolonial theorists examine the ambivalent relationships of colonizer and colonized in colonial and postcolonial discourses. Ambivalence is a key term developed from Homi Bhabha's discussion of cultural hybridity, the unclassifiable nature of the borderline, the third space, the ambiguous relationship between "center" and "periphery." Postcolonial critics have produced extensive research challenging the binary constructions of Self and Other, identity and subjectivity, the colonized and the colonizer, and the oppressor and the oppressed (Fanon, 1967; Hall, 1996a, 1996b; Spivak, 1988, 2001, among others).

For postcolonial theorists, the examination of literature is important because cultural text such as literature is the best complement to ideological transformation (Spivak, 2001). A cultural text is a discursive cultural production that embeds cultural ideology. In this study, I want to broaden and expand this point

from a communication perspective by taking into consideration the practices of representation. Hall (1997) has argued that representation is a signifying practice. Representations can never be constructed out of the play of different discourses, and they are always partial and revisionary. They produce subject positions for audiences from which particular meanings and knowledge are formed. The practices of representations should move beyond the restrictions of the linguistic or the literary. Since all social practices entail meanings, to study culture and cultural productions I look at broader units of productions of meanings such as "narratives, statements, groups of images, whole discourses which operate across a variety of texts, areas of knowledge about a subject which have acquired widespread authority" (Hall, 1997b, p. 42). In other words, I examine a much wider field of "texts" in and through which meanings are produced and communicated, including popular culture, advertising, performance, fashion, photography, films, and other media productions.

Moreover, the practices of representations are the reflections of our mental constructions, and in the meantime, viewers take meaning from representations. Discourses and representations are the productions of social life, constituted by external relationships to other social practices. Therefore they are reflexive. These cultural practitioners produce discursive and reflexive practices that generate representations reflecting their values and beliefs, therefore representing their positioning and simultaneously reproducing subjectivities and identities. Cultural texts such as representations are reproductions connected to social context; namely, the meaning in the text is the "active product of the text's social articulation, of the web of connotations and codes into which it is inserted" (Grossberg, 1996, p. 157).

From the audience position, readers and viewers learn to identify with the value system figured by a cultural text. They take meanings of the discourse by locating themselves within the rules and positions that the discourse constructs, hence becoming "the subjects of its power/knowledge" (Hall, 1997b, p. 56). Literary theorist, Holland, observed that readers would use cultural texts to reassure and reaffirm their cultural beliefs, thereby turning private desires into socially acceptable aspirations by the projection of the fantasy onto the world (as cited in Sarup, 1996). Audiences identify themselves in discourses and representations, thus becoming subjected to the position the speakers and producers create for them. Cultural productions are effective instruments for gradually transforming the mind, and thus are good resources for examining the negotiation of meanings and cultural identities.

Beginning with Said's groundbreaking work, *Orientalism*, colonial discourse became an academic subdiscipline within literary and cultural theory (Young, 1995a). Orientalism, according to Said (1978), is a tactic constructed by the

dominant Western powers to domesticate and represent the "Orient." Orientalism is based on the distortion and misrepresentation of the subaltern subjects.

Bhabha questioned Said's claim that Western colonial discourse *always* works successfully when put into practice by adding psychoanalysis to Said's analysis. He challenged Said's argument in *Orientalism* by pointing out that Said "assumed too readily that an unequivocal intention on the part of the West was always realized through its discursive productions" (Bhabha, 1983, as quoted in Young, 1995a, p. 75). Orientalism works at two levels of psychoanalysis, according to Bhabha: "a 'manifest' Orientalism, the conscious body of 'scientific' knowledge about the Orient, and a 'latent' Orientalism, an unconscious positivity of fantastic desire" (Bhabha, 1983, as quoted in Young, 1995a, p. 75). By providing a systematic track to examine colonial discourse, Bhabha concluded that Orientalism in effect operated both as instrumentally constructed knowledge *and* as an ambivalent fantasy and desire of the relationship between the colonized and the colonizer.

Drawing upon Lacan's linguistic psychoanalysis, Bhabha (1994a) argued that ambivalence is produced within the double inscription of the colonial discourse. The presence of origin and displacement, discipline and desire, mimesis and repetition, fantasy, and psychic defense problematizes the "authority of recognition." In other words, the existence of double vision of articulation with the colonial authority is *always* ambivalent within the colonial text. Bhabha sharply critiqued the dualism of the colonial authority and colonized subjectivity, the center and the periphery, and power and the powerless. The incompatible cultural difference complicates the regulated binary opposition. The "third space" signifies a form of resistance and the shifting dynamics of power play. He remarked that

> resistance is not necessarily an oppositional act of political intention, nor is it the simple negation or exclusion of the "content" of another culture, as a difference once perceived. It is the effect of an ambivalence produced within the rules of recognition of dominating discourses as they articulate the signs of cultural difference. (1994a, p. 110)

Difference and the construction of Otherness are the crucial components to justify colonial conquest and dominance. However, difference and otherness could also disrupt the presence of colonial authority and make recognition problematic. The ambivalent, double-inscribed space actually produces a third place where the rule of recognition becomes dynamic. The dialectic power struggle is produced within the in-betweeness—the mother culture and the imposed alien cultures.

Moving beyond postcolonialism, the liminal experiences of migrants due to the transnational flow of capital have emerged into a more scattered and ambivalent space of cultural syncretism. The experiences should be more flexible; rather than merely emphasizing the monolithic distinction and European colonialism, one should also account for the more contemporary forms of migrations and

diasporic conditions. The syncretic culture created by transnational migrants in liminal spaces is more scattered than scripted by the binary constructions of the self and Otherness. The self is always in relation to the Other and should be considered a product of interaction with others. Thus, any clear delineation between self and Other is disrupted and dissolved. As Bhabha told us, "to exist is to be called into being in relation to an Otherness, its look for locus. . . . It is always in relation to the place of the Other that colonial desire is articulated" (Bhabha, 1994a, p. 44). The moment one's self-identity becomes actualized is in the moment of being recognized by the Others. That is, one's existence and "being" is always in relation to Others, through the gaze of Others.

In this respect, without the oppositional Other, there would be no essence of a "self-identity." This is because identity is apprehended only *in relation*, not as an essential or inherent characteristic possessed by any given subject without reference to a constitutive outside and without mediation by different representations, language practices, memory, fantasy, and so on. The construction of self lies in a contradictory nexus of intertwining projection, desire, affect, identification, and self-denigration that simultaneously contains an element of self-affirmation. The desire and envy of becoming the Other mark the existence of the self. The ambivalent affect explains why one could be so hateful yet simultaneously so passionate about the colonizers or the Other.

Under such complex processes of affective identification, Bhabha proposed that the act of "mimicking" the colonizers on the part of the colonized actually produces an ambivalent third space of enunciation, resulting in a syncretic subject that neither becomes the colonizer nor remains the colonized. The act of mimicry, therefore, accounts for the blurred relations between power and knowledge through which the master discourse had already been questioned by the colonized in their own native accents. The ongoing conditions of mimicry and hybridity suggest that it is impossible for the colonizer to exercise absolute power because the native's inappropriate imitations of the colonial discourse actually result in a threatening of colonial authority through mimic, reform, and distortion. Essentially, ambivalence is located within the fluctuating relationship between mimicry and mockery. In describing a native's colonial mimicry, Bhabha argued,

> Mimicry emerges as the representation of a difference that is itself a process of disavowal. Mimicry is, thus the sign of a double articulation; a complex strategy of reform, regulation and discipline, which "appropriates" the Other as it visualizes power. Mimicry is also the sign of the inappropriate, however, a difference or recalcitrance which coheres the dominant strategic function of colonial power, intensifies surveillance, and poses an immanent threat to both "normalized" knowledges and disciplinary powers. (1994b, p. 86)

The static binary distinctions between power and powerlessness, the self and the other, dissolve because of the paradoxical double articulation produced in the colonial encounter. The processes of mimicking the colonial culture, internalizing the Others as self by writing or speaking in other tongues, inform an indeterminate ambivalence. In light of this, even though a colonial subject is recognizably similar to the colonizer, there are *still* differences. The result of mimicking also signifies the colonized's dis-identifying with the roles and the difference assigned to them by colonizers. Mimicry, in this sense, displaces the colonial discourse where ambivalence shifts the gaze of Otherness to confront the surveillance of colonial eyes. Bhabha described mimicry as the colonizer's disciplinary device: the inevitable failure presents itself as the doomed result. The colonial subject becomes "a subject of a difference that is almost the same, but not quite" (Bhabha, 1994b, p. 91). The inherent failure of mimicry only reveals the disruption of the narcissistic authority.

Frantz Fanon, another guru of postcolonialism whose inspiring writings focus on French colonialism in Algeria, has produced groundbreaking works illuminating the colonized's paradoxical and intertwining affective desire toward the colonizers. Even though he did not address explicitly the notion of ambivalence, his works, *The Wretched of the Earth* (1963) and *Black Skin, White Masks* (1967), present a provocative study of ways of destabilizing the binaries of Self/Other and identity/subjectivity. The problem of colonialism, according to Fanon (1967), "includes not only the interrelations of objective historical conditions but also human attitudes toward these conditions" (p. 84). Racial minority groups such as "Negro kids" in a predominantly White society grow up internalizing the White dominant attitudes and behaviors, assimilating into the White dominant culture in order to "pass." Fanon proclaimed that "the Negro recognizes the unreality of many of the beliefs that he has adopted with reference to the subjective attitude of the white man" (1967, p. 149). That is, Blacks conduct themselves subjectively and intellectually like White men. They do not think of themselves as Black men. Yet they are Negro, as Bhabha (1994c) put it, the mimicry of the colonizer, "almost the same, but not quite." The Negro is thus a slave of the cultural imposition—"a victim of white civilization" (p. 192). This aspect reflects a strong ambivalence when a marginalized subject is living in-between multiple cultures; the fragmented subjects indicate how they take on the imposed "*burden*" from the colonized of the "Negro culture."

Through internalizing the colonial rules, the colonized eventually are *complicit* in the process of colonization. That is to say, colonization was never simply external to the postcolonial subjects and the societies of imperialism. It was always "inscribed deeply within them—as it becomes inscribed in the cultures of the colonized" (Hall, 1996c, p. 246). The colonized people, such as the native bourgeoisie, are well adapted to European capitalism, establishing a complicit

agreement—a kind of homogeneity—to rule their own people (Fanon, 1963b). In doing so, the natives become "political animals in the most universal sense of the word" (Fanon, 1963b, p. 81). The processes of naturalization and essentialization of the self and the other, determining who gets to be included and who gets to be excluded, cause the internalization of *self-as-other*.

Spivak's argument of "double colonization," on the other hand, contends that the native's voices themselves have already been subjected to a larger history of imperialism, that is, they are part of the subjected knowledge. For example, native subaltern women were subjected to both the patriarchy of men, and the patriarchy of colonial power (Young, 1995a, 1995b). Considering the margins marked out by imperial epistemic violence, Spivak stated:

> We must now confront the following question: On the other side of the international division of labor from socialized capital, inside *and* outside of the circuit of the epistemic violence of imperialist law and education supplementing an earlier economic text, *can the subaltern speak?* (1988, p. 283).

The subaltern subjects are not allowed to actively speak for themselves because they are subjected to a discursive formation created by the colonizers. However, such a proclamation ignores and eliminates the possibility of human beings as active agents of resistance and change.

This section has been focused on discussing the ambivalent relation and the shifting power dynamic of self-identity, subjectivity, and the Others developed from a postcolonial context. The second aspect examined in this section looked at how the ambivalent formation emphasizes the equivocation and contradictions in mimicry. The emotional attachment and affective desire toward the "oppositional others" are indeed crucial in constructing a sense of "self." Such ambivalence toward self and others, presented in a sense of double articulation with the colonizers, generates a dynamic power relation between the oppressor and the oppressed, that is, there is no absolute authority or dominance because of the natives' inherent failure to assimilate into the colonizer's alien culture. More specifically, the fundamental incommensurability of the "difference" manipulated for the justification of dominance could function as a double-edged sword. This leads to a further discussion of the representation of national and ethnic identity in a contemporary transnational context.

Representing the Self and the Others: Representation as a Burden and a Becoming

Although Bhabha's argument of ambivalence focuses on the side of colonial authority, the intention of the following discussion is to understand the ways in which ambivalence has been transformed, reproduced, and modified on the side

of the racialized Others. Theorizing ambivalence in the contemporary Chinese diasporic context requires some modifications and adjustments from the postcolonial framework. Even the most ideologically compromised ways of desiring or longing convey a genuine human need (Su, 2005). Ambivalence is a double-edged sword; the construction of self-identity is a process of taking on a *burden* and a *commitment* in becoming a *complete subject*. The process of becoming the Others, as painful as it could be, is, however, both embodiment and disembodiment, both self-impoverishment and nurturing. I argue that the profound ambivalence produced by the minority subjects actually presents a strong sense of "ethnic tenacity," in Rey Chow's words. This strong affective desire to hold on to a cultural "past," the identification with a national and ethnic identity, is *self-sustaining* and *self-reaffirming* for marginalized subjects who struggle in a liminal space. Therefore, in this study I ask somewhat contrary questions: Does the space of paradox always lead to the hatred or eradications of the "self" and the "Other"? Could the space of ambivalence be empowering and open some possibilities? How does the diasporic condition in an era of transnationalism complicate the "paradox of assimilation" (Cheng, 2001)? And in what kinds of cultural effects do Chinese diasporic subjects (Ang Lee in this case) seek recourse when they strive to ground themselves in a subject position? In what ways and to what subjectivity do they devote themselves and project their own desires, and with whom do they connect?

Ambivalence is a process of naturalization and essentialization of the self and the Other, determining what gets to be included and what gets to be excluded, leading to the internalization of *self-as-other*. Such self-internalization has become a form of *cultural burden* for split minority subjects who must reform and transform their cultural identity in the age of multiculturalism. This profound and complex ambivalence is deeply inscribed in minority subjects. Marginalized cultural diasporas, living between or among various cultures, invariably develop an ambivalent sense of the designations of identity in relation to the nation-building in their new host countries. In the new nation, they develop a strong sense of alienation from an identity that was imposed on them and rejection by the adopted country.

Combing through psychoanalysis theory, the psychic trauma and anxieties resulting from racial discrimination or other systems of discrimination including classism, sexism, or homophobia are *soothed* by assimilating into the dominant culture, thereby destroying the minority subjects' once-positive feelings about their native cultures and themselves. The native subjects embody a strong sense of ontological liminality and existence between discursive self-identity and alienated other. They embrace the transformational process of becoming the Other, or *self-as-other*, the correctness or worth of the self, even though they have strong contradictory feelings and inner conflicts. Paradoxically, in order to achieve the idealized Other, the native people need to renegotiate their positioning. Oftentimes, as-

similation leads to dissociating from and abandoning their native culture. Cheng (2001) called this "the becoming body" (p. 78). The self-identity of marginalized groups is constituted by those holding power, and they come to internalize the terms in the process of becoming subordinated by the constructed subject.

Cultural Memory, Nostalgia, and Diasporic Imagination

The profound, ambivalent relationship with the object and the subject with which the marginalized identify embodies not only resentment but also passion and empowerment. In this case, representing a distinctive, Chinese national identity in transnational cinema could be considered as a burden, and the representation of the national subject becomes "mimic, performative, and constitutive" (Lim, 2006). The burden of self-representation denotes a condition in which the some-how inauthentic, partial, and revisionary experiences of the past and the cultural memory continue to shape present values and beliefs. As stated before, ambiva-lence is rendered during the syncretic, hybrid style of mimicking the colonizers while retaining cultural authority in diasporic subjects' own political milieu. The new identities (hybrid selves that marginalized diasporas create) are actually a *liberation* for themselves from their cultural and historical burden—*the burden of becoming a complete subject*. Only through taking on such a burden does a diasporic subject achieve freedom and liberation. The space of "complicity" and paradox not only functions as a reproduction or endorsement of essentialism, it also enables an equivocal aspect of examining national and ethnic identity.

The following sections will connect ambivalence to a diasporic condition. Closely intersecting with the aspect of the cultural and historical burden of eth-nic minority film directors, the struggle over representation, for "Third World" artists to be "recognized" in the world market, is a result of the historical denial of their access to mechanisms of representation (Lim, 2006). To complicate mat-ters, minority subjects, and specifically, diasporic subjects, embody a collective history, experience, and cultural memory through the processes of dispersion and scattering.

For minority artists, the "burden" of *becoming* a complete subject indicates an ambivalent relationship with their historical and cultural existence in self-rep-resentation. The recurrent themes of their lost homeland, the national and ethnic culture, and the longing and desire to return to a lost place indeed denote how the "past" has continued to shape the present. As Hall (1990) asked in his remarkable piece, "Cultural Identity and Diaspora", "who has not known, at this moment, a surge of an overwhelming nostalgia for lost origins, for 'times past'?"(p. 236). Through cinematic representation, the ideas of "returning to the origin," search-ing for the past, and the loss of identity actually conceal the feelings of fear, frus-tration, and anxiety of living in the new host land.

The strong affective desire and emotional attachment to their ethnic cultural past impart to diasporic artists the constructive effect of being able to facilitate understanding. This allows the artists to connect audiences who have been divided and driven apart by political ideologies in history. In other words, the burden of representation embodies a utopian ideal. This ideal tends to transcend the "differences," create a more connected understanding of human beings, and envision constructive resolutions to the dilemmas of fragmentation and displacement represented in the aesthetic cultural productions of diasporic artists. While ethnic minority groups and the diasporic subjects always carry a weighty burden for speaking the "authentic truth" of their own ethnicity, it is precisely these increasing opportunities for self-representations that can be utilized as a way of "redefining" and defending themselves, converting the "ethnic-hailed" self (Chow, 2002) and reclaiming their authority and legitimacy. Self-representation, therefore, could be both emancipatory and utopian.

For diasporic subjects, "the collective maintains its sense of people-hood through networks of travel, communication, economic exchange, and cultural interaction that crisscross national borders" (Klein, 2004, p. 26). Clifford called them "lateral axes" of affiliation, implying that instead of grounding one's sense of identity in the dispersal community that exists in the present, diasporic subjects are settling down "elsewhere" and creating their sense of identity in a homeland that exists mainly in memory (Klein, 2004). San Juan (2004) in his book, *Working Through the Contradictions*, proposed a similar argument: ambivalence is a characteristic of subordinated Filipino women laborers, who are seen as resisting oppression in the new land, yet at the same time participating in their own subordination. Diasporas that live in-between do not necessarily fall into the trap of self-victimization, self-subalternization, or self-dramatization. Instead, the liminal space could be a form of empowerment, granting the marginalized a specific kind of power. This position echoes Rey Chow's discussion on double marginalized positions, such as being Chinese in postcolonial Hong Kong and being a Chinese diasporic intellectual in the West. Diasporic intellectuals who operate from the ambivalent position between Asia and the West actually enact a "specific kind of social power" (Chow, 1993, p. 22).

The ambivalent positions bring out the inherent contradictions in the posited truths. Ambivalence becomes a site of intervening and interrupting tactically dominant discourses of Chinese national identity. A diasporic status therefore could be an intervention to provide an alternative identity paradigm. Such diasporic "tactical intervention" does not necessarily completely destroy the nation-state affiliation or provide a formula for solutions, but instead, it complicates matters based on the ambivalent enunciation from a "third space."

Diasporas are displaced populations that usually remain in subordinate positions by means of established social structures such as racial exclusion or sub-

ordinated ethnic status in the new land. Through the attachment to homeland, cultural traditions, and a shared history of displacement, diasporas establish a collective, symbolic community and identity, contributing to cultural solidarity. That is to say, a collective, diasporic identity is "necessary," because in a sense, it provides the community with a new possibility to appreciate and critique the past—their history and their positioning.

Transnational identity formation emerges out of "a shared history of dispersal, myths/memories of the homeland, alienation in the host (bad host?) country, desire for eventual return, ongoing support of the homeland" (Safran, 1991, as quoted in Clifford, 2005, p. 527). The essence of a collective diasporic identity is defined by the relationship with history and the past. The *history* and the *past* of the diasporic subjects are not buried in the past but instead continue to shape the present, providing an alternative avenue for a new construction of subjects. The emotional attachment and the deeply seated embodiment of the nostalgic sentiment about the collective past emerge as a form of cultural empowerment. As Peters (1999) suggested, the dispersed develop and sustain a sense of community through various forms of communication, such as language, media, or rituals. The collective memory of homeland therefore enables the scattered fellows to bind together, creating real or imagined relationships with each other. That is, "diaspora is always collective" (Peters, 1999, p. 20). The act of remembering and the sense of nostalgia are the ways to bind a diasporic community together.

Distance from one's motherland generates a sense of loss, as Liao (2005) suggested. Asian diasporas, for example, have sustained critical networks of exchanging material and symbolism with their homelands (p. 504). The issues of home and migration are negotiated from art, popular culture, language, and the Internet. Uprootings and regroundings, Ahmed et al. (2003) argued, "emerge from this collective work as simultaneously affective, embodied, cultural and political processes whose effects are not simply given" (p. 2). Thus, one needs to rethink home and migration. For diasporic communities, the recreation of "home-binding" signifies the development of cultural belonging by exchanging symbolic or material meanings.

The work of collective memory in constructing the imagined homeland closely connects concrete materialities of objects, traditions, or rituals. The rebuilding of "home" depends on the "reclaiming and reprocessing of habits, objects, names and histories that have been uprooted" (Ahmed, Castañeda, Fortier, & Sheller, 2003, p. 9). The methods of forgetting and remembering reflect an intimate relationship between the personal experiences of the history and a collective memory. Oftentimes, the personal history counters the dominant historical narrative. As Dai & Chen (1997) observed, the nostalgic atmosphere is created in the cultural memory, whereas self-reflexivity is reflected within a specific historical and cul-

tural imagination. The nostalgic sentimentality—the longing for the "lost" home-
land and the past—is, therefore, another layer of the notion of ambivalence.

The affective and physical creation of the imagined home is a continuing pro-
cess; individual memory contributes to the rise of nostalgia. Imagined fragments
are pieced together as a wholly imagined "home." The sense of self is fragmented.
Identity becomes a *bricolage*. By piecing together fragmented bits of a distant,
collective, historical past and the current self, the people who live in a liminal
space invent and negotiate their hybrid identities and cultures. These do not pres-
ent mixtures from other purer or more authentic identities but rather represent
the tensions demonstrated in those periods. That is, during the hybrid style of
mimicking the alien cultures while retaining cultural authority in the marginal-
ized subjects' own political milieu, the *equivocal* ethnic and national identity is
rendered.

The ambivalence here is that the longing for a lost or an imagined homeland
reflects diasporic desire for a *rootedness* that is, paradoxically, built on a rootless ex-
perience. Diasporas function as discursive communities in which people establish
a paradigm of who will belong and who will be excluded. However, such diasporic
solidarity is developed through some communal experiences; that is, it is the his-
torical experience of mistreatment through racism that has driven the dispersed
to stick together to defend themselves. Geographical and cultural displacement
creates new forms of cultural belonging, as well as increasingly informing us of
the local-global cultural dialectics. Thus, even though the diasporic discourse of
homeland and culture to some extent creates a myth of racial purity or ethnic
absolutism, it needs to be situated in a historical context in order to understand
the whole complexity of the constitutive nostalgic sentimentality.

Due to their daily encounter with racial prejudice, there is a strong attach-
ment to—one might say, an "obsession" with—a traditional culture within
diasporic communities. Such a defense mechanism paradoxically lies in an am-
bivalent sense toward a nation, its people, and its culture. Indeed, the aspect of
nostalgia has been exploited for commercial and nationalist political interests.
Politics of remembering, imaginary, and politicization of memory have been ma-
nipulated and inculcated by cultural producers and capitalists. However, through
self-representation, diasporic cultural representation opens up the possibility of
refiguring the relationship to the culture and the past.

Greater attention must be paid to the prevalence of nostalgia in the cultural
representation in transnational cinemas, especially under diasporic conditions.
Cultural memory, selfhood, nostalgia, self-reflexivity, and the employment of an
ambivalent diasporic imagination of a *nation* and a *culture* all interplay in con-
structing a collective subject position. Apart from the controversial representa-
tional strategy of constructing artifacts and cultural objects as commodities, I
intend to add complexity by accounting for the constructive effects of such an

"entrance," or more precisely, the creation of a global market and cinematic aesthetic, especially in the transnational cinema of Ang Lee.

Naficy (2001) stated that diasporic films emphasize the multiplicity and additional meaning of their homeland since the diasporic community tends to maintain a "long-term sense of ethnic consciousness and distinctiveness" (p. 14). In other words, "diasporic consciousness is horizontal and multisided, involving not only the homeland but also the compatriot communities elsewhere" (p. 14). We need to take into consideration identity politics and the problematic critique of authenticity in the cultural representation of a national culture. We should view cultural representation of transnational cinema in a postcolonial and transnational world as a kind of cultural translation (Bhabha, 1994a). As Bhabha noted, cultural translation is an important process for "Third World" nations to gain a foothold in the global cultural market. Specifically, he wrote, "In the postcolonial text the problem of identity returns as a persistent questioning of the frame, the space of representation, where the image—missing person, invisible eye, Oriental stereotype—is confronted with its difference, its Other" (Bhabha, 2000, p. 95). In late modernity, there is no simple return to the "origin" or the "ancestral past." This is because even such presumed origin or ancestral past is itself constructed discursively from communal narratives. Thus, it usually partly resides in the imaginary and is therefore inevitably politicized in its process of construction.

The notion of "nation as narration," to elaborate on Bhabha's argument of cultural translation, clearly proposes that nation is inscribed in and dispersed through various narratives and discourses. The category of national people is constructed by means of double-writing. The double-writing or dissemi-*nation*, according to Bhabha, is "a space that is *internally* marked by cultural difference and the heterogeneous histories of contending peoples, antagonistic authorities, and tense cultural locations" (Bhabha, 1990a, p. 299). The speculation about the national culture lies in contingent and fluid relationships. The national culture, therefore, should not be seen "simply as 'other' in relation to what is outside or beyond it" (Bhabha, 1990b, p. 4). The fluid relations in the construction of a "national culture" lie not only in the nation-in-itself but in the symbolic meaning given to the nation.

Ambivalence as a Site of Contestation

I argue that the intense sentimentalities and enthusiasms simultaneously affirm and reinforce a diasporic subject's identity and sense of belonging. Nationalism is reactive to perceived historical and contemporary oppression. It is also important to note the complexity of the politics of recognition for the marginalized subject in the global world. The nostalgic sentimentality toward the homeland and the host-land challenges the traditional model of community, opening up new spaces

of subjectivities. Such an ambivalent situation raises issues of place, culture, and memory, calling into question the identity of a displacement of cultural dialectics (Liao, 2005, p. 503).

The nostalgic identification with a place and a positioning requires an act of imagination not only for the cultural producers but also for the viewers. It is significant to analyze the positionality of transnational audience communities. Individuals identify with mediated representation to shape, affirm, and/or reinforce their sense of identity, feelings, and affective desires (or despair) toward a culture. Specifically, for the diasporic communities, they engage in such mediated experiences actively or passively as audiences recollecting cultural memories or revisions of them. This will be discussed further in chapter four.

Historically speaking, audience research is predominantly conducted in television studies and primarily focuses on fandom studies since television dramas are considered to have greater impact on audiences (Chua, 2008). In contrast, in film studies, the predominant research focuses on the ideological analysis of the cinematic texts. The study of audience perceptions of cinematic practices has been given little, if any, academic attention. In this study an attempt is made to incorporate audience discourse into the analyses of the forms of cultural nationalism and the ways in which transnational cinematic practices function as a discursive site for negotiating cultural and political meanings under different conditions. By studying the cinematic discourses of Ang Lee, a "Third World" artist based in the West, I will explore the ways in which transnational films become an ambivalent site that reflects cultural struggles over representation.

This book draws on an alternative framework for theorizing the notion of ambivalence, specifically in relation to the representation of national culture and identity under a diasporic condition. In order to gain a more holistic understanding of the politics of national identity and culture represented in the transnational cinema of Ang Lee, one needs to adopt a nonmonolithic theoretical framework. Individuals can position themselves as agents yet simultaneously participate in the ideological social construction. Individuals can be simultaneously both object and subject or victim and agent. Moreover, identity, which is always contested and fluid, cannot be independent from the larger social structure. Both identity and subjectivity are discursively constituted under various political, cultural, and social conditions. Identity is not the given; instead, it is imaginary, only operating within ideological subject positions (Hall, 1996a).

This chapter proposes four aspects for the notion of ambivalence. From a psychoanalytical perspective, the most significant aspect of ambivalence refers to the coexistence of contradictory feelings, emotions, and attitudes toward an object or a person. Moving to the postcolonial perspective, ambivalence is rendered during the hybrid style of mimicking the colonizers while retaining cultural authority in the diaspora subjects' own political milieu. The cultural syncretism produced by

transnational diasporas highlights the profoundly ambivalent nature of identity politics. That is, for marginalized diasporic subjects, becoming *complete* subjects and gaining liberation is, paradoxically, based on taking on the historical and cultural burdens that have been used to constrain them. Intensive, nostalgic desire and affective attachment to a symbolic and material ethnicity and nationality present a complex politics of self-representation for those who are both postcolonial and transnational subjects in a globalized era. The space of contradictions and paradox facilitates an equivocal aspect of examining the politics of national identity and ethnicity, which could be ideological yet constructive. Ambivalence, therefore, lies both inside and outside of the self; it presents a liminal space between the need for self-preservation and the need for others' recognition.

This theoretical framework will be used to examine the connections between different practices. I will explore the discourse of ambivalence (a) in relation to Chineseness in *Lust, Caution* and *Crouching Tiger, Hidden Dragon*; (b) in the public discourse and the conjunctures between ideology and social formations; (c) between various components within ideological structures; and (d) between different cultural communities constituting social and ideological effects. In so doing, the hope is to find larger implications for the production of identity politics in film discourse and in the global market as a whole.

The Burden of *Becoming* a Chinese Diasporic Director

The Discourse of Bridging the East and the West in Crouching Tiger, Hidden Dragon

Because of your love . . . I will never be a lonely spirit.
 (Li Mu Bai, *Crouching Tiger, Hidden Dragon*)

The world is getting smaller, and the line between the center and the periphery is blurred. I wish the world is like the [John Lennon] song goes: "Imagine there's no country [sic]" I would like to be in that gray area, where people see me as "all of the above."
 (Ang Lee, 2007)

In what ways has the notion of Chineseness become ambivalent? Why does one work so hard to hold on to a national and ethnic identity on one hand yet simultaneously participate in a borderless, global world? In what ways could films become a site of cross-cultural communication and collaboration?

Ang Lee's prototype of transnational film is his martial arts (the *wuxia* genre) film, *Crouching Tiger, Hidden Dragon*. The revision and repackaging of transnational Chinese identity not only crossed cultural and national boundaries but also was utilized as an instrument to reclaim cultural representation of ethnic minority in the West to use Ang Lee's own words, to "tell our story, and to explore the legacy of classical Chinese culture" (Lee, 2000, p. 7). Martial arts films have long remained the top commercial success of the Hong Kong film industry, yet, compared to other international films, they have not gained major success in award ceremonies such as the American Academy Awards. Exceptionally, *Crouching Tiger* gained enormous attention and brought exhilarating entertainment into

the global film market. Its emphasis on "the greater Chinese theme," as Ang Lee remarked, makes it a good case for examining the ambivalent representation of Chinese identity, the changing dynamics of (trans)nationalism, and localization in relation to audience reception.

While much critical energy has been directed toward deconstructing ethnicity and nationality, less attention has been paid to *why* and *how* an individual or a community remains invested in maintaining a racial or ethnic subject and a continuation of a distinct version of culture. Even those categories have been argued to be problematic. In previous chapters, the criticism directed toward Ang Lee and his construction of Chineseness in his transnational films primarily focused on the charge of his self-exoticism. Such criticism that is based on an anti-Orientalism stance ironically falls into a tautological implication; that is, it reinforces a tendency to theorize that any Third World or non-Western minority subject should perform an "incontrovertible ethnic truth and essence" (Chow, 2002, p. 116). It also generalizes the notion that *all* non-Western subjects are habitually and invariably solicited in a manner of coercive mimicry of the White, Western world. I argue that such a line of theorization is rather limiting and hence requires one to rethink the politics and political implications of national identity and recognition.

Consequently, instead of repetitively citing the obvious, ideologically charged racial images and taking on the task of critiquing the pitfalls with which we are already very painfully familiar, this work pushes forward to explore the ways in which the passionate identification with a nation, racial and ethnic imagination, and desire have been structured through cinematic and audience discourse in the first place. Since less academic attention has been given to the viewers who co-construct and complete the meaning of films, this chapter will incorporate public discourses, interviews, and the discourses of *Crouching Tiger* and *Lust, Caution*. These films present two cases where Chineseness is represented as a site of indeterminate ambivalence and deconstructed as a site of contestation.

Central to the argument is an exploration of the (de)construction of the discourse on Chineseness (which is fundamentally rooted in Confucian philosophy) and the *maintaining* and/or the embracing of it in Ang Lee's most prominent contemporary, transnational films. By examining the audience discourse generated around viewing the films and audience perceptions of the films' director, I hope to contribute a further understanding of how a specific, cultural meaning is circulated through the films. This chapter seeks to answer two questions: How is the notion of Chineseness being constructed, deconstructed, and reconstructed? How do the audiences reflect a sense of Chinese identity from the transnational films of Ang Lee, and what are the implications? By focusing on the specific reception contexts, it becomes clear how Ang Lee has become a Chinese media

icon and how the discourse on Chinese identity in his films functions as a site of negotiation.

Previous academic attention has been focused on the highly unequal, global cultural flow, i.e., the flow of cultural imperialism from the Global North to the Global South or from the West to the East. The empire of Western media and the predominance of various forms of cultural productions have been gradually disrupted by the reversed cultural flow both from the "periphery" to the "center" and among the periphery nations (Wu & Chan, 2007). Given its great box office success and the attention drawn from the global film market, *Crouching Tiger* has solidified its significant international status. At the end of the first decade of the twenty-first century, *Crouching Tiger* was rated the most popular foreign-language film in the North American film market.

This chapter will examine the ways in which Chinese culture and the *wuxia* genre are (re)produced through transnational film discourse and will further detail how the film becomes a site for cultural negotiation and empowerment. By comparing and contrasting the public discourses of different cultural communities, this work aims to understand the ways in which Confucian philosophy and traditional martial arts films have been destabilized, revised, and/or re-envisioned through the successful engagement of cross-cultural audiences. By recounting the notion of Chineseness that is reconstituted through the film and its audience, I argue that Chinese identity is co-constructed as a disparate, yet collaborative *project* by audiences from different Chinese communities. *Crouching Tiger* and its international success function as a site of cultural empowerment; a bridge to communicate, maintain, and/or strengthen a symbolic tie with the national identity and an imagined "home."

Public Discourse as Construction of Film Reception

The Internet has become a major vehicle for individuals and communities to organize and exchange information and discussions about pop culture productions. As researchers point out, instant communication technologies help facilitate borderless, virtual communities (see, for example, Ang, 2001a, 2001b, 2001c; Appadurai, 1996; and Chua, 2008, among others). This chapter is concerned with how national identity has been formed through online communities. I explore the receptions of Ang Lee and his transnational films and further connect these to an attempt to understand the broader implications of how specific cultural meanings in terms of Chineseness have been constructed, produced, and circulated in and through various online communities.

When viewers co-construct the meanings of a cultural text, they engage in public discourse about films after they see the films through face-to-face communication or online discussions. Hence, ongoing "talk" generated after film view-

ing is a key factor in understanding the political, cultural, and ideological effects that a film text has on an individual and a community. As Sturken & Cartwright (2001) argued, meanings of a cultural text are produced through a complex social interaction among the text, viewers, and the context in which it is perceived. In other words, meanings are created at the moment audiences interpret and *experience* the cultural text.

Scholars have suggested that audiences have various ways of engaging with a cultural text, as they can reject or reconfigure it (see, for example, Ang, 2003; Chua, 2008; Iwabuchi, 2008; Kim, 2008; Morley & Robins, 1995; Staiger, 2001). In this light, audiences could be active interpreters of a cultural production, such as a film. Through different channels of communication exchange, public discourses among viewers continue to process a text, co-constructing a sense of an individual or a communal identity through reflexivity and resonance with the text. Audience position also impacts one's film-viewing experience and responses. For example, for a transnational, diasporic subject, watching a television program concerning one's home country might facilitate a national identification and a nostalgic sentiment. Another situation is that audiences might easily and "naturally" identify with characters and themes of locally produced programs, since they are embedded in their own culture. Media programs become a cultural space, as Chua (2008) argued, within which local audiences actively engage, appropriate, and absorb cultural elements and fragments.

Methodological Note

The multiple resources utilized in this study include news articles, published interviews, and Internet bulletin boards. Predictably, there are a growing number of online websites, organized by cyberfan communities, that are catering to different celebrities, films, television shows, and popular culture. The cybercommunities travel across restrictive geographical and physical boundaries, connecting passionately with each other in order to exchange information on popular cultural figures and productions. I particularly focus on Chinese-language websites where I can access collections of discussion forums about Ang Lee and his films. The Chinese-language sites I examine are popular among audiences in Mainland China, Taiwan, Hong Kong, Malaysia, Singapore, the U.S., and overseas Chinese communities. Examples of these websites include www.blog.sina.com.cn, www. mtime.com, http://www.douban.com/, http://www.ptt.cc/index.bbs.html, and http://bbs.ntu.edu.tw. They are the largest Chinese-language websites devoted to discussions of films by public-professional film critics and their audiences. In particular, Sina, Mtime, and Douban are specific online discussion forums that include links to various updated news resources about newly released films, and discussions from both fans and professional critics. As the most active sites, these digital platforms offer a community section comprised of message boards as well

as a database that covers information regarding Ang Lee and relevant film information such as news, interviews, actors, actresses, various collections of audiences' notes, film reviews, open discussion forums, etc.

The sources of media coverage include the *China Daily*, the *Southern China Morning Post*, the *Epoch Times*, and the *China Times*. Google and LexisNexis Academic Universe were utilized to collect English news published around the world, and WiseNews was accessed for Chinese-language news articles and magazine reports regarding *Crouching Tiger* and *Lust, Caution* in Greater China. I narrowed down the news resources to the most authoritative newspapers, as they present the most valid information, mainly focusing on the Chinese-language newspapers and online discussion boards, including film reviews and relevant news.

The *China Daily* is one of the most influential English-language daily newspapers published in Mainland China. It has the widest print circulation of any English-language newspaper in China. The *Southern China Morning Post* is Hong Kong's premier English newspaper. The *Epoch Times* is an independent news media based in New York mainly targeting Chinese overseas readers and international readers. The news coverage predominately focuses on events in Mainland China, Hong Kong, and Taiwan. In addition, Ang Lee's autobiography, *Movies: A Ten-year Dream Come True* (Shi nian yi jiao dian yin meng), is an important text for examining the strong impact of his diasporic subjectivity on his filmmaking. Since the collection of a large amount of documents is an arduous task, the data are cross-checked to examine the intertextual themes of the documents. Finally, for purposes of comparison with the audience discourse, a textual analysis is conducted of *Crouching Tiger* and *Lust, Caution*, primarily emphasizing the cinematic narratives, themes, plots, and characters. Such an analysis enables a relation of the film texts to the analysis of the ambivalent discourse of Chinese identity. In chapter five, particular focus will be placed on *Lust, Caution* and its audience responses. In this chapter, an examination will be conducted of the discourses and receptions of *Crouching Tiger*, with particular focus on the aspect of Confucian philosophy and the *wuxia* genre.

Several layers of audience communities are identified and explored in this project. I examine audience responses from Mainland China, Taiwan, and overseas Chinese communities who primarily live in the United States. Audiences were defined broadly, including professional film critics and online fan communities. Reception contexts, therefore, could be identified as news construction and audience perceptions. A total of about 400 online audience responses, 30 professional critiques, and 238 news articles regarding *Lust, Caution* and *Crouching Tiger*, published in the years the two films were released—2000 and 2007, respectively—were collected and analyzed. Numerous discourses on the two films were (and continue to be) published. An extensive amount of these published sources was examined in this analysis, even though it is impossible to exhaust the literature.

The analysis proceeds as follows: first, explicating how *Crouching Tiger* reconfigures an alternative version of Chinese *wuxia* tradition and subverts the dominant ideology of Confucianism; second, analyzing Ang Lee's published interviews and autobiography to understand his diasporic subjectivity and its heavy impact on constructing an imagined cultural China; and finally, comparing and contrasting various audience perceptions of the represented Chineseness, specifically concerning the *wuxia* genre and Chinese philosophy. The ambivalent themes expressed throughout the published discourses are identified and then categorized into the sections that follow.

Crouching Tiger, Hidden Dragon: A Dream of China

Crouching Tiger is a Mandarin-language film adopted from a romantic and tragic novel by Wang Du Lu, a famous Chinese *wuxia* writer. The screenplay is co-written by Taiwanese screenplay writer, Wang Hui Ling, Tsai Kuo Jung, and American writer, James Schamus. Categorized as a multinational cultural production, it was produced by film companies from the U.S., Taiwan, and other nations. The story is set in the Qing Dynasty in ancient China, featuring a young woman, the daughter of a visiting Manchu aristocrat, Jen Yu (Yujiaolong) and her adventure of self-discovery. Rebellious, with a sense of discontent with her arranged marriage and the attendant contradictory emotions and feelings, she embarks on an adventure to search for an alternative life. The film starts with the *wuxia* expert, Li Mu Bai (Chow Yun Fat), who is a master *wudan* swordsman. He plans to return his legendary sword, "Green Destiny," in order to retire from *jianghu* (the world of martial artists) and pursue a peaceful life. However, his plan is interrupted when Green Destiny is stolen by a thief. Mu Bai and his lifelong intimate, widowed female warrior, Yu Shu Lien, track the theft to Jen. The film then unfolds the complex relationships of Jen, Mu Bai, Shu Lien, and Jen's mentor, Jade Fox, combining martial arts, romance, and high-arts aesthetics. Instead of following the conventional course of a romantic love story, Ang Lee subverts conventional social codes deeply rooted in traditional Chinese philosophies such as Confucianism, Taoism, and Buddhism. In other words, by (re)presenting the social constrictions of relationships and conventions that dictate people's daily lives, the film problematizes three main themes of the Chinese virtues of chastity, loyalty, and filial piety.

The title, *Crouching Tiger, Hidden Dragon*, is a Chinese expression that refers to the underestimated, potent characters that lie under the surface of a society or an individual; in Chinese, dragons and tigers signify powerful individuals who have extraordinary potentials or abilities. The title, *Hidden Dragon*, signifies Jen. Her name contains the Chinese character for "dragon," a characteristic that is embedded in her dual lives—as a proper and innocent daughter of a wealthy, aristocratic family, who longs for freedom yet still grudgingly fulfills her social

obligations; and as a passionate, yet dark, anarchic rebel who practices the *wudan* sect of martial arts to pursue her passion for the *jianghu* lifestyle. On the surface, it is easy for viewers to underestimate Jen, given her seemingly well-trained life as a daughter of a royal family. She is accomplished in the arts of brush calligraphy and lives a cloistered life. In her secret life, she is a young rebel and is trained as a highly skilled martial artist. *Hidden Dragon* hence denotes the character's complex double lives; as for Jen, nothing is what it seems.

Yu Shu Lien (Michelle Yeoh) and Jade Fox (Cheng Pei Pei) are two main female characters whose fates closely intertwine with that of Jen Yu. While Jade Fox, Jen's mentor, is portrayed as a villain who urges Jen to break social conventions in order to pursue a carefree life, Shu Lien is portrayed in the role of a moral advisor, who spends her entire life pursuing justice, abiding by traditions, and repressing her feelings for Mu Bai. Shu Lien and Mu Bai try to convert Jen from a bandit who stole the legendary sword into a model of virtue and justice.

The story features two repressed loves: one is the undercurrent of emotions between Shu Lien and Mu Bai; the other is Jen and her secret lover, Lo Shiao Hu (Chang Chen). Lo is a rough bandit living in the Gobi Desert who stole Jen's comb. His name, "Hu," refers to the Chinese character, tiger, which is also reflected in the first part of the film's title, *Crouching Tiger*. Jen and Lo develop a passionate love for each other that puts her in a struggle between her inner desire for true love and docile acceptance of an arranged marriage. Repression, characterized by the unspoken love between Shu Lien and Mu Bai, plays a significant role in the film. The undercurrents of emotions, desires, and passion between them are never openly expressed because Shu Lien was married to Mu Bai's brother, who was killed. To express love for each other would violate the honor code of *jianghu* and dishonor the memory of Mu Bai's brother. They place honor of the social codes above their true emotions, feelings, and desires, sacrificing their true selves and suppressed longings for each other. Encountering Jen, the young, wild, and rebellious soul, ignites Shu Lien and Mu Bai's long-repressed passion. Jen steals Green Destiny, cross-dresses like a young, male *wuxia* fighter, and betrays her mentor, Jade Fox, thereby putting everyone in jeopardy. Her wild behaviors break the *jianghu* chivalric code, leading to the deaths of Mu Bai and Jade Fox. *Crouching Tiger* ends with Jen's leap from the Wudan Mountain.

Ambivalent Discourse on Transnational Chineseness: Disrupting Confucianism, Buddhism, and Taoism

The ambivalent attitudes toward various social constraints are revealed in the representation of Mu Bai and the three-generation female protagonists (Jen Yu, Shu Lien, and Jade Fox) throughout the film. This suggests a way of problematizing the notions of justice, morality, and specifically in this case, Chinese philosophy.

The distinction between *Crouching Tiger* and other traditional *wuxia* films is its ambivalent representation of those alleged "truths" and principles of moral virtues that have been unquestionably pursued in the *wuxia* world. *Crouching Tiger* opens with Li Mu Bai's being weary of *jianghu* after years of fighting and killing. He has a love-hate relationship with the Green Destiny sword. Leaving Wudan Mountain and unable to finish the meditation training, Li Mu Bai experiences his deep inner conflict with *jianghu*, a result of his discovery of the coexistence of both virtue and vice in it. He says to Yu Shu Lien,

> Li: *During my meditation training I came to a place of deep silence, I was surrounded by light. . . . Time and space disappeared. . . . I didn't feel the bliss of enlightenment. . . . I was surrounded by an endless sorrow.*

The following conversation takes place when Li Mu Bai unwraps the astonishing Green Destiny and passes it to Yu Shu Lien:

> Yu: *I don't understand. How can you part with it? It has always been with you.*
>
> Li: *Too many men have died at its edge. It only looks pure because blood washes so easily from its blade.*
>
> Yu: *You use it justly, you're worthy of it.*
>
> Li: *It's time for me to leave it behind.*

Here, we clearly see the ambivalence of *jianghu*. Instead of adopting the stereotypical plots of *wuxia* films, this film reconfigures the theme. The Wudan Mountains represent a monastery for Taoist disciples to acquire the diligent discipline of martial arts, practice meditation, and pursue the ultimate morality that leads to harmony with the natural world, reducing people's conflicts with each other. And yet, in the world of *jianghu*, such a pursuit of morality is, ironically, based on numerous fights and killing. Being moral and being vicious both turn out to be fabricated and fraudulent.

Central to Confucianism are human relations and social harmony, which are based on social order, training, and self-discipline. It suggests that the social order needs to be followed in order to maintain a harmonious society. Filial piety, loyalty, and benevolence are three main virtues that should be applied to human relations, such as those with family, friends, and others. The ambivalent attitude toward *jianghu*, and the struggle between the pursuit of personal freedom and social obligations are not only expressed by Mu Bai, but also by Shu Lien. While trying to quell Jen's yearning for the freedom of a fighter in *jianghu* and persuading her to obey the social norms, Shu Lien tells her that "fighters have rules too: friendship, trust, integrity. . . . Without rules, we wouldn't survive for long. . .

[getting married] is the most important step in a woman's life, isn't it?" She encourages Jen to show filial piety to her parents by following the traditional path of getting married. By spending her life pursuing justice and honor and being loyal to her husband, who had already passed away, Shu Lien represses her genuine feelings for Mu Bai in order to adhere to social obligations, namely, abiding by the traditional femininity, even as a martial artist in *jianghu*. Shu Lien is depicted as a firm believer in Chinese tradition, yet at the same time she is, ironically, one of the strong female fighters in *jianghu*. Such depiction of the character is translated into a profound ambivalence of traditionalism and modernism, resulting in a strong, ironic contrast, a simultaneous contradiction.

While Shu Lien is portrayed as a character who embodies both traditionalism and modernism, Jen represents another example of the ambivalence of the praxis of morality that is inherent in the construction of the role. Her passion for giving up the privilege of a royal family and breaking free from socially imposed ideologies in order to be a free-floating warrior reflects her secret life as a bandit who stole the Green Destiny, and more obviously, her love affair with Lo (Chang Chen). As he is a desert bandit from Xing Jiang, the obvious class differences prevent them from being together. Lo's character becomes a metaphor denoting an "ineligible" desire because that contradicts the social bond—Jen's arranged marriage. Lo struggles between his emotional attachment to and personal longing for Jen. On the one hand, he claims he has been an unrecognized, wandering bandit who does not follow rules, yet on the other hand, he also struggles with his desire for Jen and persuades her to return home. He tells her he will marry her when he earns her parents' respect.

A rational choice and an impetuous emotion are no longer distinct from each other. Internalized social obligations have been translated into the characters' personal desires. Hence the binary opposition of "social norms" and "personal freedom" is no longer an adequate explanation for the complexity of human relations. The external, socially constructed subjectivity is deeply rooted in the inner self-identity. In order to fulfill their passion and desire, they need to first draw themselves into an *acceptance* of the family and the society. In other words, desire itself is not an independent variable separated from a social structure but rather a constructed longing and identification that *need* to be fulfilled within the parameters of the social burden that is imposed on the individual. Inner desire and external social forces become intrinsically fused and confused. Ambivalence is therefore a key concept to understanding the complex entanglement, dilemma, and dynamic relationship between rational choices and impetuous emotions, constitutional practices, and individual liberty and freedom.

References to traditional filial piety in Confucian philosophy are constructed throughout the film not as an endorsement but more as subversion and destruction. It is particularly evident in the representation of Jen, Shu Lien, Jade Fox, and

Mu Bai. The emphasis on strong and active female characters indeed challenges Chinese patriarchal authority, especially the macho world of *wuxia*. In traditional Chinese society, Shu Lien and Mu Bai serve as the moral model; they sacrifice their personal desires and freedoms for a society and a country. However, the film invites audiences to ponder some questions: What exactly is morality or justice in a human society, and is there an intrinsic worth to the ends served by righteousness? Whose justice is it and for whom does it work? How does a society reconcile various interpretations of morality, or can they ever be reconciled? Throughout the film, Shu Lien and Mu Bai both present intense, conflicting emotions toward the principles of morality that they have been following. Rather than gaining peace from *jianghu*, they *suffer* an endless inner turmoil from the principles of morality.

The ties between Jade Fox and Jen are also complexly mediated by a strong love-hate relationship. They are long-term friends, embodying a master-and-disciple relationship, yet, simultaneously, each is the other's most intimate enemy. The interactions between Jade Fox and Jen indicate the fragile, yet deeply bonded nature of human relationships. Neither can leave the other, yet, toward the end of the story, they both betray each other. Jen once told Jade Fox of her ambivalent feelings toward her—that she became frightened and disoriented when she realized that her martial arts skills surpass those of her mentor. Fox tells Jen toward the end of the story, "You deserve to die . . . ten years I devoted to you. But you deceived me . . . my only family . . . my only enemy. . . ." This scene echoes Jen's mixed emotions toward Shu Lien who has been trying to direct her to a moral path. The fighting sequence at the Yuan Security Compound highlights the fragile friendship, and, by extension, the notion of loyalty, in an imagined world like that of *jianghu*.

By utilizing an ambivalent approach to questions of friendship, loyalty, and trust, Ang Lee challenges the universal notion of humanity and the virtues of human thought and conduct rather than providing a doctrine of absolute truth. It is clear that an ultimate truth provided by the Grand Narratives can no longer satisfy many life situations. Hence, through the narrative of the intertwined entanglements of the three generations of female fighters, the film actually invites audiences to ponder: What happens when rules become rule-less, an intimate friend becomes an enemy, trust becomes betrayal, the established social order is no longer a protection but only repressive, and the principles of justice are actually harmful for human relations?

Toward the end of the film, the unquestionable norms and social obligations emerge as tragic undetermined ironies. The simultaneous contradiction and conflicting emotions are manifested in the dialogue between Li Mu Bai and Yu Shu Lien:

Li: *My life is departing. I've only one breath left.*

Yu: *Use it to meditate. Free yourself from this world as you have been taught. Let your soul rise to eternity with your last breath. Do not waste it . . . for me.*

Li: *I've already wasted my whole life. I want to tell you with my last breath . . . I have always loved you. I would rather be a ghost, drifting by your side . . . as a condemned soul . . . than enter heaven without you. Because of your love . . . I will never be a lonely spirit.*

The scene again amplifies the irony, ambivalence, and contradictions of the binary construction of the pursuit of morality and forbidden personal longings. For Mu Bai, the lifetime pursuit of justice and morality ends up as a lifelong regret and a tragedy. Fighting under the rules of *jianghu*, romance is the last thing that a loner, a martial artist warrior, should worry about. Ironically, the pursuit of ultimate justice and martial art skill does not bring him inner peace but instead brings repression and conflict in his genuine feelings toward human relations as well as constant self-denigration, and disillusion with a corrupted *jianghu* world. He says multiple times, "Like most things, I am nothing. It's the same for this sword. It's just the state of mind."

The freedom Jen has always longed for in *jianghu* soon becomes disillusionment. The utopia of a complete freedom does not exist because human relations are still ultimately bonded with responsibility, honor, and loyalty, principles that martial arts warriors need to follow. By focusing on the role conflicts, the film challenges audiences' assumptions of socially accepted moral paradigms, contrasting Shu Lien and Mu Bai with the social villains Jade Fox, Lo, and Jen. When an imagined moral paradigm actually performs as a burden and social constraint, it becomes disempowering and problematic. Mu Bai, Shu Lien, and Lo embody intense sadness and agony that clearly demonstrate a profound ambivalence—that is, men could suffocate, suffer, and even die from the rules they create. The socially constructed principles of norms and standards that serve morality or justice could be a double-edged sword, which can both free humankind and constrain it. The argument can be made that this ambivalent approach brings an alternative paradigm, a critical and somehow anarchic viewpoint into the film.

Reconfiguring Gender Politics

All fighting scenes center around the female fighters, who possess martial arts skills and who are capable of competing with, and, most of the time, defeating men. Instead of being portrayed as the embodiment of the traditional, feminine role of beings who are weak and dependent, or who serve only as sex objects, female characters in this movie are strong and rebellious. Female power is best manifested

through the fighting sequences between Jen and Lo in the Gobi Desert, between Jen and a group of male bandits in a tea stall, and between Jen and Shu Lien in Yuan Security. To stress the artistic aspect of martial arts fighting sequences, Ang Lee uses slow motion and poetic movement. These techniques, combined with the grand rhythms of Tan Dun's drum performances—such as "Night Fight" in the musical score—highlight Eastern aesthetics.

The presence of such gender politics in *Crouching Tiger* is not a coincidence. In the Chinese *wuxia* genre, hero and heroine warriors are not two mutually exclusive subjects; rather, it is common for them to coexist, as Kim (2006) pointed out. The depiction of female warriors also has a long history in Hong Kong's *wuxia* genre. Though such characterizations may be new to Western audiences more accustomed to cinematic fare that compounds certain Western feminist perspectives based on a stereotype of passive Asian femininity, this egalitarian perspective cannot be attributed to modern, Western discourses on feminism. As Kim (2006) suggested, though "orientalism inevitably serves as most U.S. viewers' framework for understanding" (p. 1), feminism is not necessarily why such representations take place. As Logan (1995) also remarked,

> Contrary to the Western perception of Chinese culture as chauvinistic in the extreme, Eastern cinema has featured an extraordinary number of women warriors compared to Hollywood. Tinseltown has long since relegated women to the stereotypes of victim, prize or queen bitch, whereas Hong Kong actioners have always featured fighting females doing battle with the menfolk on an equal footing. (Logan, 1995, as quoted in Kim, 2006)

Ang Lee posits that he is particularly interested in representing strong female characters in his films, as he specifies that "it is just to destabilize a stereotypical impression of Chinese females who have long been portrayed as the different gender tension in traditional Chinese culture and Chinese societies" (Zhang, 2002). Such deployment of female power does not necessarily intend to impose a postfeminist theory to attract global (especially Western) audiences (Wu & Chan, 2007) but is more of a tactic to destabilize Westerners' long-term Orientalistic imagination of the exoticized, fetishized, and racialized Chinese Other, and particularly, of passive Asian femininity.

While some scholars argue that Chinese female action figures disrupt masculinity, such arguments embody the imposition of Western gender politics on such a genre. In the early period of classic Chinese films, the representation of ambiguous gender roles was omnipresent. It is more common and "natural" to see cross-dressing in traditional Chinese theater, such as in Huangmei Tone[1] performances

1 Huangmei opera is also known as Huangmei Tone. Originated as rural folklore and dance, Huangmei Tone has existed in Taiwan, Mainland China, and Hong Kong. In Chinese operas, traditional, cross-gender performances are very common and typical. The all-male troupe did not exist in Huangmei performance prior to 1940 (See-Kam, 2007; Siu, 2006).

like the 1953 opera, *Liang Sanbo yu Zhu Yingtai (Butterfly Lovers).* While studying the kinesthetic movements in Chinese action films, Anderson (2001) remarked that Chinese martial arts movements are hard to divide into masculine or feminine. Additionally, the open acceptance and the great popularity of ambiguous gender roles and cross-gender performance in Chinese opera traditions reflect the intrinsically different attitudes between Chinese and Western audiences. This point also explains the different perceptions of *Crouching Tiger,* which is predominantly favored by Westerners but not necessarily by Chinese audiences. This will be discussed in the sections that follow.

Ang Lee's Culture (Con)fusion and Mimicry

As a globalized cultural production, *Crouching Tiger* indeed embodies a strong sense of transnationalism: it was financed by the U.S.-based Sony Pictures, based on a Chinese *wuxia* novel, produced by Taiwan and Hong Kong, shot in diverse and breathtaking landscapes in Mainland China, and distributed worldwide. Additionally, a Pan-Asian characteristic is also evident in the cast, comprised of actors from Hong Kong, Malaysia, Taiwan, and Mainland China. The music is played by Chinese American musicians, Yo-Yo Ma and Coco Lee. As a world citizen, Ang Lee pointed out that there is a global implication. In other words, if America is indeed a desire, what about the dream of a united, pure, cultural China or perhaps a "pan-Chinese identification"? And, what exactly is a *global implication* for a citizen living in a borderless world?

In many of his interviews, Ang Lee maintains that his traditional Chinese upbringing and the rootless experiences as a *wai-sheng-ren* (people from outside of Taiwan province) in Taiwan, combined with living as part of a Chinese diaspora in the U.S. enable him on the one hand to desire and grasp for a cultural root, yet, on the other hand, simultaneously to question it. In other words, a cultural root becomes a constructed *survival tactic,* empowering and enabling connections of humanity and solidarity rather than just an unchangeable entity. It becomes a means for some, especially diasporic subjects, to achieve agency. Ang Lee explains that the desire to make a martial arts film such as *Crouching Tiger,* an international and/or transnational film, comes not only from a nostalgia for *classic* China but also from his sense of being a *world citizen.* He views it as a good exercise to "make it reasonable for a worldwide audience—not just a western audience—a worldwide audience and to some degree a modern Chinese audience as well" (Lee, as quoted in *Guardian,* 2000). To him, it is a test, examining his ability to tell a story with a global sensibility.

By employing a transnational marketing strategy, working with Pan-Asian actors and combining local and international resources and professionals, it is obvious that Ang Lee's ambition is to move production beyond nation-states, and

to globalize it. Embodying a (con)fusion of syncretic cultures, he always attempts to reconcile disparate and sometimes *incompatible* values, finding coexistence amongst them. His philosophy of *balancing* two seemingly mutually exclusive or opposite values is translated into the film production. Paradoxically, the balance of "differences" is simultaneously based on a belief of universal humanity. He said in an interview, "I think people are universal" (*The Guardian*, 2000). To him, humanity, relationships, emotions, and progressions are shared universally by humankind. Thus, these are the primary elements that we, as viewers, are drawn into.

Ang Lee's conceptions of ancient China, a sense of connection to its history and culture, are reflected through the process of filmmaking. In other words, a sense of connection is mediated through film making. Lee constantly addresses the fact that his culturally mixed background—the traditional Chinese upbringing coupled with his diasporic status as a Chinese person living in New York—is deeply reflected in his filmmaking.

> Personally, coming from Taiwan, I hate to be categorized . . . all the ethnic, they all expect you to do one thing or another, and I am desperately trying to jump out of it. And each time I make that leap, I am stretching myself. So I still want to be who I am, but not who I am at the same time. (Ang Lee, *Museum of the Moving Image*)

This quote illustrates the sense of cosmopolitanism which is transcendently polarized or drawn from a culturally particular experience.

Being a member of a Chinese diaspora, the (re)creation of an imagined homeland and culture involves a hybrid mimicry process. Through such a mimicry process, instead of merely submitting to an ideological compromise, autonomy and agency are painstakingly negotiated, even though they are practiced within a constrained, global, capitalist film market. Lee said in an interview, "Who I am, how I was brought up, I use that a lot in my work. I feel that deep inside of me; there's a mistrust of depending on things. Everything changes; that's the essence of life. It's kind of Taoist. At a certain age, every Chinese person thinks that way. That's our belief; that's our faith." As Ang Lee also explained, making *Crouching Tiger* fulfilled his boyhood dream, a dream of a cultural China that never existed (Lee, quoted from Yang, 2005). As presented in most of his films, a complete freedom or self-agency is always closely intertwined with a social structure. *Crouching Tiger* signifies a painstaking cultural negotiation and/or a breakthrough of a binary of ancient Chinese arts and philosophy with modern Western technology (cinema); an imagined homeland with an adopted host country, the local with the global.

Personal history interacts with the present, reflected through an intensely nostalgic longing for the *loss* of "culture." As a diasporic film director, there is a yearning to accomplish a cultural burden, to present qualified, authentic, tradi-

tional Chinese films to global audiences in order to glorify Chinese films and the culture (Zhang, 2002). Such nationalist sentimentality is not uncommon among diasporic subjects, especially when they occupy a culturally and politically inferior status in their host land as discussed in previous chapters. The *dream* of (re)creating a memory is partial, selective, and revisionary, to some extent fabricated and fraudulent. Ang Lee's diasporic subjectivity undoubtedly shapes a distinct version of transnational Chinese identity. I suggest that it is indeed the creative filmmaking process that subverts a static notion of "Chinese identity" and the nature of Chinese culture, reenvisioning and reshaping a specific culture within a global context. By examining Ang Lee's discourse on Chinese culture, one is able to gain further understanding of the ways in which his diasporic conditioning redefines and reshapes the *wuxia* tradition.

Discourses of Audiences

Theme one: Pan-Chinese cultural pride

The discourse of collective national pride for the people of Taiwan was evident in numerous newspaper reports after *Crouching Tiger* won the Oscar for the Best Foreign Language film. This study examines 29 articles written about *Crouching Tiger* in the *Epoch Times* and the *World Journal*[2] in 2001, after it won for Best Foreign Language Film at the Academy Awards. Ang Lee has been framed as "the pride of Taiwan" in almost all news titles and content regarding this award. With the consistent emphasis on Ang Lee's ethnic and national origin, he has been discursively constructed as a national hero. It is significant that Lee was honored by both former and current Taiwanese presidents, Chen Sui-bian and Ma Ying-jeou. In 2001, former president, Chen, made a personal visit to Lee and his family in his hometown of Tainan in southern Taiwan to honor Lee as the first Taiwanese national to win at the Academy Awards (Zhang, 2002).

Because of *Crouching Tiger*, Ang Lee has been referred to in news discourses and audience reviews as *a credit to all Chinese people*. The recurrent themes of Ang Lee's success as a Taiwanese national—the first Asian director who has received an Academy Award and numerous awards from international film festivals—preoccupy all the media discourses. The negative discourses predominantly focus on the question of the authentic portrayal of a *wuxia* story, or, by extension, *Chinese history, tradition, and culture*. When most of the news discourses praised *Crouching Tiger*'s groundbreaking achievement and elevated Ang Lee to the status of "national hero," audiences from Taiwan raised questions about the cultural representation of actors' accents and acting. As Kenneth Chan (2004) pointed

2 Both newspapers are very popular among Chinese communities in North America. More data were found in *Epoch Times*. Articles regarding Ang Lee and his films in the *World Journal* predominantly overlapped with news reports in Taiwan, because this newspaper is linked to *the United Daily News*.

out, films like *Crouching Tiger* carry the burden and responsibility of representing an authentic culture. I want to elaborate on this discussion of the ambivalent discourse of the audience by arguing that such reactions reveal a complexity of mixed emotions, national sentimentality, and anxiety about being Chinese in a postnational and transnational world order.

The discourse of collective cultural and national pride is also situated in an invariable emphasis on Ang Lee's "Oscar triumph," that is, his achievement of successfully introducing Chinese culture into the dominant Hollywood film industry in the West. The particular interest in his success overwhelmingly represents a mixture of cultural chauvinism and deference towards Western culture.

Film industries from Mainland China, Hong Kong, and other East Asian countries such as South Korea were inspired and eager to emulate the trajectory of *Crouching Tiger*'s success. For example, the most well-known and controversial Chinese Fifth Generation director, Zhang Yimou, commented that the *wuxia* film market created by Lee can "survive" for two or three years if there are more good *wuxia* films made in the market.[3] Later on, both of his *wuxia* films, *Hero* (2002) and *House of Flying Daggers* (2004), were blockbuster hits in the international film market. Zhang Yimou noted that Ang Lee's "inevitable" and unprecedented success in the West, especially the world-influencing Academy Award, brought a very high commercial value to the film market of Chinese cinema. Another example is that Chinese sixth generation film directors, such as Feng Xiaogang, aim to win Oscars in order to reach international audiences ("Chinese Director," 2006). The strong desire to be nominated for the Oscar for Best Foreign Language Film has driven the production team to speed up their work, following the success of *Crouching Tiger* and *Hero* (Havis, 2006).

Winning an Oscar is regarded as a grand achievement for the Chinese film industry, and, by extension, for East Asian directors. The international success of Ang Lee's *Crouching Tiger* brought enormous hope to the domestic film industry. An analysis in *China Daily* pointed out that the use of top transnational film workers, i.e., Chinese composer, Tan Dun, violinist virtuoso Itzhak Perlman, and cinematographer Christopher Doyle signifies Ang Lee's ambition of engaging in cross-cultural collaboration. Moreover, Hollywood Mainland kung fu movie stars are important factors, contributing to the world's attention (Sun, 2003). The reflourishing of the domestic film industry was precisely because of the international commercial success of these films. The argument implies that the Chinese film market has long neglected the public's taste, since directors preferred high artistic value. This resulted in a shrinking domestic film market. "The public has little interest in watching home-produced films and instead opts for those mainly coming out of Hollywood" the report stated. Here, one clearly sees that the public's taste has long been shaped by American Hollywood films. The critique of

3 *Southern Daily*, 24 November, 2001.

the domestic Chinese directors' films reflects a deep-seated cultural logic—the *intimate* relation of the Western film market and the non-Western audience. In other words, the cultural logic behind the commercial success signifies the fact that as long as a Chinese film is being recognized by a Western award, it is almost guaranteed popularity in the domestic film market. It is mainly through the recognition of the world market—especially Hollywood—that Chinese language films acquire some sort of authority, and to some extent, are "legitimated" and considered worthwhile to cultivate.

The success of *Crouching Tiger* has created a role model not only for Chinese directors but also for Asian Americans. Ang Lee was juxtaposed with other prominent Asian American directors who inspire the community, such as Wayne Wang and M. Night Shyamalan.[4] The recurrent theme of the news reports is the praise of Ang Lee's universal filmmaking skills. He is lauded for drawing international attention and for shooting stories outside of his own community. For the diasporic community, Ang Lee and his films are presented as the great *victory* and *glory* of the Chinese nation, and, by extension, Greater China, signifying a *unification* of the ethnic Chinese community. The article entitled, "*Crouching Tiger* Makes South Africans Admire Chinese Communities" (2001), described the popularity of the film among both the Chinese diasporic community and South African audiences. Similar to another news report that compared Ang Lee with other Chinese diasporic directors who are well known for their Asian American subjected films, it juxtaposed *Crouching Tiger* with the films of Chinese kung-fu movie star, Bruce Lee, shown on E-TV in South Africa. The report stated:

> There is an oral story/rumor being passed around in South Africa. During the racial segregation era, South African blacks have admiration and respect for the Chinese community because of the fact that Bruce Lee always defeats the whites in kung-fu movies. Hence, after winning the Academy Award, Ang Lee's *Crouching Tiger*, South Africans will have more respect for Chinese. ("*Crouching Tiger* Makes South Africans," 2001)

The term, "South Africans," used in this report, indicates the non-Chinese community. Films and cultural icons, such as Bruce Lee and Ang Lee in this case, become a medium through which viewers project their unacceptable desires and private fantasies, transforming them into culturally acceptable meanings. The introjection and projection of one's desires form a symbolic cultural nationalism, which represents a symbolic reaction to experiences of physical rejection and exclusion in the local society.

To illustrate, the news reports I examined included film critiques and analyses of Ang Lee's success. The recurrent theme of the news discourse was critical ex-

4 Chinese director pins his hope on an Oscar, *China Daily*, 8 February, 2006. Retrieved from http://www.highbeam.com/doc/1P2-8848128.html.

ploration of the ways in which his success in the West could bring glorification to all Chinese communities. In one article, Ang Lee specifically pointed out that the winning of the Academy Award symbolized that Eastern culture, such as Chinese culture, was not only recognized but also accepted by the West; it is a cultural phenomenon ("Ang Lee: Sharing the Honor," 2001). It is worth noting that the exceptional examination of the international marketing strategy of *Crouching Tiger* by major U.S. newspapers, such as the *Wall Street Journal* and *The New York Times*, was constructed as another milestone for reverse cultural flows from the East, in this case, the Ang Lee phenomenon. From the Chinese audience's perspective, the emphasis on the rarity of Asian directors whose works were reported on and analyzed by the prestigious U.S. media elevated the great achievement of Ang Lee.

Permeating the news discourse is a sense of a revival of Chinese cultural nationalism formed within a context of a long-term ambivalent relationship between China and the U.S. For the Chinese community, Hollywood has long been conceived as a competitor (or the most intimate enemy) to be defeated, as expressed by the title of a report, "China: Winning Global Audiences" (2001). However, such "defeat" is simultaneously based on the mimicry of Western filmmaking and marketing strategy, and a film is deemed successful if it first garners the recognition of Hollywood. Moving beyond the film market, to echo the discussion in chapter one, such a phenomenon indicates that the West has been subjectively constructed by Chinese communities, which desire to define their self-identity according to the standard created by the West and constantly compare themselves with the West, both consciously and unconsciously. In other words, such comparison is inevitable; that is, it is the essential process of constructing a *national identity*, as discussed in previous chapters.

The central, structuring argument also reveals a long history of the local culture and domestic film industry being infiltrated by the American pop culture empire. It is therefore not too surprising to see the rampant cultural nationalism following the international success of the transnational films of Ang Lee. While *Crouching Tiger* was predominantly favored by Western audiences, it generated lengthy discussions on the cultural representation of Chinese *wuxia* films among audiences in Taiwan, Mainland China, and Hong Kong.

Theme two: Bridging the East and the West

The second theme that is expressed throughout the audience discourses is the cultural achievement of *Crouching Tiger*, which bridges Eastern and Western cultures. From the discourses, Eastern aesthetics has been constructed as a Pan-Chinese aesthetics whereas the West is generally perceived as U.S. or American culture. Taiwanese audience member, okbom (2000), stressed that the film incorporates the character Jen as a symbol of the Western concept of "freedom,"

whereas Mu Bai and Shu Lien symbolize the traditional Chinese literati who are emotionally reserved.[5] Okbom continued

> Zhang Ziyi represents part of the American cowboy spirit—to be expressive, love freedom, and pursue dreams. On the other hand, Mu Bai and Shu Lien are constrained by social conventions, and therefore they both are very repressed and unhappy with their lives. Ang Lee questions both core cultural ideals, as the story ends in tragedy. Searching for a balance between the two cultures is the lesson he provides for the viewers. Throughout this film, Ang Lee wins Westerners' attention, opening up a window for them to understand the sophistication and beauty of Eastern philosophy. . . . Winning Academy Awards means the affirmation of our culture in the world.[6]

Overseas Chinese audience members, such as davilee, reinforce the idea that *Crouching Tiger* bridges the knowledge gap between the East and the West.[7] "Ang Lee presents Chinese culture for the Western audiences," davilee noted. In his critique, Chinese audience member, Kai (2006), remarked,

> *Crouching Tiger* becomes a model for many local Chinese directors such as Zhang Yi Mou. They are eager to produce more Chinese *wuxia* films to expand into overseas markets. Now the critical issue is we should consider the ways in which we present our Chinese on screen, and to let Westerners who haven't been exposed to our culture understand different layers of Chinese culture. It is difficult because to some extent we do need to *simplify* our language in order to be understood. "Cultural translation" becomes an issue. . . .[8]

Taiwanese audience member greenbug (2000) reiterated that *Crouching Tiger* should be a good resource to educate non-Chinese audiences about the specific culture.[9] In his post, he encouraged local (Taiwanese and Chinese) audiences to take their "foreign friends" to introduce them to Chinese culture, as it is also a good opportunity to conduct a cross-cultural exchange. A film critique in *Epoch Times* explicitly pointed out that Ang Lee's diasporic background enables him to be familiar with both American and Chinese audiences' preferences and tastes in films. The flexibility of the script and English subtitles both facilitate international audiences' understanding of the film. Chinese audience member yunyeh (2008) asserted that "the mysterious Eastern culture presented in the film evokes Westerners' curiosity. *Crouching Tiger* further shapes a future paradigm of martial arts films."[10]

5 Retrieved from bbs://bbs.ntu.edu.tw
6 Retrieved from bbs://bbs.ntu.edu.tw
7 Retrieved from http://culture.zwsky.com/n/200801/23/199716.shtml
8 Retrieved from http://blog.sina.com.cn/s/blog_4ca9b1b50100anbc.html
9 Retrieved from bbs://bbs.ntu.edu.tw
10 Retrieved from http://www.mtime.com/group/live/discussion/144411/

Considered collectively, audiences consider the major achievement of *Crouching Tiger* to be the aspect of "recognition." That is, audiences share a collective emotional sentimentality and ambivalence about the success of the film. It is a profoundly mixed feeling. On the one hand, Chinese audiences are proud that their culture is finally being appreciated in an international market; on the other hand, the discourse invariably embodies a sense of cultural chauvinism, namely, the constant defense of Chinese culture and repetitive statements about Westerners' presumed difficulty in understanding Chinese philosophy. Such ambivalent emotions are revealed throughout various audience discourses. Oftentimes, the discourse of "bridging the East and the West" can also reproduce a distinct binary opposition of both cultures.

Theme three: (Re)constructing the wuxia world and a cultural China

While many fans are fascinated by the cultural representation of *Crouching Tiger*, the "authenticity" of the represented *wuxia* world is a much-debated topic in the audience discourse. The discourse also surrounds Ang Lee's portrayal of repression, which was discussed previously, since *wuxia* is a popular cultural genre that stimulates Chinese people's imaginations and is derived from a shared history and collective memory. Such a collective cultural imagination holds significance. Before engaging in a detailed discussion of the audience's debate of the *wuxia* genre, we should have a firm grasp on the genre.

Wuxia pian is commonly known as Chinese martial arts films, a cinematic genre developed in the Hong Kong film market in the 1960s. Ang Lee drew on the *wuxia* tradition, yet developed it into a modern format by combining martial arts, traditional and modern language, classic Chinese dancing, opera, and music. We want to have a brief understanding of *wuxia* before we further discuss the film. *Wuxia* is a cultural world with a tradition dating back more than a thousand years and exists in the popular imagination of Chinese-speaking communities. It is a traditional Chinese literary genre that has been transformed into various cultural forms, such as television dramas, films, comics, operas, and so on.

Wuxia originally referred to a literary genre that has a history of fiction and a long tradition in Chinese popular TV series and films, combining "historical facts [with] folklore and legends about the heroes who fought against unjust rulers and the corrupt legal system" (Lee, 2003, p. 283). The *wuxia* world predominantly features male but sometimes female adventures. In Chinese, *wu* literally means martial arts; it usually signifies a powerful warrior who possesses martial arts training and skills, and who searches for ultimate justice and righteousness in order to help eliminate oppression. *Wuxia* is a world where a *xia* (swordsman) is searching for knightly chivalry. It has been considered a macho genre. In the *wuxia* world, swordsmen with strong and supreme martial arts skills usually have extraordinary powers to defend the rights of the helpless and the oppressed, carrying out acts of

righteousness on behalf of the poor and the disadvantaged. In essence, the spirit of *xia* is heavily influenced by various ancient Chinese philosophies—Confucianism, Buddhism, Taoism, and Moism (Lee, 2003; Lo, 1990). Based on such a premise, the fantasy world of *wuxia* heroes and heroines has become one of the most popular Chinese genres.

Wuxia fiction, according to Lee (2003), provides "an imaginary world away from the harsh reality caused by political turmoil and economic as well as social upheaval" (p. 283). *Wuxia* fiction reached its climax from the 1920s to 1940s (Lo, 1990). During that period, writers experimented with new ideas such as adding romance, fantasy, and a detailed description of the landscape and urban settings, to enrich narratives and construct a fantasy world for ordinary readers (Lo, 1990). For viewers, *wuxia* is a popular genre onto which they project their feelings, emotions, imagination, and sometimes frustrations with the government, while seeking comfort in *wuxia* fantasy culture. *Wuxia* stories usually feature a specific historical period, with characters wearing appropriate period costume (Lee, 2003).

Wuxia films originated from *wuxia* literature. Most *wuxia* films are adapted from popular *wuxia* novels by *wuxia* maestros such as Jin Yong or King Hu. Swordplay characterizes martial arts films developed from the Cantonese-based Hong Kong film industry. Swordplay martial arts films, as Bordwell (2000) pointed out, comprised the early Hong Kong cinema. They became a mass-produced, commercial genre of film export with broad audiences, including East and South East Asians, overseas Chinese communities, and Westerners. Hong Kong *wuxia* films predominantly feature fast-paced action, stylized fighting, magical effects, and fantasy swordplay. Story plots usually are based on distinct characters—villains and superheroes—and embrace the values of loyalty and faithfulness. Plots of vengeance, competitions for the highest rank of martial arts skills, sensationalism, and vigorous fighting sequences play essential roles in the Cantonese *wuxia* films (Bordwell, 2000; Lee, 2003). Viewers watch *wuxia* dramas mainly for visual pleasure and sensationalism. Hong Kong *wuxia* films often draw much criticism because of their strong emphasis on violence and fighting. Due to the fact that they are predominantly low-budget products, they are also critiqued for their low aesthetic and artistic values. Ang Lee's *Crouching Tiger*, in contrast, provides an alternative layer of meaning for the genre of martial arts film, disrupting a traditionally preconceived notion of Chineseness through his transnational reinterpretation.

Wang Du Lu's novel, *Crouching Tiger, Hidden Dragon*, is a five-part series. Wang's style emphasizes humanistic concerns and the characters' inner worlds; his work elaborates on the characters' dramatic emotions, feelings, and romantic plots in greater detail (Lee, 2003). As *Crouching Tiger* is condensed and adapted from Wang Du Lu's work, Ang Lee intends to introduce a more sophisticated portrayal of the romantic tragedy between a pair of lovers. This challenges the

dominant ideology of Chinese philosophy, developing nuances from traditional martial arts films and balancing Eastern and Western aesthetics.

Mixing Eastern and Western filmic philosophy (the translation and simplification of the original story from Wang Du Lu's novel) and employing a production team and actors from various Chinese-speaking regions, Ang Lee destabilizes a static conception of the *wuxia* genre. Such creativity, unsurprisingly, challenges Chinese audiences' responses, resulting in a series of critiques and passionate debates over the authenticity of the cultural representation of the *wuxia* world. While the film received an overwhelmingly warm reception from Western audiences in North America and Europe, the nonstandard Mandarin accents of the actors and actresses became important criteria for Chinese audiences to evaluate whether or not the production is an "authentic Chinese *wuxia* film." However, it is precisely the nonpurity of the spoken Mandarin accents that marks the transnational nature of the cultural product. Chang Chen is from Taiwan with a Taiwanese accent; Zhang Ziyi, who plays Jen, speaks Mandarin with a Beijing accent, and both Michelle Yeoh and Chow Yun Fat labor through their lines with a Cantonese accent. Although Zhang Ziyi and the soundtrack composer, Tan Dun, have actually lived in Mainland China, other principal workers constructed and articulated an imagined cultural China from their shared, collective memory of the land and their previous experiences with *wuxia* popular culture. As Berry and Farquhar (2006) asserted, the mixed accents and origins signify the ethnically diverse China and the Chinese communities in the diaspora. Through the accented Mandarin and the nontraditional (or inauthentic) way of repackaging a *wuxia* story, *Crouching Tiger* could be considered a product of the transnational Chinese diaspora.

Suona (2009) from Taiwan described her viewing experience, saying,

> I have seen the film five times and not until the third time, did I really appreciate it. We are so used to fast-paced Hollywood movies that we no longer are easily able to appreciate alternative films. Ang Lee presents a very real, down-to-earth style of Chinese culture, featuring ordinary people. There are no fancy clothes, luxury, or magnificent buildings, but only a realistic reflection of people's frugal lifestyle at that time.[11]

Madgic (2006) commented on the detailed shooting of the fighting scenes:

> Ang Lee brings a refreshing perspective of martial arts by concentrating on sophisticated fighting sequences and styles. For example, I love the bamboo forest fight where Mu Bai and Jen stand on bamboo stalks, and the nighttime chase when Jen cross dresses in a black outfit as a male thief, leaping up to the roof, running across walls and trees, being chased by Shu Lien . . . these fighting se-

11 Retrieved from bbs://ptt.twbbs.org

quences make this film remarkable compared to other coarse *wuxia* films . . . the scenes are astonishingly beautiful. . . .[12]

Gnrx (2006) also remarked, "I was completely astonished by the fighting scenes and the 'gravity leaps'; they are the most beautiful fights I have ever seen in *wuxia* films!"[13]

While some audience members appreciated Ang Lee's reconstruction of *wuxia* fighting scenes, there were viewers who critiqued the fighting scenes and the dialogues, stating that they found them exaggerated and inauthentic. Audiences debated whether or not the representation was made to pander to Westerners' craving for exoticism. To echo previous analysis, the heated debate on cultural authenticity was always in a comparative mode; that is, audiences were mainly concerned about Western audiences' (mostly from North America and Western Europe) perception of the nation, as the discussion predominantly focused on the winning of the Academy Award. Taiwanese audience member conbar (2006) offered the critique that Taiwanese audiences exaggerate the impact and the performance of *Crouching Tiger* based simply on its popularity among Westerners, especially in the U.S.[14] Conbar said, "It seems that our confidence is based on Americans' approval."[15] Such an argument is not uncommon. Taiwanese audience member zeox (2006) pointed out the inauthenticity of the dialogues. He said,

Much of the dialogue is created to appeal to Westerners. I don't believe that the ancients spoke in this way. . . . I guess the screenplay is written in English and translated back in Chinese. The translation of the subtitle is very funny!!! Mu Bai's last line to Shu Lien 'I have always loved you' is very modern and fake . . . plus we can see the wires behind the actors' back in those fighting scenes, they jump too slow and are not realistic . . . the scenes last too long . . . Jen's crossdressing thief role reminds me of Tsui Hark's *wuxia* classic film *The Butterfly Murders* . . . Lo's clueless dialogues in the film also make audiences laugh out loud, his look just doesn't match his role in the film. . . .[16]

Audiences compare Ang Lee's movies to conventional Hong Kong *wuxia* films such as the most well-known director Tsui Hark's classic works, *New Dragon Gate Inn* and the *Shanghai Blue* or the most well-known Kung Fu series, *Hwang Fei-Hung*. In other words, for some fans, the Hong Kong *wuxia* film genre is the prototype judged as the standard of authenticity by which to evaluate Ang Lee's interpretation of *wuxia*.

12 Retrieved from bbs://ptt.twbbs.org
13 Retrieved from bbs://ptt.twbbs.org
14 Retrieved from bbs://ptt.twbbs.org
15 Retrieved from bbs://ptt.twbbs.org
16 Retrieved from bbs://ptt.twbbs.org

Taiwanese audience members appleapple and gly (2000) noted that the dialogue in the film sounds very unnatural.[17] Gly said,

> Ang Lee uses Western notions to tell an Eastern story. The culturally hybrid representation of the story makes the film neither purely Western nor Eastern. The gravity leaps are not authentic, and seem like the American film "Casper," or vampires, something like that. Plus, the architecture is not Chinese; for example the palace looks like a European castle with a semi-Eastern appearance . . . all in all, this film may be novel for Westerners, but not authentic for Chinese.[18]

Audiences from Hong Kong critiqued the slow-paced fighting which did not have much action and consider the films boring and unnatural. Antiach (2000) noted that "the dialogues do not sound like what people would say at that time; they are very contemporary conversations, and they sound very bookish and genteel. Michelle Yeoh and Chang Chen speak Mandarin very robotically."[19] Besides the perceived "inauthentic" gravity leaps and certain martial arts scenes, actors' pronunciation of Mandarin was also critiqued by audiences.

Taiwanese audience member, sylvax (2000), expressed dissatisfaction with *Crouching Tiger*, stating the following:

> Mu Bai and other actors' martial arts techniques are weak. Life-force and energy are not expressed thoroughly. Hong Kong *wuxia* film master Tsui Hark probably knows traditional Chinese theatrical opera and acting better as we can see from *Peking Opera Blues*, etc. Perhaps incorporating more Beijing Opera would make this film more "Chinese."[20]

Again, Ang Lee and his diasporic background are constantly compared to Hong Kong *wuxia* master Tsui Hark and his works, with the aim of evaluating whether or not *Crouching Tiger* is "Chinese" enough. In other words, the main criticism of the film from Chinese audiences focuses on the charge of Ang Lee's interpretation of *wuxia* in Western terms and the film's "self-exoticising" strategy, designed to attract Western audiences. However, Chinese audience member wenchingyu (2006) asserted that there was a valuable contribution made by *Crouching Tiger*.[21] He suggested that this film encouraged more Chinese viewers to value and (re) search their cultural roots and to consolidate their cultural identity, which was once removed and destroyed by the Cultural Revolution. The film is perceived as a form of *cultural education*, not only for international audiences but also for Chinese themselves. The global popularity of *Crouching Tiger* indeed functions in the manner described by wenchingyu:

17 Retrieved from bbs://bbs.ntu.edu.tw
18 Retrieved from bbs://bbs.ntu.edu.tw
19 Retrieved from bbs://bbs.ntu.edu.tw
20 Retrieved from bbs://bbs.ntu.edu.tw
21 Retrieved from http://www.mtime.com/my/yuhailinlin/blog/17559/

For a long time, Chinese as well as other countries lack respect for the Chinese culture; Chinese themselves do not have a strong emotional attachment to the cultural tradition. Following the increasing "modernization" and "westernization" of the nation, we gradually lose our attachment and understanding of moral, historical, and cultural values of ancients. It is as if Chinese civilization only has existed for the last thirty years, and doesn't include the previous five thousand years of history. I reread many *wuxia* novels after my first time seeing *Crouching Tiger*. Then I went back to watch it again and was able to connect it to other cultural references from classic *wuxia* works such as Jin Yong's classics *The Book and the Sword*, *The Legend of the Condor Heroes*, *The Smiling Proud Wanderers*, etc.[22]

Audiences view *Crouching Tiger* as a chance to reconnect to the essence of *wuxia* and Chinese culture. Additionally, the success of the film brings pride to the community, as, in the words of wenchingyun (2006), audiences "recognize how difficult it is to reconstruct a Chinese tale and translate it into a global visual image that could be appreciated worldwide." *Crouching Tiger* functions as an infinite, intercultural process and discursive communication site, through which audiences (re)affirm and co-construct the meaning of Chineseness as well as reflect on what it means to be a Chinese under current social circumstances. *Wuxia* values and traditional Chinese culture once again become topics of heated discussion about the moral challenge of contemporary Chinese life. Determining what constitutes an authentic Chinese culture is therefore an issue of cultural negotiation.

Theme four: Nostalgia and reflexivity

For most audiences from Mainland China, the representation of Chineseness in *Crouching Tiger* evokes an intense emotional and *nostalgic* resonance. Audiences spend much time discussing the landscapes, various classical Chinese cultural elements, and the *wuxia* genre in the film. Audience member Jason (2008) from Shanghai, commented that *Crouching Tiger* evokes a deep resonance for classic Chinese culture.[23] He said, "We as Chinese need to ask ourselves questions such as 'who are we? Where do we come from?' in order to engage a deep, thorough self-reflexivity of our cultural identity." He continued:

There are no exaggerated or phony Chinese cultural elements presented in the film. We see a very authentic historical setting presenting our ancestors' lives and further leading the viewers to a nostalgic dream. Ang Lee aims to bring the lost classic Chinese culture back to our memory. . . . We are so westernized that we seem to be no longer familiar with our cultural roots, which is why some people think this film is 'unrealistic'. . . . *Crouching Tiger* interprets a classic Chinese *wuxia* tale in a modern, Western cinematic way. This film also incorporates Ang Lee's personal dream of China. We see a traditional Chinese literatus' inner

22 Retrieved from http://www.mtime.com/my/yuhailinlin/blog/17559/
23 Retrieved from http://www.mtime.com/my/984824/blog/1326541/

world—reserved, merciful, and persistent—reflected in the struggles among the characters. Mu Bai and Shu Lien's consistent guidance and caring for Jen and Lo reveal their lifelong commitment of mentoring and . . . this portrayal reflects a larger context of Ang Lee's merciful and sensitive attitude towards other people's misfortune.

Crouching Tiger is considered a cultural product that passes down the essence of a five-thousand-year Chinese tradition and philosophy. A strong, nostalgic sense of the past and cultural memory and reflexivity are expressed throughout audience discourse.

Since *wuxia* is one of the most popular literary and film genres, audiences can easily relate to the characters and the story line. Most audience members watched *Crouching Tiger* multiple times and expressed the deep emotional resonance of their viewing experiences. It can be argued that one of the main reasons for the success of *Crouching Tiger* is the portrayal of the fictional characters, romance, fantasy, and Chinese philosophy in *jianghu*. All of the intertwined elements and perceptions subtly intersect to arouse a sense of cultural identification and nostalgic reflection. The film reflects a *lost* aspect of classic Chinese culture that used to be felt deeply by numerous members of the audiences, from China, Taiwan, Hong Kong, and overseas communities. The film therefore conjures cultural memory, evoking a longing for lost social vigor. Such nostalgic feelings should be contextualized as a general response to encountering Western modernity. China, especially, has been going through a dramatic socioeconomic reformation since the 1990s.

Chinese audience member, sololau (2008), commented that the representation of the fighting scenes in the bamboo forest translates the poetics of Eastern aesthetics into a visual language, since bamboo represents righteousness, which is a central spirit in the *wuxia* world. He said,

> We gain great visual pleasure and experience the real, concrete, authentic Eastern poetic feeling while watching the film. Jen and Shu Lien's fighting styles well incorporate the *ying* and *yang* of Taoism. I can't help but wonder about my own life after watching the film. What is the meaning of life?[24]

Taiwanese audience member, Quiff (2000), expressed his intense, nostalgic feeling toward *Crouching Tiger*. He noted,

> There must be many, many *wuxia* fans who are so moved to see the dream and fantasy of the *wuxia* world being presented on the big screen worldwide. The film reminds me of the good old times when I skipped class, secretly hiding under the bed (in order not to be caught by my Mom) every night in junior high school, reading Jing Yong novels again and again until I can almost remember every single line of the story. In fact, most of my knowledge about Chinese philosophy is from reading *wuxia* literature, not the textbook. . . . Through the

24 Retrieved from http://blog.sina.com.cn/s/blog_4b9f54530100an64.html

notion of *wuxia*, Ang Lee presents the essence of Chinese culture thoroughly and seriously. Compared to the Hong Kong *wuxia* commercial films, *Crouching Tiger* digs deeper into the conventions of the genre of the *wuxia* tradition. It contains all the essential elements such as inter-ethnic romance, cross-dressing fighter, Purple Yin poison, vengeance, sword fights, etc. I was so touched to see how vibrant the film authentically represented *wuxia*; I had tears in my eyes during the fighting scene of Jen and Shu Lien. . . . [25]

Respectively, some Taiwanese audience members stated their astonishment at how the "Chinese ink and wash painting"-like *wuxia* scenes were shown on the big screen. *Wuxia* fans also distinguish themselves from viewers who watch the film just to support transnational Chinese cinema. In their minds, this film represents more than a popular Chinese film but fulfills their nostalgic dream of the *wuxia* world.

Elliot (2000) remarked that audiences who are familiar with *wuxia* would understand the "aura" of the film, that is, he felt that Ang Lee expressed the fantasy world thoroughly. "I was so very moved to see the eloquent portrayal of sword fighting that I was in tears while watching it," Elliot said. He continued:

Western audiences must have a hard time comprehending the essence of the film, given that this is an entirely new and unexpected representation of Chinese martial arts . . . perhaps Chinese audiences could understand better, and Western audiences might merely see the exotic side of the other culture. I always expected Ang Lee would enhance the level of *wuxia* films by using astonishing special visual effects and he didn't disappoint me.[26]

Audience member sulfadiazine (2000) interpreted the film as an alternative representation of *wuxia*, compared to traditional Cantonese martial arts films. He commented that viewers may not be accustomed to the visual style of *Crouching Tiger*, given that most Chinese audiences grow up watching the "stereotypical *wuxia* films" that do not focus that much on drama and the inner world of characters but more on fast-paced fighting styles. Ang Lee's inclusion of geographic and ethnic diversity preserves Wang Du Lu's expansive and inclusionist view in his novels. Yet, since such inclusion of ethnic and regional diversity has rarely been presented in previous *wuxia* films, the debate on cultural authenticity has been raised across audiences from different Chinese communities. This point will be elaborated on in the next section.

Fan Jazzy (2000) also noted:

Even though there are places that could be "problematic" such as free running, the slow-motion fighting scenes that do not match the typical *wuxia* warriors' fast-paced actions, the film yet accurately presents a delicate, vigorous portrayal

25 Retrieved from bbs://bbs.ntu.edu.tw
26 Retrieved from bbs://bbs.ntu.edu.tw

of fanciful images on screen, bringing the beauty of Chinese martial arts into the international film market. This film brings back one part of our long lost and treasured classical Chinese culture, which was once popular in our parents' and grandparents' generations! I was so absorbed in the film that I was in tears while watching the film. . . . *Crouching Tiger* regranted the dignity and respect that *wuxia* films deserve. . . . We should be so proud to see a film on screen which can really awaken and remind us of the beauty and significance of traditional Chinese culture, and hence to be more confident to be Chinese.[27]

Chinese audience member raison_detre (2005) argued that the film aims to present a wonderful balance of drama and action, and a combination of folklore, legends, and historical facts. He continued:

An ideal world of the ancients and Chinese literati is a world in which one is well versed in both martial arts and literature. The fusion of Taoism, Buddhism, and Confucianism represented in the film speaks to Ang Lee's dream of a united cultural China . . . it is also a dream of a huge fan of *wuxia* like myself, being extremely moved by the cultural representation . . . it is also a collective dream of the majority of Chinese who share a nostalgic longing for a disappearing ancient Chinese culture and value . . . *a China that is fading away in our heads.*[28]

The above statements reveal ambivalent emotions about the film—a combination of melancholy and delight. On the one hand, the cultural discourse of *wuxia* in *Crouching Tiger* plays a crucial role in strengthening a sense of self-identity. Yet, on the other hand, it provides a source of self-reflexivity, that is, the questioning of an essential discourse of Chinese identity.

The discourse of Chinese audiences demonstrates the dream of the *wuxia* world that is deeply embedded in many people's lives, as a "root" of Chineseness. Audience member raison_detre (2005) stated, "I believe that Chinese who really love traditional *wuxia* would be deeply moved by the film, and understand the collective dream of China that is surging in our blood as Chinese." Further, he argued that the spirit of *wuxia* has long been part of Chinese culture, representing an old China:

It represents the traditional moralist value of China, and yet it is disappearing . . . we love the film because we long for our past, the lost Chinese cultural spirit. The old moral values and martial arts spirit are just like bones and blood to our human bodies. They are symbols of Chinese culture.[29]

Another Chinese audience member said,

27 Retrieved from bbs://bbs.ntu.edu.tw
28 Retrieved from http://www.mov8.com/dvd/freetalk_show.asp?id=28041
29 Retrieved from http://www.mov8.com/dvd/freetalk_show.asp?id=28041

Toward the end of the film, I can't help myself but cry. . . . It is the sense and the aura of solitude and repression, and the intense emotions presented in the film that touch me. It forces me to reflect back to my own life.[30]

Davidgood (2006) responded, "I fell in love with the film the first time I saw it. The struggles between social obligation and personal freedom reflect my own gay identity."[31]

The above discourse is filled with a strong sense of longing for the past, and passionate emotions about personal life experiences. Essentially, the audience discourse is imbued with nostalgic melancholy over a lost past. Such nostalgia should not simply be condemned as a tainted version of history or cultural memory, nor should it be dismissed as discontent or as a merely complacent and reassuring sentiment in this context. On the contrary, it reflects a complex, ambivalent emotion toward not only the past but also the present and the future. Boym (2001) examined the effects of postcommunism in postsocialist Europe and Russia in her work, *The Future of Nostalgia*. Nostalgia, as she explicated, "shared some symptoms with melancholia and hypochondria" (2001, p. 5). According to Boym, there is a distinction between "reflective" and "restorative" types of nostalgia. Restorative nostalgia evokes a collective national imagination and past that is recoverable and returnable, whereas reflective nostalgia concerns the personal, collective, and affective cultural memories that are ambivalent, ironic, inconclusive, fragmentary, ambiguous, and compassionate (Boym, 2001).

To borrow the distinction, in this case I contend that the audiences' nostalgic reflection is more reflective than restorative, yet, at the same time, it seems to be a combination of both. That is, even though *wuxia* is an imaginary cultural world, it represents a quintessential, ancient Chinese value that contributes to a collective national imagination. Ambivalence arises from a sense of longing for a lost, preexisting society that pre-dates the modern reformation. Audience discourse of such reflective nostalgia, in this sense, also implies critical reflection. It signifies an intersection of personal and collective cultural memories with an enduring past that is evoked, invoked, and remembered through the images of *Crouching Tiger*.

For audiences from Mainland China, nostalgic sentimentalism in relation to the vanishing of traditional values in a "postsocialist" China is particularly intense. Given the political turmoil in China and Taiwan and the increasing Westernization of both nations, such yearning for the past embodies a critical reflection on "the good old days." In the age of "post Material China," to use a term coined by Huang (2000), Chinese people experience tremendous economic and social transformation from the old system of a "planned economy" to a market economy

30 Retrieved from http://www.mtime.com/group/live/discussion/144411/
31 Retrieved from bbs://ptt.twbbs.org

(as quoted in Lu, 2007). Emotional uncertainty and insecurity accompany such urbanization and industrialization. Materialistic desire characterizes almost every action in the nation. As Huang (2000) pointed out, Chinese are now struggling "to build their own consumer culture while dealing with their loaded historical past such as thousands [of] years of cultural residue and the more recent political turmoil such as the Cultural Revolution" (Huang, 2000, as quoted in Lu, 2007, p. 150). Under the drastic socioeconomic transition, what substitutes for the quickly vanishing, ancient cultural values—such as Confucianism, traditional familial structure, and the old, collective and caring community lifestyle—is social alienation, the breakdown of interpersonal relationships, and endless materialistic desires that cause psychological confusion and moral dilemmas. The "urban generation" (Zhang, 2007), such as the film's audiences, therefore uses the cinematic discourse as a way to reengage in a moral ideal. The past, whether it is existing in collective memory or imagination, has been (re)kindled through Ang Lee's cinematic discourse. Such reliving of the past in memory revitalizes personal passions and contributes to a different understanding of Chineseness.

Crouching Tiger plays an essential role in reinforcing one's sense of "being Chinese" in a global world. It further contributes to a "cross-cultural" emotional solidarity, reconfiguring a collective cultural identity. In a broader sense, political ideologies divide Taiwan and Mainland China, due to the Civil War, yet through the audience discourse, a rare, united, and collective imagined Chinese identity has been reinforced and reformed. Nostalgia, as Palmer (2007) posited, "weaves together fantasy, consumption, and an emotionally colored interpretation of the past to create a 'new' yet seemingly continuous notion of identity" (p. 183). To put it another way, one can argue that *Crouching Tiger* becomes a site of intercultural connection for both nations, allowing Chinese of different origins to negotiate a collective sense of self. *Wuxia*, in this case, is conceptualized as an essential element that evokes emotional resonance about Chineseness in the past, becoming a source of inspiration and cultural connection. The nostalgic discourse articulates reflexivity, connecting the present to the past, and juxtaposes past values with those of the present, while vindicating the past. That is to say, *wuxia* is a site of Pan-Chinese collectivism.

Additionally, the fantasy world of *wuxia* has successfully been transformed into a cross-cultural, mediated experience. The realms of fantasy and consumption are inextricably linked in this cultural text, which references a commonly shared, pop culture experience of viewers. Appadurai (1996) once stated that collective imagination has a projective sense that creates an imagined neighborhood and nationhood. The intersection of restorative and reflective nostalgia represents a complex ambivalence. Indeed, Ang Lee follows the logic of the global economy in marketing consumable images of the traditional Chinese cultural icon for in-

ternational audiences. However, one should not overlook the impact that a cultural commodity actually has on the "local" audiences themselves.

Finally, cultural authenticity also becomes an ambivalent site; that is, what constitutes an "authentic" cultural China is fundamentally based on a constructed, imagined *wuxia* world that should be subject to interpretation. Hence, the question becomes: If, as some professional critics claim, *Crouching Tiger* is a cultural product of self-Orientalism that essentializes and/or fetishizes Chinese culture, what exactly should a nonessentialized and authentic cinematic discourse of Chinese culture be? The discourse of Chineseness in *Crouching Tiger* raises the debate on cultural authenticity, and broaches the discussion about bridging the East and the West.

Conclusion

Crouching Tiger indeed plays a crucial role in the history of cinema, shaping and reshaping a paradigm of "transnational Chinese cinema." Its ambivalent and ambiguous status speaks to the nature of a diasporic cultural production; that is, it is uncategorizable and indeterminate. Not only does the cinematic discourse of Chineseness in *Crouching Tiger* challenge a static notion of national identity, but it also repackages, re-envisions, and reshapes the paradigm of transnational Chinese films, and specifically the *wuxia* film genre. Audience members co-construct the meaning of Chinese identity and transnational cultural China and utilize the film as a discursive site to negotiate and renegotiate their cultural identity.

In this chapter, the argument is made that *Crouching Tiger* should be considered a site of infinite cross-cultural communication that generates enormous discussion across audiences, from professional film critics to online fan communities. The discourse of audience members reveals four themes: collective, Pan-Chinese cultural pride; bridging the East and the West; reconstructing the collective past and determining cultural authenticity; and finally, narrative reflexivity and nostalgia. Moving beyond the simplified criticism that primarily focuses on the self-Orientalism debate among professional critics, *Crouching Tiger* indeed provides both Chinese and non-Chinese audiences a site for imagining the nation, as demonstrated by the audience discourse. Online audience communities tour the *wuxia* culture and cultural China as represented in *Crouching Tiger*. By engaging the cultural text multiple times, they embark on various journeys of self-reflection and emotional resonance.

The different audience communities contribute various interpretations and meanings to Chineseness. It is indeed the various processes of interpretation that invite a productive cultural dialogue that furthers one's understanding of the disparate subjectivities and positionalities. *Crouching Tiger*, as a product of cultural syncretism, also signifies an ethnic minority artist's constant negotiation

of avenues of participation within a global context. Ang Lee's strong emotional attachment to his ethnic identity is transformed into a new *opportunity* to appreciate and critique the past—both the history and the positioning. Essentially, the *commitment* of his ethnic and national identity functions as a tactic to relocate his positioning within the ethnic group while participating in a transnational world.

The Discourse of Cultural and National Pride

The Ambivalent Discourse of Chinese Identity in Lust, Caution

In this chapter an exploration is made into the rich thematics of *Lust, Caution*, and I attempt to situate the analysis within a broader historical context. Interestingly, this film has received lukewarm reviews in the U.S., yet it has generated enormous, passionate, and divergent debates in Pan-Chinese regions, including Taiwan, Mainland China, Hong Kong, Singapore, and East Asia in general. The plethora of reviews ranged from the debate on the "naming" of the film, such as whether or not this film should be considered "Taiwanese cinema," to the nostalgic reconstruction of an old Shanghai city, and the representation of the history of the Second Sino-Japanese War.

Given the current political climate in China and Taiwan, the controversial portrayal of the national history triggered deep-seated patriotic resentment and outbursts of chauvinistic nationalism in Mainland China. Yet, it received uniform praise among Taiwan, Hong Kong, and overseas Chinese communities. The intense divergence of receptions from the Pan-Chinese regions indicates that the collective political consciousness of the national identity is at stake. The discourse of Pan-Chinese identity is therefore deconstructed, reconstructed, and punctuated by heated controversies.

One must examine audience discourse, not only to problematize the notion of Chineseness and antagonize, anger, or dispute it but to *understand* why and how perceptions are formed. Through the prevalent, passionate, public discourse

circulating around Ang Lee and his films, the Internet becomes a site for the fans to connect with (and sometimes to disassociate from) each other.

The chapter proceeds as follows: first, a textual analysis of *Lust, Caution*; second, the incorporation of Ang Lee's published interviews to understand his filmmaking processes and the cinematic construction of Chinese identity which is closely influenced by his diasporic conditioning; and finally, the comparison and contrast of various audience perceptions of the represented Chineseness in *Lust, Caution*, and the ways in which the audiences co-construct and (re)produce the notion of Chinese identity as a site of indeterminate ambivalence. Identification of the recurring themes expressed throughout the published discourses is made. These themes are then categorized in the sections that follow.

Only Through Performing Can One Reach the Ultimate Truth of Self

Lust, Caution unfolds in Japanese-occupied Shanghai in 1942 during the Second Sino-Japanese War (which is also known as the War of Resistance Against Japan and the invasion of Manchuria), under the collaborationist "puppet" regime of Wang Jingwei (1940–1945). It was a sensitive period that has rarely been explored by historians or portrayed in contemporary cultural productions. The story explores the ambivalent nature of love and betrayal, the blurred area of reality and fiction, nationalism and patriotism, the self and the Other.

The film begins with a somber establishment shot of Yee's residence, the headquarters of Wang Jingwei's government. Then the camera moves to the mahjong game in progress at Yee's, which is located at an elegant residence with numerous guards. Wong Chia Chi (Tang Wei), a sophisticated, well-dressed wife of a wealthy Hong Kong importer, also known as "Mrs. Mak," plays mahjong with Mr. Yee's (Tony Leung Chiu Wai) wife, Yee Tai-tai (Joan Chen),[1] and their elite friends. Ang Lee begins the film by building suspense and an eerie atmosphere. Yee is the security chief of Wang Jingwei's regime, the puppet state set up by the Empire of Japan. Wong plays a secret nationalist agent with a patriotic mission to assassinate Yee, who is viewed as a national traitor working under Wang Jingwei.

Playing mahjong involves a high level of skill, strategy, and calculation; the game functions as a metaphor, signifying the undercurrent of events in progress. At the table, four women—"Mrs. Mak," the hostess Yee Tai-tai, avaricious and grasping Leung Tai-tai, and young, attractive Ma Tai-tai gossip about politics, families, and business, switching between Mandarin and Shanghai dialects. They all dress in traditional Chinese cheongsam, wearing delicate makeup and nail polish, which effectively conveys their elite social status. The close-up shots of the

1 "A Tai-tai is a married woman with a certain social status—'Ma Tai-tai' means something like 'Madame Ma.'" (Lovell, 2007, *Lust, Caution*)

mahjong game clearly set the tone of the film, that is, suspenseful, gloomy, and repressed. The ladies are busy playing mahjong and they gossip incessantly about each other's lives. Coupled with the highly contextual jargon of the mahjong game, their gossip is also highly coded with metaphorical and nonverbal language, such as the expressions in their eyes, the lifting of one's eyebrows, and the smiles exchanged during conversations. Conversations range from collecting information and exchanging gossip, to comparing each other's wealth and husbands' businesses, signifying a subtle competition amongst the four women. Traditional Chinese snacks such as wonton soup, dried dates, and sticky rice are served. As the most common social activity, competitions among the players could be observed, from the size of diamond rings being flashed and the quality of fabric used to make their cheongsam, to makeup and manners. Cues about their real lives and social status could be picked up from the game itself.

By playing endless mahjong with the wives of Shanghai elites, Wong Chia Chi successfully earns Mr. and Mrs. Yee's trust. However, her repetitive losses of the game also signify her seemingly doomed status in her patriotic assassination mission. The film progresses to the scene in which Wong Chia Chi walks into a coffeehouse in Shanghai. She makes a phone call with coded language and then sits and waits for her secret resistance comrades to carry out the assassination mission. As mentioned previously, Ang Lee devotes great effort to re-creating an authentic historical setting of a 1940s Shanghai street scene. The New Commander K'ai's Café is located at the corner of Nanjing West Road and Seymour Street in the French Concession. The series of shops include Ping-an Theatre, the Siberian Fur Store, and the Green House ladies' clothing store all of which really existed in 1940 Shanghai. In interviews, Ang Lee says, "Everything is authentic, including the plate number on the rickshaws, or Buttonwood trees on Nanjing Road. We planted every single tree."

Putting tremendous effort and meticulous attention into achieving historical authenticity, Ang Lee and the crew traveled to Penang, Malaysia to reconstruct old Hong Kong streets from the 1940s. As Taiwanese cultural critic, Lung Yin-tai pointed out, Ang Lee transformed himself into a cultural ethnographer and anthropologist (Lung, 2007). While discussing the meticulous attention to detail evident in the décor, settings, and materials, Ang Lee talks about his memory of his family and father. Many of the costumes and décor of the Republic of China era are lost and can hardly be found. Actors and actresses went through a series of training sessions in order to become familiar with that era. For three months, they read Eileen Chang's works, her story about her most well-known husband, Hu Lancheng;[2] took language courses; listened to popular music; and watched popular movies of that era.

2 Chang's well-known first marriage. It is said that the story Lust, Caution is her autobiographical story with Hu Langcheng, who is also a prominent literary figure and official, serving briefly in Wang Jingwei's govern-

Nostalgia is invoked not only in the film but also in Ang Lee's interviews. By linking his personal memories of his father, family, and the nation to larger political and historical discourses of China, the fragmented parts of history are pieced together, mediated, and manifested not only in the film production but also in the filmmaking process. *Lust, Caution* becomes a site of mediation for his projected emotional attachment to, fantasy of, and affective desire for the history of China. He consistently speaks about his memories of his father, imagined classic Chinese culture, and the most turbulent era of Chinese history, during the Japanese occupation. The nostalgia that is invoked moves beyond a simple intention to please the West (or by extension international audiences) or to simply mimic Hollywood styles of Chineseness. But rather, he intends to revise and bring into question the long perceived, static notion of Chineseness and its historical authenticity.

The film moves forward with a long flashback sequence in 1938 to express Wong Chia Chi's journey from a young, naïve college student to a secret agent of the Nationalist Party (Kuomingtang), the government of the Republic of China. At Lingnang University where she starts her college life, she encounters Kuang Yu-min (Wang Lee-hong), who hosts a patriotic drama club that aims to perform various patriotic fund-raising plays to support anti-Japanese occupation resistance. Chia Chi was recruited, and a group of college students perform their first serious patriotic play at Hong Kong University. Kuang Yu-min once tells the fellow students that through performance, oneself is no longer a real self since it is acting. The play was a successful hit, and ended with a climactic scene when Wong Chia Chi shouts: "*Let me bow to you on behalf of our country, my dead brother, and our nation for generations and generations to come! China will not fall! China will not fall!*"

Choked with emotion and tears, Wong's trembling voice resonates around the hall. Audience members, with tears in their eyes, stand, clap, and shout "China will not fall." Here, nationalism and patriotism are deeply invoked by the climactic scene of the play. The group of college students, due to their patriotic spirit, and led by Kuang, later decides to develop an assassination plot to contribute to the war against Japanese occupation. Mr. Yee, working as special agent of the Wang Jingwei regime, is their target.

To the government of the Republic of China, individuals who appear to collaborate with the Empire of Japan are undoubtedly traitors and need to be killed. Wong Chia Chi is chosen to be the undercover agent, and to pose as "Mrs. Mak," a successful Hong Kong businessman's wife. She is required to approach Yee Tai-tai, and to insinuate herself into the social circle of the wives of the elites. In one scene, she is "assigned" to sleep with her fellow student from the patriotic drama club, for whom she does not have any physical or emotional attachment in order

ment. The couple was considered as traitors by some Chinese. They are both controversial figures in Chinese history.

to be familiar with the necessary sexual behavior that she will face with Yee and to perform as the wealthy, well-experienced, mature "Mrs. Mak."

However, the first assassination mission fails, as one of Yee's subordinates, Tsao, finds out their real status, and Mr. and Mrs. Yee move back to Shanghai. At this point, Yee is already deeply attracted to "Mrs. Mak." During that period of time in Chinese society, a woman's virginity and sexuality, to some extent, were considered to be as essential as one's life. Wong's forced sacrifice of her virginity indicates the severity of Chinese nationalism. This is not an endorsement, but rather, the very beginning of Ang Lee's challenge of nationalism. Ironically, the explicit sex scenes and the representation of a Chinese woman's sexuality in relation to seductiveness trigger criticism from some audiences, especially from Mainland China. By presenting the patriotic students' reckless mission (which inevitably results in failure), the film unpacks the always unquestionable patriotism and unfolds the complexity of humanity, the binary diction between moral and immoral, right and wrong.

Kuang and Wong reconnect after three years and resume their assassination mission. Yee and "Mrs. Mak" are therefore reconnected. Mr. Yee has become the head of the secret police department for Wang Jingwei's government, and is responsible for capturing and executing the resistance working for the government of the Republic of China (Kuomintang). "Mrs. Mak" and Mr. Yee develop their "love" into a deep, ambivalent, and emotional relationship through violent yet extremely passionate sexual relations. The line between love and hate is blurred. Their relationship further challenges the audience's perceived notions of what constitutes "normalcy" in love, echoing the title of the film "Lust, Caution." Wong has become greatly immersed in her performance as "Mrs. Mak," constantly oscillating and struggling between her performed role and her "true self."

In the name of nationalism, "loyalty" and "betrayal" need to be redefined, as they are usually presented as opposed to each other. On the one hand, loyalty to the Chinese nation is challenged after the head of the PRC secret agents, Wong and Kuang's supervisor, gradually reveals his true, selfish, and menacing face hidden under the mask of national loyalty. In other words, the notion of loyalty needs to be contexualized. Betrayal, on the other hand, is not a major issue, as long as it is done in the name of nationalism. For example, in a scene where Wong is meeting with Kuang and another skilled secret spy of the ROC government named Old Wu, Old Wu says affirmatively and emotionally to Wong, *"As an agent there is only one thing, loyalty. Loyalty to the party, to our leader, and to our country."* Yet, Old Wu did not keep his promise to deliver the letter Wong wished to send to her father in England. All the broken promises, unnecessary killings, and authoritarian political orthodoxy gradually shake her belief in the nationalist party and the nation.

Performing, for Wong, is no longer simply a performance. Wong immerses herself into the fictive role, yet she finds that she is not performing herself, but

instead *being and becoming a true self.* As she has slowly developed her passion toward Yee, she tells both Kuang and Wu about Yee:

> *He knows better than you how to act his part. He not only gets inside me, but he worms his way into my heart. I take him in like a slave. I play my part loyally, so I too can get inside him. And every time he hurts me until I bleed and scream before he comes, before he feels alive. In the dark only he knows it's all true.*

Through their passionate and sometime animalistic, violent sexual behaviors, they each release their oppressed "self." Beneath the lines exists an extreme ambivalence of identity; that is, through performing and imitating "something by nature cruel and brutal: animals, like her characters, use camouflage to evade their enemies and lure their prey" (Lee, as quoted in Lovell, 2007).

The three controversial sex scenes present the progress of Wong and Yee's relationship. The first scene is simply violent, sadistic, and animalistic, all about dominating and being dominated. Then their relationship progresses to be deeply emotional and passionate, yet, at the same time, conflicted for both of them. Yee must remain cautious, emotionless, because of the nature of his job, yet he develops a strong emotional attachment to Wong Chia Chi. For Wong, she performs "loving" Yee in order to set him up for an assassination.

The *love* presented in the film is not beautiful but, rather, cruel and destructive. In a struggle with her inner self, Wong is anxious to experience love but must remain in her role, a professional, patriotic secret agent who is forbidden to be emotionally attached to her enemy. However, she can only attain her pleasure—being with Yee—by reimaging the pain, that she needs to have him killed eventually. Paradoxically, she can be true to herself by *performing* someone else or just by *being* herself. Her ambivalent feeling toward the government, as a member of the collective self and political consciousness, is in fact deeply contradictory to her desire. It is no longer clear whether the desire is constructed or natural. Self and Other become intersected and intertwined.

Yee, on the other hand, has ambivalent feelings about being perceived as a "traitor" who serves the puppet government developed by the Japanese, as he believes that through cooperating with the enemies he can help redevelop the Republic of China. In one scene, when Wong and Mr. Yee meet in a Japanese tavern, Yee says,

> Yee: *You hear that? (Japanese singing) They sing like they're crying, like dogs howling for their lost masters! These Japanese devils kill people like flies, yet deep down they're scared as hell. They know their days are numbered since they got the Americans on their case. Yet, they still hang around with their painted puppets, and keep singing their off-tune songs—just listen to them! I know better than you how to be a whore.*

The onslaught of emotions increases to its fullest as he listens to Wong singing a classic song to him. Yee is unaccountably moved, tears flowing. The dialogue and

the scene reflect the deep sensitivity and humanity of the perceived cruel, emotionless traitor. Ironically, deep in his heart, he struggles with his own role as a secret agent collaborating with the Japanese. Both of them, in a sense, need to be themselves by performing others. Truth, in this respect, is only achievable when that truth is performed. The line between patriotic and traitorous, good and bad, love and hate is indeterminate and ambivalent.

The significant transition of the film occurs when Wong finally lures Yee to the jewelry store to get the diamond ring he bought for her. The trap set up to assassinate Yee fails once again, this time because Wong urges Yee to escape unharmed, due to her sudden feelings of affection and sentimentality toward him, when he expresses his deep love for her. The successful escape of Yee eventually leads him to sign the death warrants of the members of Kuang's resistance group, including Wong Chia Chi.

Finally, exploring the murky aspects of the war, the Nationalist Party, the government of the Republic of China funded by Dr. Sun Yat-sen and examining morality in such a period of turmoil, Ang Lee indeed evokes a collective sense of cultural collaboration among communities of different Chinese origins. In the film, both regimes antagonize each other, yet they both embrace the same orthodox lineage of Dr. Sun. The emblems of political symbols are omnipresent throughout the film, on both Old Wu's and Yee's official uniforms as well as in Dr. Sun's portrait and on flags in Yee's office. The signifiers indicate the ambivalent nature of "hero" and "villain," especially while both sides behave with the same orthodox and patriotic behavior. Who is the real victim, and who is the real hero? Who is the amorous prey and who is the dominator? To borrow the words of Ang Lee's long-term collaborator, James Schamus, the *truth* is attainable through being performed. Or, as the question was posed by Eileen Chang: "for at the crucial moment when we choose, when we decide, when we exercise our free will, are we not also performing?" (as quoted in Schamus, 2007).

Ang Lee: Recreating Authentic Shanghai in the 1940s— Defining Chinese Identity: A Site of Ambivalence

In his numerous interviews, Ang Lee discusses his diasporic experiences and emotional attachment to Taiwan and China, the imagined homeland. Ang Lee always talks, in his autobiography and interviews, about his ambivalent affective desire to make an "authentic" Chinese film, and his deep commitment to being a *Chinese* director presenting Chinese culture and recreating the taboo, repressed period of Chinese history. Making this film conveys his complex sensibility toward Chinese national history, the peoples, and the culture as well as his ambivalent attitude toward Chinese identity. Paying meticulous attention to the details of the setting and décor of the film, Ang Lee was successful in re-creating the scenes of 1940s

Shanghai during the Sino-Japanese War. He has done exhaustive research on that part of history to instruct the actors and recreate the scenes and historical background.

In addition, Ang Lee expresses his intense interest and personal attachment to Eileen Chang's *Lust, Caution*. More than once, he talks about the autobiographical nature of the story by this most controversial Chinese woman novelist who inspired and haunted him. As a Chinese director who is from Taiwan and who currently lives in New York City, reenacting the story of the Chinese legendary novelist also fulfilled Lee's desire to explore the dark aspect of people's lives during that time period. The ambivalent and politically sensitive nature of the story, according to Lee, is what attracted him the most. He said, "no story of Eileen's is as beautiful or as cruel as *Lust, Caution* . . . as a trauma, reaching for pleasure only by varying and re-imagining the pain" (Roberts, 2007). In discussing the making of the film, Ang Lee further said,

> That's my destiny . . . my real cultural roots in classic China and what I was taught now feel like a dream. I feel more of an insider in movies than real life. Very much like the girl in this movie. By pretending, actually you connect with the true self. (Abeel, 2007)

From here, we see the burden of self-identifying as a Chinese diasporic director, like Ang Lee. As mentioned in chapter three, in order to be recognized in a borderless world, the most significant requirement becomes the demand for ethnic particularity, finding and reaffirming one's cultural roots. Through mediated communication technologies such as filmmaking, national and cultural belonging is reinforced. Filmmaking, then, becomes a process of cultural translation, reconstructing one's cultural roots, (re)searching one's diasporic subjectivity, and maintaining a sense of national distinctiveness.

The strong sentiments and enthusiasms simultaneously affirm and reinforce a diasporic subject's self-identity and sense of belonging. In an interview with *The Wall Street Journal*, Ang Lee stressed the historical background, and his vision for the projection of the history portrayed in *Lust, Caution*: "I try to revive what was, and nobody can do it alone" (Parker, 2007). As he undertakes the burden of the representation of history, I would argue that, to some extent, the process also makes claim to one's agency, autonomy, and selfhood, as a reaction to a perceived historical and contemporary oppression. Lee added: "If I don't do it now, in five years it's probably gone . . . because the people who remember it will die" (Parker, 2007). His self-absorption with the cultural burden and the weight of tradition is heavily translated into his films. As he described Chinese tradition, he constantly emphasized the *root* and the *origin* of classic Chinese culture inherited by members of that society. Lee said that for his children, who were born and raised in the U.S., a pop culture production is one of the most prominent media through

which they may acquire the culture. Yet, cheap and twisted images about the Chinese culture and people permeate media representation. He continued,

> You have to come from somewhere. . . . That's your culture, your backbone, who you are. You cannot give that away. Whether it's in the elite culture or pop culture, you just need to come from somewhere. And the best way to introduce [this] to young people is to make profitable films that relate to the past. (Parker, 2007)

For Lee, his motivation to present an alternative, sophisticated version to the global audience has been manifested in his other Chinese films, including his early "Father Knows Best Trilogy" and *Crouching Tiger*. Ang Lee's historical representation reflects that "history" is not a buried past but continues to exist in the present and extends into the future. For ethnic minorities, such a *burden* and strong ethnic commitment present as ethnic tenacity. It becomes the most important way to possess their own sovereignty, reclaim their legitimacy and authority, (re)present themselves, and (re)define their own cultural identity. As Lim (2006) remarked, for ethnic minorities, self-representations are oftentimes the only stories providing insights into their subaltern Other.

(Re)searching for a cultural root is a way for Ang Lee to redefine himself. However, the self-representations in *Lust, Caution* are deeply embedded in a sense of subversive (mis)representation that invariably raises a lot of controversies among the audience. To put it another way, in the transnational era and borderless world, it is no longer easy or feasible to position oneself in a rigidly defined nation-state position. The anxiety of self-representations, namely, redefining one's self-identity, is manifested and fueled by the affective desire to simultaneously rectify the historical past that is subjected to interpretation and constant negotiation. Ang Lee discussed his cultural background, which inspires his filmmaking:

> I grew up in Taiwan, we always lose. . . . Nobody wins anything. . . . We're always on the losing side. My parents get beat by the communists, they escape to Taiwan. . . . In Taiwan we carry the torch of the classic Chinese culture, of feudal society, so to speak. We didn't go through Cultural Revolution and communism. (Parker, 2007)

The classic Chinese culture that Ang Lee strongly holds on to has long been translated in his cinematic discourse focusing on the notion of "repression." Confucian ethics indeed prevail in his films, but through a subversive and deeply self-reflexive way of revising this philosophy's future and its relationship with the rest of the world. *Lust, Caution* could be seen as Ang Lee's personal confrontation of the grand narrative of Chinese history; traditional Confucian ethics are not only being reproduced but also challenged in his films.

Discourses of Audiences

In the following sections, recurrent themes expressed by audiences from different Chinese origins are analyzed. These themes are addressed in relation to cultural ambivalence by connecting them to the historical and current conditions of the perception of Chineseness. Cultural positionalities play significant roles in film-viewing experiences. The polarized perceptions and receptions among Chinese communities of different origins result from different reading strategies and the variety of frameworks they adopt. Even though Ang Lee's public discourse commonly emphasizes his success across ethnic and cultural lines, both *Crouching Tiger* and *Lust, Caution* raised sharp questions on issues of the politics of recognition in relation to multiculturalism. In Taiwan, the public considers Ang Lee to be "the pride of Taiwan." While there is an enormous sense of cultural glorification amongst the people of the Chinese-speaking area (and, by extension, amongst the people of the East Asian countries), severe criticism of Ang Lee regarding his "inauthentic" representation of "the Great Chinese theme" arises.

The ambivalent audience reactions toward *Lust, Caution* reveal a deeply mixed emotion: strong nationalist sentimentalism as a result of the long history of the ambivalent relationship between Eastern and Western cultures. The success of Ang Lee's transnational films transforms him into an Eastern cultural icon, a position which symbolically signifies and is perceived as *resistance* from the East to the West. Ang Lee's transnational films therefore represent reverse cultural flow by filmmakers who have long been emulating the West due to the unequal relationship long dictated by the West. Such a cultural phenomenon also indicates that the films become a site for viewers to negotiate their cultural identity and identify with, affirm or reaffirm their subjectivity. Simultaneously, the films are also a site of political and cultural *empowerment* and *resistance*.

Finally, the extensive discussions about and enormous popularity of the films signify a shift—"the new national in transnational" (Berry & Farquhar, 2006). The films themselves should be considered as a symbolic image of *rejection* of Western imperial cultural force, but this image itself is constructed as a global commodity. Namely, the glamorous cultural connotation that was brought to the Chinese-language speaking communities simultaneously becomes a form of political solidarity, allowing them to participate more actively and equally in a world market.

Theme one: The question of Chinese history and the blurred line between the "Eastern self" and the "Western other"

Despite the fact that *Lust, Caution* was cut by thirty minutes because of the censorship system in China, it still broke box office records and generated numerous

online discussions.[3] The divergence of opinions demonstrates the popularity of the film, which also contests the lukewarm reception in the U.S. The plethora of reviews indicates the different positions of the audience. Among Chinese communities of different origins, ambivalence frames the responses they have toward Ang Lee and *Lust, Caution*. In her speech at Beijing University, Chinese film scholar Dai Jinhua (2007) commented on the "Ang Lee phenomenon." She stressed that Chinese audiences stood up to applaud for a long time after the *Lust, Caution* premiere in a Shanghai theatre. The audiences even yelled "Bravo, Ang Lee! Marvelous!" "Ang Lee" has become a cultural and social phenomenon, a brand name.

A group of Mainland Chinese diasporic scholars seriously charged that Ang Lee revised the history of WWII in *Lust, Caution*. Criticism mainly focused on the ways in which Ang Lee *distorted* Chinese history, especially the Second Sino-Japanese War, and charges of bringing shame to the country were leveled against him. Forty-eight Chinese scholars from Mainland China, Hong Kong, and the U.S., in various disciplines ranging from Chinese Studies to Engineering, together drafted a letter. The statement said:

> Since the first Sino-Japanese War in 1840, one of the worst civil wars in Chinese history, the Chinese were mobilized and united for a strong national consciousness. Countless men and women sacrificed their lives and dignity for the nation. However, unscrupulous writer Eileen Chang's novel *Lust, Caution* sought to tarnish Chinese national hero Zheng Pingru's reputation through her own personal desires. Then Ang Lee's movie goes even further to present naked, explicit sexual scenes to denigrate the dignity of our war martyrs and the innocent victims of the Sino-Japanese war. It is an intolerable public flagrant violation and insult to our martyrs of the war. We seriously condemn the film *Lust, Caution* for its inappropriate representation of the Chinese nation, and his despicable behaviors toward the martyrs. We at the same time express our deep admiration for the martyrs, and pray for world peace and the reunification of the Chinese nation.[4]

The statement reveals intense emotional conflicts and disputes over the interpretation of the film. The main theme of the discourse of the letter is a preoccupation with female sexuality and chastity, and the intersection of these with the *purity* of the nation. The representation of Wong's sexuality is equated with the violation of the dignity of a nation, since chastity has been one of the most important and universal virtues in traditional Chinese culture. Wong's relationship with Yee is undoubtedly perceived as an alleged violation of the conventional moral code—chastity being supplanted by sexual transgression. By the same token, "losing chastity" is perceived as a *shame* that metaphorically denigrates a heroine's value and further disrupts a reunited national consciousness or injures a nation's

3 *Lust, Caution* earned more than 4,000, 000 RMB (Chinese yuan) within the first four days.

4 Retrieved from bbs://bbs.ntu.edu.tw

spirit. Sexuality, in this case the sexual relationship between Wong and Yee, is considered a filthy subject.

Additionally, as posited in this letter, Chinese nationalism and the possibility of *reunification* are disrupted by the negative representations of the war and the martyrs. In other words, history was perceived as a fixed and static notion. Such a perception is clearly expressed through strong ambivalence. The complex situation of China during World War II is characterized by excessive Chinese cultural nationalism, evoking widespread national solidarity. As discussed in chapter two, cultural nationalism results from a long-term resistance to multiple forces of Japanese and Western imperialism. Tang Wei, the leading actress, as a result, was banned by China's State Administration of Radio, Film, and Television ("*Lust, Caution* Actress," 2008).

The emotional response to Ang Lee's representation of Chinese history is also translated into the discourse of nonprofessional audiences. The public discourse about *Lust, Caution* predominantly surrounds issues of authenticity, the representation of sexuality, and Ang Lee's "responsibility" of being a Chinese diasporic director. Again, this criticism clearly reflects the fact that Ang Lee is widely considered to be a representative Chinese director. Some Chinese audiences are ashamed of the ways in which Ang Lee presents the history of the war, charging that he is insensitive toward Chinese audiences' feelings about that period of history. Han (2008) articulated his point of view as follows:

> Ang Lee, as a collective cultural pride of all Chinese people, he needs to remember his fundamental *mission* of representing the nation while constructing cultural representation of Chinese history. Western audiences will definitely laugh at the "revolutionarists" and "patriotic students" presented in the film, resulting in misinterpretation of *correct history* of China. It will also bring negative impact to the young domestic audiences! (Han, 2008)

Lust, Caution is constructed as a film that distorts history by "glorifying" the national traitor Wang Jingwei's Japanese-oriented puppet state during the Second Sino-Japanese War. For some Chinese audiences, *Lust, Caution*, adapted from Eileen Chang's story of the same name, is a *Hanjian* film.[5] The well-known Chinese actor, Sun Haiyin, once said in an interview, "I do not regard Ang Lee as an artist because of the films he makes. I will never watch his films, no matter how many more Academy Awards he wins" (Sun, 2009).

Chinese writer and literary critic, Yan Yanwen, posted a series of articles critiquing the representation of Chinese history, especially the portrayal of Wong Chia Chi, who is thought to be based on a real secret agent from the WWII

5 *Hanjian* literally means "traitor," someone who betrays Han Chinese ethnicity. The use of this term dates back to the Qing Dynasty. Eileen Chang is one of the most famous yet controversial women writers in the history of modern Chinese literature; she is criticized as a national traitor because of her critical viewpoint of the Chinese communist government.

period named Zheng Pingru. For Yan, this results in the maligning of the whole Chinese nation and people, even though Ang Lee has pronounced that the film is not based on an actual historical event. The perception of this film reflects the subjectivity of the audience. In her invited lecture on the film *Lust, Caution*, in Beijing University, Yan (2007) remarked,

> Ang Lee should apologize for the film that "rapes" the history of the (Chinese) nation and its culture through a problematic representational strategy. It ruins the positive image of China and defames our war martyrs. . . . The twisted adaptation from Eileen Chang's story indicates the completely illogical interpretation of history. That is, it romanticizes the *hanjian* puppet government, especially the traitor Mr. Yee who was turned into a symbol of materialism. Instead of focusing on the dehumanization and cruel reality of the war, the film is focused on the love story between Wong Chia Chi and Mr. Yee. (Yan, 2007)

In her other critiques, Yan charged that Ang Lee, despite being a Taiwanese director, has a very twisted historical point of view toward China, which immensely disappoints those who are loyal and deeply patriotic toward their own nation. Such twisted cultural representation, she remarked, "presents as a *ritual* that *seduces* the audience to participate in a subversive image of the evilness of *hanjian*, and to have them have a false interpretation of the national traitor" (Yan, 2007). She then asked, "why didn't he [Ang Lee] choose to represent how the Chinese martyrs sacrificed themselves to fight against the Japanese military's bloody killing, our national history, and showcase the twisted humanity to the world audience?" The discourse suggests that in order to *protect* Chinese core cultural values (akin to the need to protect our environment), the film should be banned.

Hundreds of reports echoed this criticism. The main theme expressed through the audience text consists of a constant comparison of the native history and the cinematic discourse. In other words, unfortunately, the burden of representation was imposed upon Ang Lee. *Lust, Caution* was stigmatized by a lack of fidelity to its native obligation. A number of audience reviews critiqued Lee's filmmaking, labeling the movie as an aberration from Chinese history and culture. The discourse also consisted of a series of discussions on the ethical boundaries of the arts. For example, audience member (*sina* blogger) Duan, in his article, "What *Lust, Caution* Maligned Was Chinese National Spirit," suggested that this film is not an artistic product but instead a commodity that conveys a specific political message aimed at disrupting the positive image of China.[6]

In his panel discussion in Shanghai University, well-known writer and scholar, Liu Xiaofeng, said that it is a warning sign that there were so many Chinese audience members who had a favorable view of the movie. He argued that Ang Lee's ambiguous attitude toward 'lust' and 'caution' leads to his being criticized

6 Retrieved from http://blog.sina.com.cn/s/blog_4b6e09dc01007r3y.html

as a national traitor.[7] Liu concluded that in order to unleash his personal desires and to pander to the vulgar tastes of some audiences, Ang Lee gave up the pursuit of virtue, dignity, and morality. Thus, it is argued that *Lust, Caution* represents a deterioration of the Chinese film industry.

Considered collectively, the underlying message of such audience discourses reflects a strong sense of Chinese cultural nationalism. Based on the critique of the representation of Chinese history in *Lust, Caution*, Chinese audiences *reaffirm* and/or *reassert* their Chineseness. By constantly disassociating from the cultural identity represented in the film, the audience simultaneously recreates and advocates a Great Chinese Nation. Critics who evoke history as a guideline for evaluating the worthiness of the film indicate a close, ambivalent relationship between the construction of the Chinese *self* and the Western *other*. That is to say, the Western other always plays a significant role in defining the Chinese self; national identity is always in an ambivalent relationship to its imagined other.

In comparison with audiences from Mainland China, for the Taiwanese community, the debate over the authenticity of Chinese history was not as severe. There were several hundred audience responses and opinions devoted to *Lust, Caution* in 2007 when it was showing in theaters. Instead of arguing whether or not Ang Lee presents the most authentic Chinese history, the audience predominantly focused on the comparison between Eileen Chang's original story and the film. Taiwanese audiences generally were in awe of the sophisticated portrayal of the ambivalent relationship between the two main actors, Mr. Yee and Wong Chia Chi. What appeared to be most of interest to the audience was Ang Lee's subversive representation of national loyalty, love, and deeply human desires. This will be discussed in more detail in a later section.

One common theme that appeared in the responses of Taiwanese and Chinese audiences was the focus on Ang Lee's international success. On the one hand, the audience was proud of *Lust, Caution* and its international reputation. There was constant concern about whether or not "Western" audiences would understand the "Eastern philosophy" deeply embedded in the film. In various interviews, Ang Lee had mentioned repeatedly that for him, the responses of the Chinese audience community are essential. The *mission* delegated to him as a Chinese diasporic film director in the U.S. is to let the global audience see a noncultural, monolithic aspect of Chinese people, while also showcasing a plethora of aesthetic voices. The connotation of such *concern* for the Western audience reflects not only an anxiety of self-representation from the local community in a global era but also a *self-defensive* position, a position in need of constant self-explanation in relation to the West.

The discourse ranges from comments such as, "Western audiences should be glad if they could understand half of the story *Lust, Caution*," and "*Lust, Caution*

7 Retrieved from http://www.mtime.com/my/t193244/blog/1543153/

is so *Chinese*, embodying a traditional sense of Chinese philosophy and aesthetics that a Western audience can barely understand," to "it is too difficult for a Western audience to understand Chinese style of repression, and because of this, the film wasn't perceived well in the U.S."[8] It is through such constant comparisons of *self* and the *other* that the audience reinforces a sense of local identity, that is, their *Chineseness* and/or *Taiwaneseness*. As Georgiou (2006) asserted, the availability and immediacy of the Internet function as a tool for maintaining and reinforcing a sense of cultural belonging.

Theme two: The reunion of the Chinese community: Perceptions of the Huaren-Chinese and Taiwanese diaspora

For the overseas community, watching *Lust, Caution* is a way to enhance a communal experience. In New York City, a Chinese community organization in Flushing organized an "Ang Lee night," reserving a whole theatre for Chinese and Taiwanese overseas audiences. It is a cultural event, Fred Fu, the president of the Flushing Development Center in New York City, said to the press,

> This is a very unique experience. This is the first time we gather 200 *Huaren* (overseas Chinese language speaking community) to watch such a meaningful Chinese movie. As we all know, Ang Lee is a representative of the community whose Chinese and non-Chinese movies always embody a deep sense of cross-cultural sharing. He and his works represent the Eastern aesthetics. ("New York Chinese Community," 2007)

An audience member explained, "We (Chinese audience) can more easily understand the inherent Chinese philosophy and the Asian aesthetics than the foreigners (American audience). . . . Lee really did a good job of re-creating an authentic setting of old Shanghai" ("New York Chinese Community," 2007). Other statements from both news discourses and the overseas communities reflect ambivalence toward Ang Lee's success in Hollywood and the international film market—that is, there is a strong feeling of cultural pride simultaneously bound up with a tendency toward self-explanation and the adoption of a defensive position in relation to the West.

Unlike the criticism from the viewers in the People's Republic of China, the diasporic communities reaffirm their *Chineseness* and/or *Asianness* when viewing this film. The emotional sentimentality of being overseas Chinese enhances the communal experience. In other words, cultural symbols and cinematic narratives of Chineseness in *Lust, Caution* contribute to the cheering for the success of the film among overseas Chinese communities. Most importantly, among the overseas communities, the reconstruction of Shanghai during WWII and the depiction of people's lives during that time period foster a strong nostalgic desire and

8 Comments retrieved from ptt.twbbs.org, the largest Bulletin Board System (BBS) in Taiwan.

simultaneously (re)affirm and solidify a shared sense of a particular cultural root and a collective imagination of the homeland. One audience member expressed it thus:

> After seeing *Lust, Caution*, the images that struck home with me are histori-
> cal scenes represented in the movie. I was still thinking about China in the
> period of WWII, and how Chinese people live in that period. It is difficult for
> us to imagine the lives people have and difficulties they need to face during the
> most turmoil of the historical Sino-Japanese War, and the ways in which people
> struggle over their lives in Shanghai and Hong Kong. We all have once read
> and memorized that part of history in our textbooks, but we have never expe-
> rienced that. Ang Lee authenticates the desire to recreate that history through
> his meticulous filmmaking to revitalize that history, and to let the audience to
> experience that history by presenting the profound struggle between Mr. Yee
> and Wong Chia Chi, the street scenes back then in those cities, various dialects
> used among people, and the profound humanity. He did his best to let us believe
> it really happened, the story between Mr. Yee and Wong has really happened.
> (Yang, 2007)

For months, news about *Lust, Caution* remained on the front pages of most overseas Chinese language newspapers such as *World Journal*, *Sing Tao Daily*, *Qiaobao* (China Press), and others. It was a pervasive discussion topic and was popular not only in the news but also among various Chinese diasporic com-munities in the U.S. and other countries. For the diasporic community, the film contributes to a specific act of "remembering" a cultural root based on collective memory of the [imagined] homeland. Such cultural belonging is produced and reproduced through Ang Lee's cinematic discourse, bridging large distances and diverse cultural and geographical contexts. Simultaneously, cultural interpreta-tion and growing circulation of a particular version of Chineseness is also cocon-structed by the audience.

It is important to note that the audience from the Mainland formed groups to see the uncut version of *Lust, Caution* in Hong Kong in order to support artistic freedom. The controversial seven-minute-long sex scenes were removed by the Chinese government. One audience member named Cat, in an October 1, 2007 blog post titled, "Forming Groups to See *Lust, Caution* in Hong Kong," said:

> It is the coolest thing to form a group to go to Hong Kong to see the uncut ver-
> sion of the film . . . people of PRC use a peaceful way to defend their "freedom"
> and "right" to see that "7 minutes" (removed by the Chinese government) and to
> express our appreciation of art . . . the meaning is beyond seeing the film itself;
> it is that we have more freedom today.[9]

9 Retrieved from http://blog.sina.com.cn/s/blog_4a59649201000bjl.html

To support Ang Lee's films, for some Chinese audiences, is to support artistic freedom and the market. Interestingly, the film was still extremely popular in Mainland China.

Theme three: Emotions and reflexive selfness

After *Lust, Caution* won a second Golden Lion Award, former Taiwanese president, Chen, explicitly pointed out that the most touching fact was not only that Ang Lee's international achievement honored the country of Taiwan but also that Lee always remembers and respects his cultural roots, asserting in his award acceptance speeches that he is a director from Taiwan. Chen said, "because of this, international media are very impressed by the country Taiwan" (as quoted in Wong, 2007). Additionally, Tainan mayor, Hsu Tain-tsair designated April 28th as "Ang Lee Day" after Ang Lee became the first Asian to earn the Academy Award for Best Director for *Brokeback Mountain* ("Tainan Celebrates," 2006). Lee told everybody, "I am proud to be a Taiwanese. Now it seems as if the Taiwanese are also proud of me, and that gives me a special sense of accomplishment" ("Tainan Celebrates," 2006). Even the current Taiwanese president, Ma Ying-jeou expressed his deep sentimentality, and almost sobbed after watching *Lust, Caution*. He said, "I am very moved by the movie, yet I feel very heavy. It reminds me of the old days . . . many people were sacrificed for the country because of the war."[10] Additionally, many Taiwanese officials, such as Premier Chang Chung-hsiung, offered public congratulations: "Ang Lee's international achievements bring glorification to Taiwan, and honor this country; he contributes tremendously to our movie industry" ("Premier Chang Chung-hsiung Congratulates," 2001).

Such sentimentality toward Ang Lee's international success, especially the representation of history, and the ambivalent, complex relationship among the characters, also appears as a dominant theme among Taiwanese audiences. A strong, emotional attachment to the story, *Lust, Caution* is presented as more than just entertainment; instead acting is seen as a site of reflexivity, self-affirmation, and therapy. In other words, audiences relate details of the scenes and dialogue to themselves and their life experiences; that is, there is a partial articulation of self. They immerse themselves in the tragedy to experience the pain, struggles, and repression of the characters in the film. Further, through the viewing process, the film becomes a site for audiences to engage in self-affirmation and nostalgic imagination, and to look for self-identity and subjectivity that involve different sets of reflexive processes.

Engaging in strong, emotionally charged experiences throughout the film is the predominant theme in the public discourses of ordinary Taiwanese audiences. This involves both the passion toward Ang Lee as a public figure and the sentimentalism toward Chinese culture and the particular historical context. For

10 Quoted in *China Review*, 25 September, 2009. Retrieved from www.chinareviewnews.com

example, audience member, bloodgas (2007), described the emotional intensity felt after seeing the film:

> I have been haunted by the patriotic story and the "love story" between Yee and Wong, even one month after seeing the film . . . it is not so much about sadness, but it is a kind of melancholy that I have been deeply experiencing in my body and soul. My mind was completely absorbed in the film . . . my heart was beating so fast. The sex scenes made me so uncomfortable, yet they ironically are the expression of the "love" between Yee and Wong.[11]

Along the same lines, Catiggy (2007) described her own affective connection as indescribable: "I cannot put my feelings into a single word after seeing *Lust, Caution*, because I have too much on my mind but I can't find capable words to describe them. Love is too complex in the film."[12] In a review another audience member, Ewin (2007), noted,

> many different layers are presented in this film that aim to reveal the complexity of humanity, such as the struggle between evil and justice, the constraint of one's freedom during that historic period. Numerous close-up shots used for showing the characters' facial expressions really led me to understand their complicated hidden emotions . . . the film is an oasis for my soul.[13]

While some audiences express their love of the film, some explain their shock. Audience member Powerapple (2007) stated, "The film is so intense that the 158 minutes passed fast. I have been haunted by Mr. Yee's expressions in his eyes, his violent behaviors because of his deep inner fear of love, and his emotional connection to Wong. His tears in the final scene really gave me goose bumps. Kuang's final scene—the despairing look at Wong before they are executed—really got me.[14] Matrix31 (2007) expressed his complicated, indescribable feeling after seeing the film: "The intense repression of emotions in the film makes me tear up, especially when I can't help recall the scenes and the story again and again. . . . The emotions and feelings are so exquisite."[15] Another audience member, FM (2007), said, "I feel strongly about this film and I am so glad to see the future hope of Taiwanese film. Even though this film is internationally financed, we understand the film better because of the culture [compared to international audiences]."[16]

Lust, Caution clearly becomes a site of emotional sentimentality and outbursts for the audience. Moreover, it becomes a site of the *hauntedness* of history and a sense of *unsettledness*. To the majority of Taiwanese audiences, the film

11 Retrieved from bbs://ptt.twbbs.org
12 Retrieved from bbs://ptt.twbbs.org
13 Retrieved from bbs://ptt.twbbs.org
14 Retrieved from bbs://ptt.twbbs.org
15 Retrieved from bbs://ptt.twbbs.org
16 Retrieved from bbs://ptt.twbbs.org

challenged various notions regarding morality and humanity. The repercussions of loss, nostalgia, fantasy, affective desire, and mourning represented among characters in the film were the most frequently discussed subjects. In other words, besides a strong sense of narrative reflexivity in the audiences' public discourses, it seems that "melancholia" can become contagious within this community, and the permeability of self-reflexivity especially made the discourses interesting to read. Kasheran (2007) wrote an essay that reflects his relationship with a loved one:

> From the first day I saw Wong Chia Chi, I immediately couldn't help but connect her image to you. I was drawn into a deep whirlpool of memory. I felt so heavy; I had enormous sorrow and melancholy. I compared you and Tang Wei, the woman with an oval face and thin lips. Not only do you and she have a very similar aura, but also our relationship was even comparable to Wong and Yee. I cried hard that night, and even on my way to school next morning. After this movie, I cannot handle another heavy, strong sentimentality so soon afterward.[17]

For audiences, the pain and intense emotional shock are drawn from the perceived ambivalent relationship between personal agency and social, historical structure. Freedom is always deeply constrained by politics and social structure.

Ang Lee destabilizes patriotism in a preposterous way. Audiences ask the question "what would I do if I were Yee or Wong?" Such discomfort and unsettledness result from their reaction to the sense that fundamental humanities are being challenged. That is, the shock comes from realizing that love and morality are no longer the same as one's preconceived notions of what constitutes normalcy for these values. *Lust, Caution* becomes a site of reflection and practice that produces ambiguities, ambivalence, and instabilities. These uncertainties seem to be antithetical to the demands of a static, fixed grand narrative of a nation's history and identity. Magnolia (2007) commented on the patriotic drama conducted by the students in the film, especially focusing on their seemingly blind patriotism and passion toward the Chinese nation during WWII.[18] The slogan, "China will not fall," indeed reflects the intense emotion at that historical moment. Magnolia asked, "Under what conditions would a naïve, simple, young college female student like Wong transform herself into a special agent and sacrifice her virginity in the name of patriotism?" For the young generation that has not been through wartime, such patriotism is incomprehensible. Further, private imagination is no longer in conjunction with a collective, unified political exigency. Mckey (2007) stated,

> I am not sad about the failure of Kuang's patriotic mission, but instead I disagree with the recklessness and blindness of his act. Ang Lee employs Kuang as a character to critique the incompetence of a naïve, clueless literatus. It unsurprisingly

17 Retrieved from bbs://ptt.twbbs.org
18 Retrieved from bbs://ptt.twbbs.org

leads to such a tragedy, especially the sacrifice of a woman's virginity during that time. Wong is just a token, being manipulated not only by her patriotic fellows, but also the social, historical structure. One's humanity is sacrificed during wartime, in the name of patriotism. Politics is extremely cruel, manipulative, and cunning. All characters pay the price . . . love between Wong and Yee is both passionate and frantic, and that is why it is so ambivalent. . . . I had tears in my eyes when I saw Yee sitting on Wong's bed with the look of enormous sadness.[19]

"I feel a deep sense of loss, especially toward Mr. Yee," Deliver (2007) noted in a review.

This thorough tragedy makes me ponder *repression* and desire for a long time. How ironic it is that after making love, you can only cry, not laugh. National identity is always defined as much more important than individual identity, yet countless people suffer from such political ideology.[20]

For many audiences, love becomes a contested site. It is no longer an easy concept to define. Owlonoak (2007) said, "Yee is like black coffee, bitter, emotionless, cautious, and yet somehow passionate, just like the author Zhang Eileen. I wonder whether or not his emotional attachment to Wong represents the truth of love?"[21] Jellyfish721 (2007) remarked,

Most films or novels only promote and present a romantic side of love. *Lust, Caution* points out the essence of love, that is, it can be both painful and pleasurable. Both Yee and Wong desire for true love strongly. Wong lost her father when she was a teenage girl. She has been searching for love from a man that could be the substitute for a father's love. Ang Lee's portrayal of her searching for love is like moths flying into fire—such "love" brings destruction upon oneself.[22]

Zooka (2007) echoed this point by stating that Ang Lee presents several different layers to show the complexity of humanity and love. Ang Lee employs a very concrete yet abstract narrative style to tell the story. On the one hand, the theme surrounds "love," which is a universal concept that transcends cultural and national boundaries; on the other hand, the depiction of the role of Wong Chia Chi and the three explicit sex scenes are a symbolic representation of a woman's journey of *self-exploration*. Combining the style of social realism which closely relates the story to a historical context and the representation of the dramatic storyline of the characters, Ang Lee is able to reach broader audiences ranging from cultural critics and intellectuals to ordinary people. Therefore, for some audiences, this film is both national and transnational, both authentic and fictitious.

19 Retrieved from bbs://ptt.twbbs.org
20 Retrieved from bbs://ptt.twbbs.org
21 Retrieved from bbs://ptt.twbbs.org
22 Retrieved from bbs://ptt.twbbs.org

The public discourses of Taiwanese audiences surround the question of love, the relationships among characters, and their self-reflexive emotions and life. Through such debate about the characters and the story, audiences also immerse themselves in the process and constantly renegotiate their own cultural identity.

Theme four: Sexuality, chastity, and national identity

Sexuality is the important aspect of the ambivalent representation of love in *Lust, Caution*. For audiences from Taiwan, China, and overseas, the three controversial sex scenes were a much-debated topic. For the majority of audiences from Taiwan, these scenes are very essential to the development of the story. In other words, the relationships among Yee, Wong, and Kuang's patriotic group are interpreted as the cruelness of the reality of life during wartime, given the usual severe political and social constraints. The sex scenes present the deepest human desire, love, demonstrating that it can be both constructive and destructive.

The first sex scene between Yee and Wong happens during their reencounter three years after the students' patriotic act failed. Audiences clearly see an animalistic, violent "love" in progress, appearing as a pure act of sexual domination. The scene ends with her face in an astonished, anguished mix of anger and pleasure, and an imperceptible smile. The second sex scene presents a subtle change in their relationship, as their sexual positions vary. Wong feels more sexual pleasure and emotional exchange with Yee, yet he is still in a dominant position. In the meantime, Wong also surreptitiously converts her role, from passive to active. At the end of their sex, Wong and Yee face each other, signifying a more equal relationship between the two. The third sex scene happens in the dark, which connotes a progression between Yee and Wong, as Yee never had sex with her in the dark because of his fear of being killed. Further, their sexual position is one where Wong is on top of Yee, who allows her to straddle him. Power shifts. At that moment, Wong could easily use Yee's shotgun to complete her assassination mission, yet she only lets her tears flow from her eyes.

Audience member, Nosweating (2007), said that the "forbidden" sexual behaviors between Wong and Yee were shocking. He said:

> The first scene was very tricky since after Wong was raped by Yee, she smiled. Her smile was very ambiguous because it didn't give you (audiences) a static sense whether or not she is actually a prey of Yee. These scenes open to many different interpretations but they clearly demonstrate the change of Yee and Wong's relationship.[23]

Sexuality and sexual desire have always been obscure, mysterious, and somehow taboo subjects for traditional Chinese society. It is not surprising to read audiences' reactions to Ang Lee's explicit portrayal of sex in *Lust, Caution*. The

23 Retrieved from bbs://ptt.twbbs.org

sex positions are frequently debated among the audiences for their underlying symbolic meanings. Nosweating (2007) remarked:

> Sexual desire is very normal; Ang Lee is very bold to present it on the big screen, and adds more complexity to love and desire because it exists between a traitor and a patriotic agent. I don't think we should use moral judgment to look at the story because Wong made her own final decision to let Yee escape. As long as it is her decision to sacrifice herself because of her true feeling, outsiders can hardly judge whether or not it is a right or wrong decision.[24]

For the majority of Taiwanese audiences, rather than judging the "moralistic" aspect of the story, the need to honestly face one's own inner desire is the more important lesson they learn from the film. As previous quotations suggest, it is precisely such representation of the indeterminacy of human desire and the politics of sexuality that should be opened to interpretation, enabling most audiences to reflect on their own lives.

Love and sexuality could be interpreted as a site of a power struggle. Wong's body functions as a symbolic power struggle, as audience member Reke (2007) noted:

> Wong's body is politicized; it is a symbol of power struggle. Through various institutions such as the patriotic student group, Yee, and the national institution, the body is exploited over and over again. The double bind situation of Wong presents an intrinsic and typical relationship between the oppressor and the oppressed. The sexual intercourse hence becomes a site of *power negotiation*.[25]

Nosweating (2007) said,

> I couldn't really look straight at the screen. I felt the pain and great anguish between the two individuals in the scenes. They both can only *feel* themselves through such intensive sexual behaviors. The love is not romantic at all, but instead it becomes a sort of domination.[26]

Jalinfy (2007) explained: "I realized the deep sorrow of a lonely, repressed man. I was very moved by Yee when he tears up in the scene in which Wong sings 'Girl singing from the Earth' . . . their love seems so fragile."[27]

Emerging from these numerous posts is a greater sense of the ambivalence of love and sexuality, as both notions are perceived as indeterminate. The public discourse of audiences from Taiwan, however, barely reveals an intense sense of nationalism, Chinese national identity, or any strong sentimentality toward the reunification of the Chinese nation. Instead, the discourse indicates a very thin

24 Retrieved from bbs://ptt.twbbs.org
25 Retrieved from bbs://ptt.twbbs.org
26 Retrieved from bbs://ptt.twbbs.org
27 Retrieved from bbs://ptt.twbbs.org

sense of national identity, as the majority of audiences emphasize the dialectic and/or ambivalent relationship between the social structure and the self. What invites the most responses from Taiwanese audiences is not Ang Lee's constant reiteration of recreating an authentic Shanghai during wartime and evoking a sense of Chineseness but the complexity of love and desire. Such a trait is easily observed from the lack of discussion among ordinary Taiwanese audiences of Ang Lee's "national achievement" and the embodied Chineseness in *Lust, Caution* (that are constantly addressed by professional film critics or the news media).

As discussed in chapter two, in contemporary Taiwanese society, the sense of national identity is no longer rooted in the cultural imagination of China. The current rise of an indigenous Taiwanese identity not only weakens a sense of Chinese national identity but also enables an act of disassociation from China, under the Taiwan independence movement. It is not difficult to understand audiences' response to the national patriotism presented in the film; many found it "funny" and/or incomprehensible. There are only a few audience members, such as coldgoddess (2007), who would describe the patriotic scene as "the sentimentalism of the grandparent generation."[28] Chinese nationalism becomes only a laughable and contestable terrain. It is also through their discourse and the very textual ambivalence that one sees the symbolic meaning given to the nation as equivocal, indefinite, and indeterminately ambivalent; hence one needs to reconsider the nation as entity.

Conclusion

In this chapter an examination is made of the audience perceptions of *Lust, Caution* and *Crouching Tiger*, and of the ways in which the discourse of the two films engages with and/or disengages from their audiences. I also explored ways in which the discourses of Chineseness and cultural nationalism are being deconstructed and reconstructed. There was never an intention to condemn or endorse the notion of cultural nationalism that has been formed by the audience members from different Chinese origins. Rather, my aim was to show how ambivalence toward national identity characterized the discourse. An advocation is made for a thorough understanding of the forms of cultural nationalism and cultural identity that are indeterminate and are constantly being negotiated and renegotiated.

The chapter contributes to a further understanding of transnational films under a diasporic conditioning. Ang Lee and his different sets of cultural sensibilities and creative trajectories have not yet been explored thoroughly in the genres of Chinese national cinema (usually associated with films from Mainland China) and/or New Taiwanese Cinema (that closely emphasized Taiwanese local society and social problems) as represented by Hou Hsiao-hsien and Tsai Ming-liang. I

28 Retrieved from bbs://ptt.twbbs.org

analyze *how* and *why* a specific version of Chinese nationality is being performed, the ways in which an individual or a community remains invested in retaining a racial or ethnic subjectivity, and the continuation of a distinct version of culture.

Dealing with and "revising" the taboo part of history, Ang Lee employs a deconstructive and subversive lens to (re)present it. As history itself is a narrative that should be subjected to interpretation and challenge, this study argues that rather than being loyal to Eileen Chang's novel, Ang Lee adds complexities to it by unfolding the unanswerable, ambivalent nature of humanity, and questioning Chinese nationalism. Instead of questioning whether or not he is presenting an authentic part of history, we should ask, "what is authentic about his cinematic discourse?" In other words, multiple facets of the partial reality of history and of people's lives in that era are regenerated by filmmaking; that is, a fluid "identity-in the-making" is constructed and actualized through the process of making and seeing the film. Through representing and watching, Ang Lee simultaneously narrated his personal memories and constructed a personal history that is closely intersected with (or disassociated from) the larger historical narrative. Through *Lust, Caution*, a specific *version* of history and Chineseness is constructed and contested.

In creating such transnational films as *Lust, Caution*, Ang Lee employs cinematic discourse not only to resist the predominant Western film markets in (re) claiming the cultural proposition but also to create a possibility of a cross-boundary space that allows cross-cultural collaboration, even if just symbolically. The cinematic language Ang Lee uses as a discursive medium to enact or enforce a particular cultural imagination is not ahistorical or simply instrumental. Even though Western cultural imperialism is still alive in the deep-seated cultural identification and the structure of the cultural formation indicated through the audience response, "the transnational is no longer the old Western imperialist order" (Berry & Farquhar, 2006, p. 222). The vibrant and prevalent, active discussions of Ang Lee and his works, and the popularity of his transnational films reveal the fact that the "East" has been gradually interacting more *equally* and *actively* with the West. This also indicates that Eastern film directors have already been participating in the game of world film markets, gradually forming a "reverse cultural flow." In other words, world film directors do not need to worry about whether they will have a chance to participate in the global market. Rather, they must give more consideration to *how* they participate in the film market of contemporary society.

| SIX

Who Performs for Whom?

The Dynamic of Self-Representation and Spectatorship in an Age of Cosmopolitanism

What theoretical sense can we make out of ambivalence, the framework proposed in this project, to aid our understanding of audience research and media representation on a broader level? How does the notion of ambivalence assist in revealing how the politics of national and ethnic identity destabilize the process of identity formation that was once viewed as objective and as a "given?" Ambivalence serves as a theoretical construct that interrogates the ideological, determining which ideologies fix the unquestioned identity formation. The equivocal notion of Chineseness, subjected to historical and political forces, is a site of contestation and is therefore no longer a guarantee of ethnic solidarity. The "great reconciliation" (Chen, 2002) of Chinese and Taiwanese identity in a postcolonial and transnational context like Taiwan seems to be impossible. The politics of national identification is translated and transformed into a historical, emotional structure and affective space that signifies the broken promise of a collective national consciousness. Such affective space is actualized and communicated in and through Ang Lee's transnational cinematic discourse and in the audience receptions it receives.

This research begins to develop the notion of ambivalence, theoretically challenging ideological constructions of racial and ethnic identity that are objectively defined within a static, nation-state mechanism in a global context. The focus of the project is the relationship between communication practices and media as a source of constructing one's identity and cultural community. I use Ang Lee's

transnational works *Crouching Tiger, Hidden Dragon* and *Lust, Caution* as my case studies to explore the ambivalent representations of Chineseness. Extending postcolonial theorist Homi K. Bhabha's notion of ambivalence, my research expands the theoretical discussions on the politics of national identity and cultural syncretism represented in transnational cinema. By taking into account the complex political, social, and historical conditionings in forming and transforming cultural identity, it is argued that national identity is no longer a guarantee for ethnic solidarity; instead, it has become a site for cultural and political struggles.

In addition to analyzing non-Western artists' representational strategies for gaining recognition and a foothold in a global economic market, I examine the use of transnational media by audiences from different cultural communities. I analyze online audience discourses produced by communities of different Chinese origins in order to deconstruct audiences' positionalities. I thus examine the ways in which these audiences participate in constructing and/or consolidating a particular sense of national and diasporic identity and forms of nationalism yet simultaneously produce and strengthen a cosmopolitan sense of being a world citizen.

To support these discussions, first the contemporary theoretical debate surrounding the emergence of a new cultural politics of the representation of ethnicity and nationality in transnational films is examined. Second, this work situates the debate on Chinese identity and its complex effects in the sociopolitical and historical context of Mainland China and Taiwan, with a close analysis of the intersecting relationship with the U.S. after the Cold War. Then, the text moves forward, proposing the notion of ambivalence as the theoretical framework for providing a more comprehensive view to understanding Chineseness as a contested political site. Finally, incorporating audience discourses from three cultural positionalities—Mainland China, Taiwan, and overseas Chinese communities—it is argued that the transnational cinemas of Ang Lee become a discursive site of infinite intercultural processes, communicating and enabling cross-cultural understanding and collaboration. The vibrant discourses demonstrate the contribution of various interpretations and meanings of Chineseness in a transnational and postcolonial context. That is, it is indeed the various processes of interpretation that invite a productive cultural dialogue, thereby enhancing our understanding of disparate identities and positionalities.

Framework of Ambivalence

The theory of ambivalence in this work is developed from Bhabha's notion of ambivalence. Bhabha (1994a) addressed the equivocal power relation between the colonial authority and the colonized subject, the power and the powerless, the periphery and the center. He is critical of the paralyzing dichotomy. The key ques-

tion is if colonial authority (whether it be of the governmental, official, or Christian missionary type) has absolute power and effect in eradicating native cultures, with all their differences and contradictions. By challenging the historical logic and its continuing authority and transformative power, Bhabha suggested that, at the moment of its enunciation, ambivalence characterizes the splitting of the (colonized) subject. That is, the colonial center is disrupted by the unclassifiable, indefinite, equivocal borderline.

Bhabha's theory of ambivalence is developed from the field of psychoanalysis, where ambivalence was first described as a simultaneous desire for and repulsion from an object, a fluctuation between longing for a thing and its opposite. His idea of constitutive ambivalence lies in the native's inappropriate mimicking of the colonizer's power. This imperfect, accented mimicry represents a threat to the colonial power. Furthermore, the distinction between the internal "self" and the external "Other" is no longer clear, because the moment the "self" is actualized is through the recognition of the Others. Hence self-identity can only be constructed through and mediated from a nexus of affective projection, representation, language practices, desire, memory, and fantasy. For the colonized, the play of self, or the play of self-as-other is indeed enacted through the practice of mimicry yet mockery of the colonizer. The envy of and the desire to become the "Other" characterizes the ambivalent relationship between the colonized and the colonizer.

I extend Bhabha's discussion of ambivalence in order to understand the ways in which it has been transformed on the side of the minority subjects. I suggest that ambivalence represents itself as a struggle for constructing a holistic sense of self, even if it is mediated through, and co-constructed by the Other's gaze. It is a coexistence of contradictory feelings, emotions, and affective desire toward a memory, a person, or one's analyst self. In this study in particular, the cinematic discourse of Ang Lee's transnational films simultaneously embodies a sense of cosmopolitanism and a distinct national cultural imagination—Pan-Chineseness recurred with the idea of constructing a reverse cultural flow in order to reclaim native self-representation. The syncretic representational method (for example, the combination of Chinese tradition and Western filmic aesthetics) juxtaposes the political priorities of nationality, ethnicity, gender, and sexuality through a constant repackaging, contestation, and revision of the meaning of Chineseness. Such a self-representational strategy should be considered a tactic that disrupts rather than reinforces the West's imagination of the "exotic East." Through the mainstream of the contemporary film industry, such a self-representational strategy pushes traditional notions of Chineseness to seemingly familiar yet unrecognizable limits.

Further, this study posits that ambivalence also lies in a strong, nostalgic sentimentality, as a way for the marginalized, such as diasporic subjects, to sustain and reaffirm their self-identity. The burden and commitment to preserve one's

cultural roots, traditions, values, and beliefs in the postnational and transnational realms are significant. Nostalgia becomes an important way of (re)searching one's roots and of retaining cultural authority while participating in a political milieu. It is only through taking on the historical and cultural burden that marginalized subjects can liberate themselves and become complete. In other words, nostalgia reflects an affective desire to search for the past and reconfirm a certainty of cultural identity, helping to conceal feelings of rootlessness, fear, frustration, and anxiety. The longing for the past, intense emotional attachment, and affective desire of a national culture, expressed through collective discourse, not only reflect a long-term defensive mechanism toward Western imperialism but also enable us to reconsider the symbolic meaning ascribed to the nation.

National Imagination in an Age of Cosmopolitanism

Post-Cold War effects are embedded in one's cultural memory and sentimentalism. As "America" has been internalized as a desire, Westernization, or specifically Americanization, is deeply embodied in one's everyday cultural practices. "National identity" is not only a political issue but also a representational problem. Ang Lee's "dream of China" is mediated through the cinematic representation of the nation, which reflects a complex, postcolonial ambivalence. Namely, the (re) searching for a "lost" cultural root represents a fundamental ambivalence toward the politics of recognition in a globalized context. The naming (or categorizing) of *Lust, Caution* and *Crouching Tiger* becomes a contestable task. When confronting the seemingly irreversible trend of transnationalism, a postcolonial immigrant filmmaker like Ang Lee is faced with two challenges: on the one hand, he bears the inscribed mission of presenting an "authentic" native culture that draws on a distinct, nation-state, political boundary; on the other hand, he needs his productions to be "recognizable" cross-nationally, and to coalesce into a borderless arena. The embodiment of both "Third World nativism" and globalism characterizes a fundamental irony of the ideology of cosmopolitanism. The inherent paradox highlights the ambivalent relationship of nationalism and globalization and the ways in which native culture engages globalism.

In discussing the relationship between cosmopolitanism and particularism, Appiah (2006) stated that "cultural purity is an oxymoron" (p. 203). Cosmopolitanism celebrates the cultural differences and global intermingling yet implies that human beings hold universal values. The ideology of cosmopolitanism lies in the presumption that there is truth to the notions of purity and a set of distinct origins for each individual culture, that differences matter yet do not matter as "universal standards," which are still deeply centered in the West. Accordingly, "differences will remain, naturally, but they will remain precisely in the spheres that are morally indifferent: cosmopolitanism about these spheres will be fine,

but surely only because they are, from a moral point of view, of secondary importance" (Appiah, 2006, p. 202). This point echoes Charles Taylor's theory of an inherent paradox of the politics of recognition, which is simultaneously built on the assumption of both a universal humanity and incommensurable differences. Such ambivalence is inherent in the cultural phenomenon of the success of Ang Lee's transnational works.

In an age of cosmopolitanism, when representations of multiculturalism and diversity become a commercial necessity that usually leads to high market value, the representation of cultural particularities is deeply involved with the politics of recognition. As a postcolonial and transnational, diasporic, immigrant figure who constantly oscillates between Western and non-Western cultures, the "in-authenticity" of Ang Lee's "accented cinema" precisely speaks to the ambivalent nature of the politics of recognition in an era of cosmopolitanism. Therefore, this project is primarily concerned with the ambivalence being performed in his works and its function as a representational device, as a possible tactic of aesthetic and political intervention. Indeed, the revitalizing and/or the creation of another "new transnational Chinese cinema" should be considered as a potential reverse cultural flow that disrupts the long-term, predominant, Western cultural hegemony. Instead of viewing ambivalence as a problem or negative connotation, I suggest that the deployment of ambivalence should be considered to be an empowering practice and a site of possibility.

The analysis belies a binary conceptualization of the transnational films of Ang Lee: that they are either cultural sellouts or cultural products that only reap full commercial benefits. Instead, what emerges in the discourse of audiences is that such a repackaging of Chinese national identity engenders a strong sense of liberation and celebration. At the same time, cultural nationalism is an essential component for the audience, signifying a reaction to a long-term, complex, emotional structure toward the Western gaze. The reversed cultural flow of *Crouching Tiger* and *Lust, Caution* is considered a collective "ethnic and national pride." It is considered integral to regaining the right to self-determination, previously having been denied agency; to achieving a sense of political solidarity and to being able to (re)present the historical context in the native's own terms. The symbolic liberation from a long-term subjugation to Western cultural imperialism is achieved.

An emerging popular cultural market of East Asian countries like China, Taiwan, South Korea, Singapore, etc., becoming "visible," as Chow (2007) asserted, is more of "a matter of participating in a discursive politics of (re)configuring the relation between center and margins, a politics in which what is visible may be a key but not the exclusive determinant" (p. 11). That is, ambivalence is a self-representational strategy for the ethnic "Other," historically denied access to representation, to contest and subvert the conventional stereotyping and simplification of one's subjectivity.

Further, by analyzing the audience discourse, one is able to conceptualize their reactions as communicative moments that co-construct the meaning of the film text. This study provides a good example of the familiar cycle of ambivalent emotion toward the "West" in the aftermath of postcolonialism. China and Taiwan's long history of engaging in a subordinate relationship with the West enhances the resurgence of ambivalence. The discourse of audiences indicates that the "West" has been simultaneously desired and feared, admired and hated, essentially affecting to a Chinese person's self-identity, value, and self-esteem. While "America" has long been the internalized desire for the Chinese people, the sense of self is co-constructed and consolidated by the achievement of winning Academy Awards, and being seen, recognized, and validated by American audiences. Through such communicative practice, "the West," circulated in and through various audience communities, becomes a construct that the "non-West" constantly needs to refer to, rely on, and consult. Under the burden of representation, it is not difficult to understand why an ethnic minority subject like Ang Lee commits to representing Chineseness in globalized cultural productions.

Discourse of Ambivalence

From the audience discourse, one sees a deep-rooted sense of anxiety and defensiveness that closely intersects with nostalgia. The national sentiments simultaneously reexamine, (re)search, and (re)create the values of Chinese culture—its history, cultural value, and people—as they are perceived to have been gradually lost due to the dominance of Western modernity in current Chinese society. While audiences celebrate the needs and success of present and future global visibility, their reminiscing about China's past is concurrently omnipresent. Nostalgic sentimentality is derived from an emotional longing for the past—the glories of Chinese history. Thus, the audience discourse centers on the debate over what Chinese culture is and how it ought to be represented in a global film market.

"Preserving" an authentic Chinese cultural root, whether it is fabricated or imagined, becomes a concrete yet abstract, important yet difficult, task for the audiences, especially within the context of cosmopolitanism. The nostalgia that is invoked goes beyond the commercial intention to perform for the West; it harkens back to the essential purpose—the recreation and reimagination of a cultural past, a reawakening of the feeling of a historical period, whether or not that representation is fraudulent or authentic. For communities from Taiwan, Mainland China, Hong Kong, and the Chinese diasporas, the cross-national success of Ang Lee's works becomes an invisible cultural bond and a way to remember and reaffirm their sense of self. Communication technology, such as the Internet, further provides a cross-boundary space to continue the conversation on cultural identity;

such a mundane yet continuing discourse plays an essential role in constructing transnational networks and reifying one's cultural practices.

Under the drastic social, political, and economic transitions of contemporary Chinese society, nostalgic sentiments expressed through both films and audience discourses inextricably intersect with viewers' self-reflection, and personal memory intersects with a collective history. Each film functions as an essential catalyst for the reconstruction of one's sense of cultural belonging and identity. The emotional solidarity expressed through both the audience and the text is a result of viewing one's historical existence as being recognized; as being represented in one's own terms; as a self conceived way of self-determination. For postcolonial and transnational communities, "history" becomes a structural feeling and a way to reconnect. It is exactly at this juncture of a seeming emancipation from the previous subjugation of Western ideological domination, when they finally begin to enjoy access to the representation of their own cultural and historical existence, that postcolonial ethnic communities hold on to such putative solidarity so fiercely.

The cinematic discourse of sexuality in *Lust, Caution* is another significant theme that embodies profound ambivalence and is perceived ambivalently by audiences. Representation of sexuality in *Lust, Caution* raises cultural resentment toward the film among audiences from Mainland China, as it can be understood that it further adds to a long-term inferiority complex toward the West. The politics of sexuality in the film is interpreted as disparaging to China's national spirit, because it implies the "backwardness" of a nation, something that should not appear on the big screen for Western audiences to consume. Such an emotional structure typically and ambivalently finds its moment of anger and hatred toward the West, given the predominant legacy of history, as the West has long been a critical gaze that holds the power of determining Chinese identification.

In the analysis, one clearly sees the scathing criticism of the representation of gender and sexuality, as it reflects the moralistic ideology of sexuality as a way to police one's virtue. Sexual relations need to be regulated and orderly, as sexual aberrations are considered a threat to the maintenance of a "moral society," in this case, the condemnation of Chinese national virtue. To put it another way, for some audiences from Mainland China, a love relationship between a female spy and a perceived national traitor is not only perceived as a sexual transgression but also as a disturbance to China's national spirit. Sex and politics, for some audiences, are considered a question of morality and, subsequently, a responsibility that a film director should or should not have in guiding or representing a "nonnormative" sexual relationship in a pop culture product like *Lust, Caution*.

The positionalities of audiences play an important role in perceiving a cultural text differently; namely, the reception context demands more attention when analyzing audience response. The representation of sexuality, likewise, is the much-debated topic among Taiwanese audience communities. As love and desire are not

represented in a "recognizable" way, that is, they are portrayed as both construc-tive and destructive, audiences reflect back to their own lives to reexamine their belief system. Uneasiness and unsettledness are evoked by the indeterminacy of human desire and the politics of sexuality presented in the filmic discourse.

Postscript

While the majority of Western audiences perceive Ang Lee's films as a medium for learning about a different ethnic culture, his cultural texts, ironically, also function as a site for local Chinese audiences to regain and negotiate their cultural identity. What this phenomenon says is that in an era of globalization, namely, a postcolo-nial world, *both* West and non-West, the marginalized and the dominant, respond to the diversity of cosmopolitanism by (re)searching their own ethnic certainties. Globalization dissolves the spatial boundary yet simultaneously produces ram-pant cultural and identity fragmentation, and uncertain and intermixing cultural, political, and economic spheres. When discussing transnational media products, we can no longer draw a distinct line between the subject and the subjected, the local and the global, the margin and the center. In this case, the question of self-representation should move beyond the one-dimensional and totalizing theory that native, non-Western artists always invariably resort to Western means to ex-press themselves, with the aim of pleasing the West. This line of thought actually embodies the danger of privileging Western audiences and reinforcing their per-ceived superior status. Given the passionate discussions of Ang Lee's films within the local communities, such a claim can be challenged, rather than validated.

Within the dynamics of self-representation and spectatorship outlined in pre-vious chapters, transcultural representation of Ang Lee not only turns Westerners' gaze onto themselves but also enables the local, Chinese-speaking audience com-munities from Mainland China, Taiwan, Hong Kong, and the overseas diasporas to reexamine themselves and the notion of cultural agency in their own terms. In the contemporary film market, the question of whether or not the marginalized has opportunities to come into representation is no longer sufficient. Rather, one must ask: *Who performs for whom? Who interprets whom? Who "distorts" or "authen-ticates" whom, and in what context? Who is the object and who is the subject?* The line between the performers and the audiences, the spectators and the performers, is far from discrete and is indeed ambivalent. Hence, the question of cultural au-thenticity moves beyond the context of the cultural production and its audience receptions.

My interest in examining both cinematic texts and online audience discourses enables me to have a further understanding of identity politics and how films, and by extension media technologies, become specific agents for communities in different societies. Using Ang Lee and his transnational films as a case study, this

analysis suggests that the space of paradox does not always lead to the hatred or eradication of the "self" and the "Other" but rather, indicates that the space of ambivalence can be empowering and enable one to reexamine one's positioning in the world, indeed as a member of the "global village."

These case studies illustrate that geographical and cultural displacement creates new forms of cultural belonging and increasingly informs us of the local-global cultural dialectics. The impact of transnational forces—such as the rapid circulation of images, goods, information, and movements of diasporic populations—indeed demonstrates the limitation of the nation-state framework. When a term like *world citizen*—articulating a rhetorical meaning of boundedness across boundaries; a utopian ideal of transcendent differences; and embodying a symbolic, universalistic cosmopolitanism—becomes a heated slogan, I cannot help but wonder what exactly plays such a crucial role in binding each of us together in such a global community? My own conclusion is that the answer is media and information technology.

Representations become a significant and predominant way to mediate our bodily experiences, to connect and collaborate with one another, and to form and inform one's cultural identity. Communities are formed by representations through modern communication technologies. Representations provide a site where participants share a common story, memory, value, or history. It is through such participation and sharing, virtually or in real life, that one forms a communal self-identity and solidarity.

This study furthers the theorization of the ways in which new media technologies impact and alter the human interactions between peoples from various cultural, social, and political backgrounds and/or contexts. In order to gain a deeper understanding of how ideologies in media shape peoples and societies, it is essential for one to incorporate the analysis of audiences' mundane discourses—their life experiences and relationships with media—and to take into consideration their active interpretation of the mediated texts that help shape their perceptions of self, the Others, societies, identities, cultures, and the globe.

BIBLIOGRAPHY

Abeel, E. (2007, September 26). *Lust, Caution* director Ang Lee. Retrieved from http://www. indiewire.com/people/2007/09/indiewire_inter_110.html (no longer accessible).

Ahmed, S., Castañeda, C., Fortier, A-M., & Sheller, M. (2003). Introduction. In S. Ahmed, C. Castañeda, A-M. Fortier, & M. Sheller (Eds.), *Uprootings/regroundings: Questions of home and migration* (pp. 1–19). New York, NY: Berg.

Anderson, A. (2001). Violent dances in martial arts films. *JUMP CUT: A Review of Contemporary Media, 44.*

Anderson, B. (1991). *Imagined communities.* New York, NY: Verso.

Ang, I. (2001a). Can one say no to Chineseness? Pushing the limits of the diasporic paradigm. In I. Ang, *On not speaking Chinese: Living between Asia and the West* (pp. 31–51). London, UK: Routledge.

Ang, I. (2001b). Indonesia on my mind: Diaspora, the Internet and the struggle for hybridity. In I. Ang, *On not speaking Chinese: Living between Asia and the West* (pp. 52–74). London, UK: Routledge.

Ang, I. (2001c). Undoing diaspora: Questioning global Chineseness in the era of globalization. In I. Ang, *On not speaking Chinese: Living between Asia and the West* (pp. 75–92). London, UK: Routledge.

Ang, I. (2003). Culture and communication: Toward an ethnographic critique of media consumption in the transnational media system. In L. Parks and S. Kumar (Eds.), *Planet TV: A Global Television Reader.* New York, NY: New York University Press.

Ang Lee: Sharing the honor with all Chinese communities. (2001, February 13). *The Epoch Times,* Retrieved from http://www.epochtimes.com/gb/1/2/13/n46896.htm.

Appadurai, A. (1996). *Modernity at large: Cultural dimensions of globalization.* Minneapolis, MN: University of Minnesota Press.

Appadurai, A. (2000). Grassroots globalization and the research imagination. *Public Culture, 12*(1), 1–19.

Appiah, K. A. (1992). *In my father's house: Africa in the philosophy of culture.* New York, NY: Oxford University Press.

Appiah, K. A. (2006). *Cosmopolitanism: Ethics in a world of strangers.* New York, NY: W.W. Norton.

Armes, R. (1987). *Third World film making and the West.* Berkeley, CA: University of California Press.

Ashcroft, B. (2001). *Post-colonial transformation.* London, UK: Routledge.

Ashcroft, B., Griffiths, G., & Tiffin, H. (1999). *Key concepts in post-colonial studies.* London, UK: Routledge.

Ashcroft, B., Griffiths, G., & Tiffin, H. (2002). *The empire writes back: Theory and practice in post-colonial literatures* (2nd ed.). New York, NY: Routledge.

Behdad, A. (2005). Global disjunctures, diasporic differences, and the new world(dis-) order. In H. Schwarz & S. Ray (Eds.), *A companion to postcolonial studies* (pp. 396–409). Malden, MA: Blackwell.

Berger, M. (2004). *The battle for Asia: From decolonization to globalization.* London, UK: RoutledgeCurzon.

Berry, C. (2000). If China can say no, can China make movies? Or, do movies make China? Rethinking national cinema and national agency. In R. Chow (Ed.), *Modern Chinese literary and cultural studies in the age of theory: Reimagining a field* (pp. 159–180). Durham, NC: Duke University Press.

Berry, C., & Farquhar, M. (2006). The national in the transnational. In C. Berry & M. Farquhar, *China on screen: Cinema and nation* (pp. 195–222). New York, NY: Columbia University Press.

Bhabha, H. K. (1990a). DissemiNation: Time, narrative, and the margins of the modern nation. In H. K. Bhabha (Ed.), *Nation and narration* (pp. 291–322). London, UK: Routledge.

Bhabha, H. K. (1990b). Introduction: Narrating the nation. In H. K. Bhabha (Ed.), *Nation and narration,*(pp. 1–7). London, UK: Routledge.

Bhabha, H. K. (1994a). *The location of culture.* London, UK: Routledge.

Bhabha, H. K. (1994b). Of mimicry and man: The ambivalence of colonial discourse (pp. 85–92). In H. K. Bhabha, *The location of culture.* London, UK: Routledge.

Bhabha, H. K. (1994c). The postcolonial and the postmodern: The question of agency (pp. 171–197). In H. K. Bhabha, *The location of culture.* London, UK: Routledge.

Bhabha, H. K. (2000). Interrogating identity: The post colonial prerogative. In P. Du Gay, J. Evans, & P. Redman (Eds.), *Identity: A reader* (pp. 94–101). London, UK: Sage.

Bordwell, D. (2000). *Planet Hong Kong: Popular cinema and the art of entertainment.* Cambridge, MA: University of Harvard Press.

Boyd-Barrett, O. (1997). International communication and globalization: Contradictions and directions. In A. Mohammadi (Ed.), *International communication and globalization: A critical introduction* (pp. 11–26). Thousand Oaks, CA: Sage.

Boym, S. (2001). *The future of nostalgia.* New York, NY: Basic Books.

Brown, M. J. (2004). *Is Taiwan Chinese?: The impact of culture, power, and migration on changing identities.* Berkeley, CA: University of California Press.

Browne, N., Pickowicz, P. G., Sobchack, V., & Yau, E. (Eds.). (1996). *New Chinese cinemas: Forms, identities, politics.* Cambridge, UK: Cambridge University Press.

Chan, F. (2003). *Crouching Tiger, Hidden Dragon*: Cultural migrancy and translatability. In C. Berry (Ed.), *Chinese Films in Focus: 25 New Takes* (pp. 56-64). London, UK: British Film Institute.

Chan, K. (2004). The global return of the *Wu Xia Pian* (Chinese sword-fighting movie): Ang Lee's *Crouching Tiger, Hidden Dragon. Cinema Journal, 43*(4), 3–17.

Chang, M-K, (2000). On the origins and transformation of Taiwanese national identity. *China Perspectives, 28* (March–April), 51–70.

Chen, K-H, (2000a). The imperialist eye: The cultural imaginary of a subempire and a nation-state (Y. Wang, Trans.). *Positions: East Asia Cultures Critique, 8*(1), 9–76.

Chen, K-H. (2000b). Taiwanese new cinema. In J. H. Hill, P. C. Gibson, R. Dyer, E. A. Kaplan, & P. Willemen (Eds.), *World cinema: Critical approaches* (pp. 173–177). New York, NY: Oxford University Press.

Chen, K-H, (2001). America in East Asia. *New Left Review, 12,* 73–88.

Chen, K-H, (2002). Why is 'great reconciliation' impossible? De-Cold War/decolonization, or modernity and its tears (Part I). *Inter-Asia Cultural Studies, 3*(1), 77–99.

Chen, K-H, (2006). Taiwan new cinema, or a global nativism? In V. Vitali & P. Willemen (Eds.)., *Theorising national cinema* (pp. 138–157). London, UK: British Film Institute.

Chen, K-H, (2010). *Asia as Method: Towards Deimperialization*. Durham, NC: Duke University Press.

Chen, K-H., & Chien, S. (2009). Knowledge production in the era of neo-liberal globalization: Reflections on the changing academic conditions in Taiwan (T-L Hwang, Trans.). *Inter-Asia Cultural Studies, 10*(2), 206–228.

Cheng, A. (2001). *The melancholy of race*. Oxford, UK: Oxford University Press.

China: Winning global audiences. (2001, July 2). *China Daily*, p. 9.

Chinese director pins his hope on an Oscar. (2006, February 8). *China Daily*, p. 8.

Ching, L. (2001). *Becoming 'Japanese': Colonial Taiwan and the politics of identity formation*. Berkeley, CA: University of California Press.

Chitty, N. (2005). International Communication. *Gazette: International Journal for Communication Studies, 67*(6), 555–559.

Chow, R. (1993). *Writing diaspora: Tactics of intervention in contemporary cultural studies*. Bloomington, IN: Indiana University Press.

Chow, R. (1995). *Primitive passions: Visuality, sexuality, ethnography, and contemporary Chinese cinema*. New York, NY: Columbia University Press.

Chow, R. (2000). Introduction: On Chineseness as a theoretical problem. In R. Chow (Ed.), *Modern Chinese literary and cultural studies in the age of theory: Reimagining a field* (pp. 1–24). Durham, NC: Duke University Press.

Chow, R. (2002). *The Protestant ethnic and the spirit of capitalism*. New York, NY: Columbia University Press.

Chow, R. (2007). *Sentimental fabulations, contemporary Chinese films*. New York, NY: Columbia University Press.

Chua, B. H. (2004). Conceptualizing an East Asian popular culture. *Inter-Asia Cultural Studies, 5*(2), 200–221.

Chua, B. H. (2008). East Asian pop culture: Layers of communities. In Y. Kim (Ed.), *Media consumption and everyday life in Asia* (pp. 99–113). New York, NY: Routledge.

Chuang, R. (2000). Dialectics of globalization and localization. In G-M Chen & W. J. Starosta (Eds.), *Communication and global society*, (pp. 19–34). New York, NY: Peter Lang.

Chun, A. (1996). Fuck Chineseness: On the ambiguities of ethnicity as culture as identity. *Boundary, 23*(2), 111–138.

Clifford, J. (1997). *Routes: Travel and translation in the late twentieth century*. Cambridge, MA: Harvard University Press.

Clifford, J. (2000). Taking identity politics seriously: 'The contradictory, stony ground.' In P. Gilroy, L. Grossberg, & A. McRobbie (Eds.), *Without guarantees: In honor of Stuart Hall* (pp. 94–112). London, UK: Verso.

Clifford, J. (2005). Diasporas. In A. Abbas, J. N. Erni, W. Dissanayake, P-H Liao, T. Miller, C. Patton . . . J. M. Wise (Eds.), *Internationalizing cultural studies: An anthology*, (pp. 524–558). MA: Blackwell.

Corliss, R., Harbison, G., Ressner, J., & Turner, M. (1995, August 14). Cinema: Asian invasion. *Time Magazine*. Retrieved from http://www.time.com/time/magazine/article/0,9171,983301-1,00.html

Crouching Tiger makes South Africans admire Chinese communities. (2001, January 24). *Epoch Times*, Retrieved from http://www.epochtimes.com/b5/1/1/24/n39020.htm.

Dai, J., & Chen, J. (1997). Imagined nostalgia. *Boundary 2, 24*(3), 143–161.

Dai, J. (2007). Body, politics, nation: From Zhang Ai Ling to Ang Lee. Retrieved from http://www.chinese-thought.org/whyj/004765.htm.

Dayal, S. (1996). Postcolonialism's possibilities: Subcontinental diasporic intervention. *Culture Critique, 33*(4), 113-149.

Dennison, S., & Lim, S. H. (2006). Situating world cinema as a theoretical problem. In S. Dennison & S. H. Lim (Eds.), *Remapping world cinema: Identity, culture and politics in film* (pp. 1–18). London, UK: Wallflower Press.

Dirlik, A. (2006). Intimate others: [Private] nations and diasporas in an age of globalization. *Inter-Asia Cultural Studies, 5*(3), 491–502.

Dirlik, A. (2007). *Global modernity: Modernity in the age of global capitalism.* Boulder, CO: Paradigm.

Duara, P. (1995). *Rescuing history from the nation: Questioning narratives of modern China.* Chicago, IL: University of Chicago Press.

Ezra, E., & Rowden, T. (2006). General introduction: What is transnational cinema? In E. Ezra & T. Rowden (Eds.), *Transnational cinema: The film reader* (pp. 1–12). London, UK: Routledge.

Fanon, F. (1963a). On national culture. In F. Fanon, *The wretched of the earth* (C. Farrington, Trans., pp. 206–248). New York, NY: Grove Press.

Fanon, F. (1963b). *The wretched of the earth.* New York, NY: Grove Press.

Fanon, F. (1967). *Black skin, white masks.* New York, NY: Grove Press.

Fong, C-S. (2001, February 9–18). 'Crouching Tiger, Hidden Dragon' on 'Soul Mountain', *Posts Weekly,* 3.

Galloway, S. (2007, November 12). Oscar's foreign movie rules questioned. Retrieved from http:// www.backstage.com/bso/esearch/article_display.jsp?vnu_content_id=1003671349

Georgiou, M. (2006). *Diaspora, identity and the media: Diasporic transnationalism and mediated spatialities.* Cresskill, NJ: Hampton Press.

Gilroy, P. (1993). *The Black Atlantic: Modernity and double consciousness.* Cambridge, MA: Harvard University Press.

Gilroy, P. (1994). Black cultural politics: An interview with Paul Gilroy by Timmy Lott, *Found Object, 4,* 46–81.

Gilroy, P. (1997). Diaspora and the detours of identity. In K. Woodward (Ed.), *Identity and difference* (pp. 299–346). London, UK: Sage.

Gilroy, P. (2000a). Identity, belonging, and the critique of pure sameness. In *Against race: Imagining political culture beyond the color line* (pp. 97–134). Cambridge, MA: Harvard University Press.

Gilroy, P. (2000b). Modernity and infrahumanity. In *Against race: Imagining political culture beyond the color line* (pp. 55–96). Cambridge, MA: Harvard University Press.

Grossberg, L. (1996). History, politics and postmodernism: Stuart Hall and cultural studies. In D. Morley and K-H. Chen (Eds.), *Stuart Hall: Critical dialogues in cultural studies,* (pp. 152–173). London, UK: Routledge.

Guo, D-Y. (2001, March 27). The monster in culture criticism. *China Times Express,* p. 2.

Hall, S. (1990). Cultural identity and diaspora. In J. Rutherford (Ed.), *Identity: Community, culture, difference* (pp. 222–237). London, UK: Lawrence & Wishart.

Hall, S. (1992). The question of cultural identity. In S. Hall, D. Held, & T. McGrew (Eds.), *Modernity and its futures* (pp. 273–326). Cambridge, UK: Polity Press.

Hall, S. (1996a). Introduction: Who needs 'identity'? In S. Hall & P. Du Gay (Eds.), *Questions of cultural identity* (pp. 1–17). London, UK: Sage.

Hall, S. (1996b). New ethnicities. In D. Morley & K-H. Chen (Eds.), *Critical dialogues in cultural studies* (pp. 441–449). London, UK: Routledge.

Hall, S. (1996c). When was "the post-colonial"? Thinking at the limit. In L. Curtis & I. Chambers (Eds.), *The post-colonial question: Common skies, divided horizons* (pp. 242-260). London, UK: Routledge.

Hall, S. (1997a). The local and the global: Globalization and ethnicity. In A. King (Ed.), *Culture, globalization and the world-system: Contemporary conditions for the representation of identity* (pp. 19–39). Minneapolis, MN: University of Minnesota Press.

Hall, S. (1997b). Old and new identities, old and new ethnicities. In A. King (Ed.), *Culture, globalization and the world-system: Contemporary conditions for the representation of identity* (pp. 41–68). Minneapolis, MN: University of Minnesota Press.

Halualani, R. T., Mendoza, S. L., & Drzewiecka, J. (2009). 'Critical' junctures in intercultural communication studies: A review. *Review of Communication, 9*(1), 17–35.

Han, J. (2008, February 2). Why is Ang Lee being criticized? Retrieved from http://blog.sina.com.cn/s/blog_4e737717010087ax.html

Havis, R. J. (2006, August 20). Asian Americans start thinking—and shooting—outside the box. *South China Morning Post*, p.4.

Ibrahim, A. (1996). *The Asian renaissance*. Singapore: Times Books International.

Iwabuchi, K. (2008). Dialogue with the Korean wave: Japan and its postcolonial discontents. In Y. Kim (Ed.), *Media consumption and everyday life in Asia* (pp. 127–44), London, UK: Routledge.

Jay, J. (2006). *Crouching Tiger Hidden Dragon*: (Re)packaging Chinas and selling the hybridized culture in an age of transnationalism. In M. Ng & P. Holden (Eds.), *Reading Chinese trans-nationalisms: Society, literature, film* (pp. 131–142). Aberdeen, Hong Kong: Hong Kong University Press.

Kellner, D. (1998). Exploring society and history: New Taiwan cinema in the 1980s. *Jump Cut, 42*, 101–115.

Khanna, R. (2003). *Dark continents: Psychoanalysis and colonialism*. Durham, NC: Duke University Press.

Kim, L. S. (2006). *Crouching Tiger, Hidden Dragon*: Making women warriors—A transnational reading of Asian female action heroes. *Jump Cut: A Review of Contemporary Media, 48*. Retrieved from http://www.ejumpcut.org/archive/jc48.2006/womenWarriors/index.html

Kim, Y. (2005). *Women, television and everyday life in Korea: Journeys of hope*. London, UK: Routledge.

Kim, Y. (2008). Introduction: The media and Asian transformations. In Y. Kim (Ed.), *Media consumption and everyday life in Asia* (pp. 1-24), London, UK: Routledge.

Klein, C. (2004). *Crouching Tiger, Hidden Dragon*: A diasporic reading. *Cinema Journal, 43*(4), 18–42.

Lee, A. (2000). Foreword. In *Crouching Tiger, Hidden Dragon: A portrait of Ang Lee film*. New York, NY: New Market Press.

Lee, A. & Schamus, J. (2000, November 7). *The Guardian*. Retrieved from http://www.guardian.co.uk/film/2000/nov/07/3

Lee, A. & Schamus, J. (2003, June 7). *Museum of the Moving Image*. Retrieved from http://www.movingimagesource.us/files/dialogues/2/58965_programs_transcript_html_239.htm.

Lee, K-F. (2003). Far away, so close: Cultural translation in Ang Lee's *Crouching Tiger, Hidden Dragon*. *Inter-Asia Cultural Studies, 4*(2), 281–295.

Liao, P-H. (2005). Global diasporas: Introduction. In A. Abbas, J. N. Erni, W. Dissanayake, P-H Liao, T. Miller, C. Patton . . . J. M. Wise (Eds.), *Internationalizing cultural studies: An anthology*, (pp. 501–510). Malden, MA: Blackwell.

Lidchi, H. (1997). The poetics and the politics of exhibiting other cultures. In S. Hall (Ed.), *Representation: Cultural representations and signifying practices* (pp. 153–224). Thousand Oaks, CA: Sage.

Lim, S. (2006). *Celluloid comrades: Representations of male homosexuality in contemporary Chinese cinemas*. Honolulu, HI: University of Hawai'i Press.

Lionnet, F., & Shih, S-M. (2005). Introduction: Thinking through the minor, transnationally. In F. Lionnet & S-M. Shih (Eds.), *Minor transnationalism* (pp. 1–23). Durham, NC: Duke University Press.

Lo, L-Q. (1990). *History of Chinese martial arts fiction*. Shen Yang, China: Liao Ning.

Lovell, J. (2007). About Eileen Chang (Zhang Ailing) and translating "Lust, Caution," the story. In J. Lovell (Ed.), *Lust, Caution: The story, the screen play, and the making of the film* (pp. xi-xv). New York, NY: Pantheon Books.

Lu, S. H-P. (1997a). Chinese cinemas (1896–1996) and transnational film studies. In S. H-P. Lu (Ed.), *Transnational Chinese cinemas: Identity, nationhood, gender* (pp. 1–31). Honolulu, HI: University of Hawai'i Press.

Lu, S. H-P. (1997b). National cinema, cultural critique, transnational capital: The films of Zhang Yimou. In S. H-P. Lu (Ed.), *Transnational Chinese cinemas: Identity, nationhood, gender* (pp. 105–136). Honolulu, HI: University of Hawai'i Press.

Lu, S. H-P. (2001). *China, transnational visuality, global postmodernity*. Stanford, CA: Stanford University Press.

Lu, S. H-P. (2005). *Crouching Tiger, Hidden Dragon*, bouncing angels: Hollywood, Taiwan, Hong Kong, and transnational cinema. In S. H-P. Lu & E. Y-Y. Yeh (Eds.), *Chinese-language film: Historiography, poetics, politics* (pp. 220–236). Honolulu, HI: University of Hawai'i Press.

Lu, S. H-P. (2007). Tear down the city: Reconstructing urban space in contemporary Chinese popular cinema and avant-garde art. In Z. Zhang (Ed.), *The urban generation: Chinese cinema and society at the turn of the twenty-first century* (pp. 137–160). Durham, NC: Duke University Press.

Lung, Y-T. (2007, September 25). *Lust, Caution. China Times*, p. 4.

Lust, Caution actress banned in China. (2008, March 9). *Reuters*. Retrieved from http://www.reuters.com/article/idUSN0935238620080309

Lyman, R. (2001, March 9). Watching movies with Ang Lee; Crouching memory, hidden heart. *New York Times*. Retrieved from http://www.nytimes.com/2001/03/09/movies/watching-movies-with-ang-lee-crouching-memory-hidden-heart.html?scp=1&sq=

Ma, S-M. (1996). Ang Lee's domestic tragicomedy: Immigrant nostalgia, exotic/ethnic tour, global market. *Journal of Popular Culture, 30*(1), 191–201.

Mackintosh, J. D., Berry, C., & Liscutin, N. (2009). Introduction. In C. Berry, N. Liscutin, & J. D. Mackintosh (Eds.), *Cultural studies and cultural industries in Northeast Asia* (pp. 1–22). Aberdeen, Hong Kong: Hong Kong University Press.

Mendoza, S. L. (2002). *Between the homeland and the diaspora: The politics of theorizing Filipino and Filipino American identities: A second look at the poststructuralism-indigenization debates*. New York, NY: Routledge.

Mendoza, S. L. (2005). Bridging paradigms: How not to throw out the baby of collective representation with the functionalist bathwater in critical intercultural communication. In W. J. Starosta & G-M. Chen (Eds.), *Taking stock in intercultural communication: Where to now?* (pp. 1–32). Washington, DC: National Communication Association.

Mendoza, S. L., Halualani, R. T., & Drzewiecka, J. (2002). Moving the discourse on identities in intercultural communication: Structure, culture, and resignifications. *Communication Quarterly, 50*(3–4), 312–327.

Morley, D., & Robins, K. (1995). *Spaces of identity: Global media, electronic landscapes and cultural boundaries*. London, UK: Routledge.

Mumby, D. K. (1997). Modernism, postmodernism, and communication studies: A rereading of an ongoing debate. *Communication Theory. 7*(1), 1–28.

Naficy, H. (2001). *An accented cinema: Exilic and diasporic filmmaking*. Princeton, NJ: Princeton University Press.

Naisbitt, J. (1995). *Megatrends Asia: The eight Asian megatrends that are changing the world*. London, UK: Nicholas Brealy.

New York Chinese community got together for *Lust, Caution*. (2007, October 9). Nownews, ETTV. Retrieved from http://info.51.ca/news/world/2007/10/09/138303.shtml

Nornes, A., & Yeh, Y-Y. (1995). Introduction: *A City of Sadness*. http://cinemaspace.berkeley.edu/Papers/CityOfSadness/ (no longer accessible).

Ong, A. (1999a). The geopolitics of cultural knowledge. In A. Ong, *Flexible citizenship: The cultural logics of transnationality* (pp. 29–54). Durham, NC: Duke University Press.

Ong, A. (1999b). Introduction: Flexible citizenship: The cultural logics of transnationality. In A. Ong, *Flexible citizenship: The cultural logics of transnationality* (pp. 1–26). Durham, NC: Duke University Press.

Ong, A., & Donald, N. (1997). *Underground empires: Culture, capitalism and identity*. New York, NY: Routledge.

Palmer, A. (2007). Scaling the skyscraper: Images of cosmopolitan consumption in *Street Angel* (1937) and *Beautiful New World* (1998). In Z. Zhang (Ed.), *The urban generation: Chinese cinema and society at the turn of the twenty-first century* (pp. 181–204). Durham, NC: Duke University Press.

Parker, E. (2007, December 1). Man without a country. *The Wall Street Journal*, Opinion page.

Peters, J. (1999). Exile, nomadism, and diaspora: The stakes of mobility in the western canon. In H. Naficy (Ed.), *Home, exile, homeland* (pp. 17-41). New York, NY: Routledge.

Pines, J., & Willemen, P. (Eds.). (1989). *Questions of third cinema*. London, UK: British Film Institute.

Premier Chang Chung-hsiung congratulates Ang Lee's international achievement. (2001, January 22). *The Epoch Times*, Retrieved from http://www.epochtimes.com/b5/1/1/22/n38234.htm.

Roberts, S. (2007). Ang Lee interview: *Lust, Caution*. Retrieved from http://www.moviesonline.ca/movienews_13127.html

Rosaldo, R. (1989). After objectivism. In R. Rosaldo, *Culture and truth: The remaking of social analysis* (pp. 46–67). Boston, MA: Beacon Press.

Safran, W. (1991). Diasporas in modern societies: Myths of homeland and return. *Diaspora, 1*(1), (pp. 83–99).

Said, E. W. (1978). *Orientalism*. New York, NY: Pantheon Books.

San Juan, E. (1992). *Racial formations/critical transformations: Articulations of power in ethnic and racial studies in the United States*. Atlantic Highlands, NJ: Humanities Press.

San Juan, E. (2004). *Working through the contradictions: From cultural theory to critical practice*. Lewisburg, PA: Buckell University Press.

Sarup, M. (1996). *Identity, culture, and the postmodern world* (T. Raja, Ed.). Athens, GA: University of Georgia Press.

Saxton, C. (1986). The collective voice as cultural voice. *Cinema Journal, 26* (1), 19–30.

Schamus, J. (2007). Introduction. In J. Lovell (Ed.), Lust, Caution: *The story, the screen play, and the making of the film* (pp. xi–xv). New York, NY: Pantheon Books.

See-Kam, T. (2007). Convergence and divergence. *Jump Cut: A Review of Contemporary Media, 49*. Retrieved from http://www.ejumpcut.org/archive/jc49.2007/TanSee-Kam/2.html

Shih, S-M. (2005). Toward an ethics of transnational encounters, or, 'When' does a 'Chinese' woman become a 'feminist'?. In F. Lionnet & S-M. Shih (Eds.), *Minor transnationalism* (pp. 73–108). Durham, NC: Duke University Press.

Shih, S-M. (2007). Globalization and minoritization. In *Visuality and identity: Sinophone articulations across the Pacific* (pp. 40–61). Berkeley, CA: University of California Press.

Shin, H., & Ho, T-H. (2009). Translation of 'America' during the early Cold War period: A comparative study on the history of popular music in South Korea and Taiwan. *Inter-Asia Cultural Studies, 10*(1), 83–102.

Shome, R. (1999). Whiteness and the politics of location: Postcolonial reflections. In T. K. Nakayama & J. N. Martin (Eds.), *Whiteness: The communication of social identity* (pp. 107–128). Thousand Oaks, CA: Sage.

Shome, R. (2003). Space matters: The power and practice of space. *Communication Theory, 13*(1), 39–56.

Shome, R. (2006). Interdisciplinary research and globalization. *Communication Review, 9*(1), 1–36.

Shome, R., & Hegde, R. (2002a). Culture, communication, and the challenge of globalization. *Critical Studies in Media Communication, 19*(2), 172–189.

Shome, R., & Hegde, R. (2002b). Postcolonial approaches to communication: Charting the terrain, engaging the intersections. *Communication Theory, 12*(3), 249–270.

Siu, L. L. (2006). Un/queering the latently queer and transgender performance: The butterfly lover(s). In L. L. Siu, *Cross-dressing in Chinese opera* (pp. 109–134). Aberdeen, Hong Kong: Hong Kong University Press.

Spivak, G. (1988). Can the subaltern speak? In C. Nelson & L. Grossberg (Eds.), *Marxism and the interpretation of culture* (pp. 271–313). Urbana, IL: University of Illinois Press.

Spivak, G. (2001). The burden of English. In G. Castle (Ed.), *Postcolonial discourses: An anthology* (pp. 53–72). Oxford, UK: Blackwell.

Staiger, J. (2001). Writing the history of American film reception. In M. Stokes & R. Maltby (Eds.), *Hollywood spectatorship: Changing perceptions of cinema audiences* (pp. 19–32). London, UK: British Film Institute.

Sturken, M., & Cartwright, L. (2001). *Practices of looking: An introduction to visual culture.* New York, NY: Oxford University Press.

Su, J. (2005). *Ethics and nostalgia in the contemporary novel.* Cambridge, UK: Cambridge University Press.

Sun, X. (2003, January 4). Domestic film industries await more heroes. *China Daily,* p. 4.

Sun, H. (2009, October 10). Ang Lee is not an artist. Retrieved from http://tv.people.com.cn/ BIG5/79889/10171451.html

Tainan celebrates 'Ang Lee Day.' (2006, April 29). *Taipei Times.* Retrieved from http://www. taipeitimes.com/News/taiwan/archives/2006/04/29/2003305154

Tam, K-K., & Dissanayake, W. (1998). New Chinese cinema. New York, NY: Oxford University Press.

Taylor, C. (1992). The politics of recognition. In C. Taylor & A. Gutmann (Eds.), *Multiculturalism and 'the politics of recognition': An essay* (pp. 25–73). Princeton, NJ: Princeton University Press.

Wang, F-Y. (1995, February). Flowers blooming in barren soil. *Taiwan Review,* 4–17.

Wong, Z-M. (2007, September 13). Ang Lee explicitly stated 'I am Taiwanese' while receiving the award; President Chen: It is the most touching fact. *Nownews.* Retrieved from www.nownews. com/2007/09/13/301-2156887.htm

Woodward, K. (Ed.). (1997). *Identity and difference.* London, UK: Sage.

Wu, C-C. (2007). Festivals, criticism and international reputation of Taiwan new cinema. In D. W. Davis, & R-S. Chen (Eds.), *Cinema Taiwan: Politics, popularity and state of the arts* (pp. 75–92). New York, NY: Routledge.

Wu, H., & Chan, J. M. (2007). Globalizing Chinese martial arts cinema: The global-local alliance and the production of *Crouching Tiger, Hidden Dragon. Media, Culture & Society, 29*(2), 195–217.

Xu, B. (1997). *Farewell My Concubine* and its nativist critics. *Quarterly Review of Film & Video, 16*(2), 155–170.

Yan, Y. (2007, November 11). *Lust, Caution* as pornography pollution: Ang Lee should apologize to all Chinese peoples. Retrieved from http://blog.sina.com.cn/s/blog_49433c4a01000b6v.html

Yang, J. (2005, December 30). Ang Lee's visions from 'other side of the moon.' *The San Francisco Chronicle,* p. E-8.

Yang, X. (2007, November 4). Do you see 'lust' or 'caution'? Retrieved from http://blog.sina.com. cn/s/blog_4ad54af901000b4r.html

Yeh, Y-Y, & Davis, D. (2005). *Taiwan film director: A treasure island.* New York, NY: Columbia University Press.

Young, R. (1995a). *Colonial desire: Hybridity in theory, culture and race.* London, UK: Routledge.

Young, R. (1995b). Colonialism and the desiring machine. In R. Young, *Colonial desire: Hybridity in theory, culture and race* (pp. 159–182). London, UK: Routledge.

Young, R. (2001). Neocolonialism. In R. Young, *Postcolonialism: An historical introduction* (pp. 44–56). Malden, MA: Blackwell.

Yu, F-L., & Kwan, D. (2008). Social construction of national identity: Taiwanese versus Chinese consciousness. *Social Identities, 14*(1), 33–52.

Zhang, J. P. (2002). *"Movies: A ten-year movie dream come true" by Ang Lee, Oscar winning director of* Crouching Tiger, Hidden Dragon (*Shi nian yi jiao dian yin meng*). Taipei, Taiwan: China Times.

Zhang, Y. (1997). From 'minority film' to 'minority discourse' : Questions of nationhood and ethnicity in Chinese cinema. In S. H-P. Lu (Ed.), *Transnational Chinese cinemas: Identity, nationhood, gender* (pp. 81–104). Honolulu, HI: University of Hawai'i Press.

Zhang, Y. (2004). *Chinese national cinema.* New York, NY: Routledge.

Zhang, Z. (2007). Bearing witness: Chinese urban cinema in the era of 'transformation.' In Z. Zhang (Ed.), *The urban generation: Chinese cinema and society at the turn of the twenty-first century* (pp. 1–28). Durham, NC: Duke University Press.